Gupta Sculpture

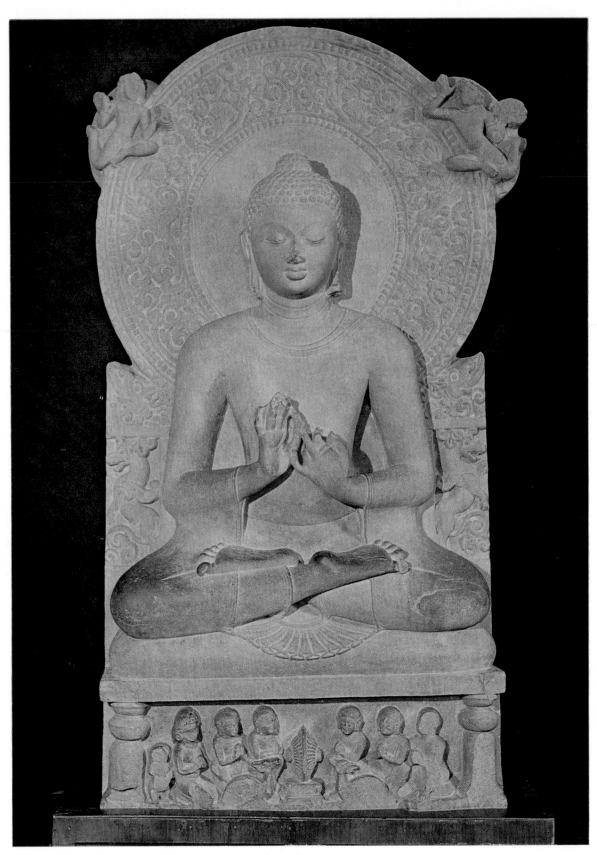

Seated Buddha, Sārnāth

Gupta
Sculpture

Indian Sculpture of the
Fourth to the Sixth Centuries A.D.

J. C. Harle

CLARENDON PRESS · OXFORD · 1974

Oxford University Press, Ely House, London W.1

GLASGOW NEW YORK TORONTO MELBOURNE WELLINGTON
CAPE TOWN IBADAN NAIROBI DAR ES SALAAM LUSAKA ADDIS ABABA
DELHI BOMBAY CALCUTTA MADRAS KARACHI LAHORE DACCA
KUALA LUMPUR SINGAPORE HONG KONG TOKYO

ISBN 0 19 817322 9

© OXFORD UNIVERSITY PRESS 1974

PRINTED IN GREAT BRITAIN
BY WILLIAM CLOWES & SONS, LIMITED
LONDON, BECCLES AND COLCHESTER

Foreword and Acknowledgements

Certain sculptures of the Gupta period have long been recognized as among the supreme achievements not only of Indian art but of that of the world, comparable in this respect to the masterpieces of fifth-century Greece. Yet this is the first book exclusively devoted to Gupta sculpture, due in part to the small number of works known until recently, and the consequent difficulty of fitting isolated pieces, from widely separated areas, into any sort of coherent framework. During the past twenty or thirty years, however, new discoveries have considerably increased, and indeed perhaps doubled, the number of works in the still limited corpus of Gupta sculpture and an account of the Gupta style, its origins, development and local variations now seems possible. Great gaps, none the less, remain, dated pieces amongst the survivors are so few in numbers that the chronology of the period can only be adumbrated in quarter- or even half-centuries, and there is still a great deal that we simply do not know. The present book attempts to illustrate a fairly large and representative selection of the stone and terracotta sculpture of the period, including most if not all of the major works, and to provide the reader with the relevant information about them as well as a fairly general account of the period and its art, but it lays no claim to being definitive. Sculpture in bronze has not been included, since few indisputably Gupta works in this medium have survived and they are minor compared to both what was achieved in stone and terracotta and to the great works in bronze of subsequent periods.

Scholars in the past have held, with markedly varying degrees of knowledge and authority, widely differing views as to when the Gupta period came to an end. A decision on this matter naturally faced me at the very outset with a hurdle which may have served to deter others in the past from writing a book on Gupta art. I have opted for a shorter period and a more restricted geographical area than some which have been proposed but here as elsewhere I have sought to avoid any extreme or radical positions. Indeed the facts did not seem to impose them. In cases of sheer perplexity, I have simply reported the views of the scholar or scholars who have dealt with the material most intensively. The direction of stylistic development in Mathurā, eastern Mālwā, Central India, and the eastern Madhyadeśa is fairly clear and one or two more dated pieces from the first of these sites may well solve the fascinating problem of whether or how late into the Gupta period Mathurā continued to impose its style on the rest of India. On the other hand, the surviving sculpture of Western India and Kashmir presents an almost total mystery as far as its chronological and stylistic connections with the rest of Gupta sculpture are concerned. Once *tardif* Gandhāra sculpture, with its obvious but as yet totally undefined connection with Gupta sculpture, has been delimited and dates assigned to it, a solution to these problems may well appear, provided that the numerous excavations now in progress in Gandhāra as well as Afghanistan and the border lands to the south, establish the chronology on a sufficiently firm basis.

The present book had its origin in a course of lectures given for several years to undergraduates and graduate students at Oxford University. Most of the photographs were obtained, and the principal museums and sites with Gupta sculpture visited,

during three months' study leave in 1970 for which I am grateful to the Visitors of the Ashmolean Museum, and I would also like to thank my colleagues of the Department of Eastern Art at the Museum, who cheerfully shouldered an extra burden of work during my absence. Information was checked on subsequent visits to India. As always, that admirable organization, the Archaeological Survey of India, extended their cordial co-operation, for which I would particularly like to thank the former and present Directors-General, Messrs. B. B. Lal and M. N. Deshpande, as well as Mr. Krishna Deva, now Director of the School of Archaeology. I would also like to express my sincere appreciation to the Directors and curatorial staffs of the various museums in India where Gupta works are preserved, for helping me both in my research and by providing photographs. Amongst them, I would particularly like to single out Dr. N. P. Joshi, Director of the State Museum, Lucknow, as well as Dr. U. P. Shah, Deputy-Director of the Oriental Institute, M. S. University of Baroda, whose researches and publications are particularly relevant to the material covered in this book and with whom I had most profitable discussions. Professor K. D. Bajpai was most generous regarding the reproduction of photographs from Eran, his special province. The photographic archives of the American Institute of Indian Studies in Varanasi (formerly the American Academy of Benares) proved invaluable and I am grateful for the unfailing help given by the Institute and its zealous staff. Without the permission to reproduce a large number of the Institute's splendid photographs, kindly accorded by the Committee for South Asian Art, I would, in many instances, have been sorely taxed to obtain illustrations of the required standard. Where my own photographs have proved adequate, it has been in part due to skillful processing by members of the photographic staff of the Ashmolean Museum. The map was prepared by Miss H. O. C. Gibson.

Permission to reproduce photographs of objets under their care or in their collections has been given by the Allahabad Museum; Archaeological Museum, Gwalior; Archaeological Survey of India; Ashmolean Museum, Oxford; British Museum; Cleveland Museum of Art; Department of Archaeology, M. S. University of Baroda; Gaṅgā Golden Jubilee Museum, Bikaner; Indian Museum, Calcutta; Los Angeles County Museum of Art; National Museum, New Delhi; Prince of Wales Museum of Western India, Bombay. Where the photographs were derived from another source, the name is given in brackets in the List of Plates.

Contents

List of Plates

THE IMPERIAL GUPTAS

Candragupta I	—	A.D. 320–*c*. A.D. 345
Samudragupta	—	*c*. A.D. 345–*c*. A.D. 380
Candragupta II	—	*c*. A.D. 380–*c*. A.D. 414
Kumāragupta	—	*c*. A.D. 414–A.D. 455
Skandagupta	—	A.D. 455–*c*. A.D. 467

Introduction

The great rulers of the Gupta dynasty, Candragupta I, Samudragupta, Candragupta II, Kumāragupta, and Skandagupta, dominate the history of India of the fourth and fifth centuries A.D. Their very names have an august ring, tolling out an unbroken succession of five uniformly long and successful reigns such as history can rarely record elsewhere. Some, and particularly Samudragupta, were noted conquerors, Kumāragupta appears to have had a peaceful reign, but all measured up, as far as we know, to the ideal of the *mahārājādhirāja*, the Indian great king of great kings. For the first time since the Mauryas in the third century B.C., and the last indeed, until modern times, all of India north of the Vindhyas acknowledged the sovereignty of a single ruler and that an Indian one. Kalidāsa, the greatest Indian dramatist and poet, lived under the Guptas, and it was towards the end of their rule that the Sārnāth Buddha appeared, probably the greatest single Indian achievement in the plastic arts. It is not surprising that the Gupta period is enshrined in the Indian consciousness as a golden age.

Lamentably little is known about the great, or Imperial, Guptas personally or even about their rule. This is not exceptional for an Indian dynasty, the peculiar sources of Indian history being what they are. One looks in vain for histories, in the Western sense, chronicles, personal documents. Instead, the sources are limited almost entirely to inscriptions recording religious donations or foundations by individuals. Rich in information concerning religious and social matters and specific enough about local conditions, references to the wider political stage are restricted, as often as not, to the name of the feudal or paramount sovereign and the date, or even simply his regnal year. It is rather as if an account of Henry VIII had to be based exclusively upon the king's name and styles, and the date, as they are found in the preambles of contemporary charters and private legal documents. Any amplification is in the completely conventional language of panegyric. Here is one of the briefest amongst the thirty odd inscriptions somewhat optimistically called 'Gupta', inscribed on the base of the Buddha image found at Mankuwar (Pl. 55):

Om! Reverence to the Buddhas! This image of the Divine One, who thoroughly attained perfect knowledge, (and) who was never refuted in respect of his tenets, has been installed by the Bhikshu Buddhamitra,—(in) the year 100 (and) 20 (and) 9; in the reign of the *Mahārāja*, the glorious Kumāragupta; (in) the month Jyeshtha; (on) the day 10 (and) 8,—with the object of averting all unhappiness.

<div align="right">Fleet, <i>Inscriptions of the Early Gupta Kings.</i></div>

In the longer inscriptions, it is true, a genealogy of the ruler will be included as well as lengthy encomiums. Then there is the full scale *praśasti*, a laudatory account of a king's attributes and exploits, usually reserved for only the greatest and most successful monarchs, listing his victories over other monarchs and the territories brought under his sway; a hundred years of history for a major region of India will often be based on a single *praśasti*. We are fortunate that there is such a record for a Gupta monarch, the well-deserved posthumous *praśasti* of Samudragupta, *c.* A.D. 345–80, engraved on a Maurya pillar now in the Fort at Allahabad. Most of what we know of this great monarch's conquests is derived from it.

If the blossoms in the form of source-material for Indian political history are of such a limited variety, they are—over the two thousand years up to the advent of the European, and particularly in some regions—exceedingly numerous. Their very uniformity, and the fact that they are deeply rooted in Indian life and thought, provides, moreover, a specially firm basis for their interpretation, and there is little reason to doubt the fundamental assumptions which Indian historians of the recent past have based on these rather narrow but deep foundations. None the less, it is natural to feel a certain scepticism as regards the Guptas. The classical Indian *Weltanschauung* is a highly realist one and it is often difficult to distinguish whether or not the ideal is rooted in experience. What more natural than to take an obscure but blameless line of kings and fit them into the mould of ideal monarchs in a golden age? The number of Gupta inscriptions is disturbingly few, only twenty-five or so. Petty monarchs of a later age can sometimes boast twice as many. There is not, moreover, a single monument or work of art which can be directly associated with the Guptas. The emperor, if not without clothes, seems very scantily dressed. The paucity of inscriptions can, however, be explained in part by the early date of the Guptas, but principally by the extraordinary scarcity in the Madhyadeśa of inscriptions or monuments of the fourth and fifth centuries of any kind, and yet we know that it was the richest, most prosperous, and without any doubt the most populous part of the Gupta Empire. Only one temple of Gupta date, the brick temple at Bhitargaon (Pls. 131–5), still stands in what was the heartland of Hindu culture and remains, with the exception of certain coastal areas, the most densely populated area of India. The prevalence of brick, attested by what remains have been excavated and confirmed by its almost universal use in the region today, made necessary by a relative scarcity of stone, provides part of the answer. The other is the destructiveness of successive wars of conquest pouring down along the Ganges valley, attracted alike by this great natural highway and the unequalled spoils which lay along its course.

The most casual of travellers cannot help but be impressed at how close together the villages are in the Ganges and Jumna valleys, from Delhi and Moradabad all the way to Patna and beyond. It is even more evident from the air. Conversely, in Central India, villages are relatively few and far apart yet the first region, densely populated as it must always have been, is almost completely devoid of pre-Muslim antiquities, at least above ground, whereas the second is one of the richest for standing Gupta remains. In Central India, the tourist in pursuit of Gupta remains there may have another experience of equal historical relevance. At the close of day, travelling back from the sun-drenched plains where Eran stands, he will notice the coolness of the air as he passes through the last still-forested belt before he reaches Bhopal, the western gate to Central India. The trees and their leaves have absorbed much of the day's heat and prevent its radiation back by the earth. Without being a climatologist, he will suspect how different life in the Madhyadeśa must have been before it too was deprived of its trees, except for the inevitable mango and bamboo grove around each village, by a process of deforestation which still continues, with the carts full of firewood lumbering into the cities at nightfall. Not that the inhabitants of the great Madhyadeśa, in Gupta times, were forest-dwellers. This indeed was the mark of the uncivilized tribals, Śabarras and Pulindas, but although they tilled the fields and travelled the roads in sunlight, they were undoubtedly far less subject in the daytime to the fierce radiated heat from the treeless earth and, worse, to the consequent prolongation of the day's heat after sunset.

If there are few, if any, Gupta inscriptions in their homeland, it can thus be easily explained. More important is the undeniable existence of Gupta inscriptions in outlying regions and these inscriptions, in Mathurā, at Girnar far in the west, confirm, although not entirely, Gupta claims to the suzerainty of all Northern India. The Guptas

founded an era, which was known by their name and widely used, an achievement limited to only a handful of dynasties in two and a half millennia of Indian history. And if few, if any, monuments can be attributed to them, they have left ample evidence of one of sovereignty's most glorious and intimate attributes, a coinage both splendid and unique.

Here the pre-eminence of the Guptas over all other Hindu dynasties is undisputed. No other Hindu dynasty produced a coinage remotely comparable in quality, no other minted regularly in gold (Pl. 2). Based initially on Kuṣāṇa models the figures of the emperors retain throughout costumes of indubitably Kuṣāṇa inspiration, with trousers and buttoned tunics. But the way in which the human body is portrayed becomes increasingly Indianized. In the same way, the Iranian divinities of the Kuṣāṇa pantheon are increasingly portrayed as Indian gods and goddesses. Certain types, the rhinoceros-hunt for instance, are purely Indian conceptions.

What was life like in the Gupta dominions in the fourth and fifth centuries? For once we are fortunate in having one of those rare eyewitness accounts by a foreigner (indeed by a man of an entirely different culture) which seem to cast an entirely fresh light on a country and its people. The Chinese Buddhist monk Fa Hsien travelled the length and breadth of the Gupta Empire during the early years of the fifth century, during what must have been the most golden years of a golden age. Unfortunately, to the pious monk, India is simply the scene of the acts, great and small, of the Buddha's life. He travels from one place hallowed by Buddhist story to another, noting the number and zeal of the Buddhist communities and the impressiveness of their *sanghārā-mas*, but little else. He does not even mention the name of the great emperor through whose dominions he travelled for years. Yet he does remark briefly, in an often-quoted passage, on the humane nature of the emperor's rule:

The people are numerous and happy; they have not to register their households, or attend to any magistrates and their rules; only those who cultivate the royal land have to pay a portion of the gain from it. If they want to go, they go; if they want to stay on, they stay. The king governs without decapitation or other corporal punishments. Criminals are simply fined, lightly or heavily, according to the circumstances of each case. Even in cases of repeated attempts at wicked rebellion, they only have their right hands cut off. The king's body-guards and attendants all have salaries. Throughout the whole country the people do not kill any living creature, nor drink intoxicating liquor, nor eat onions or garlic.

Legge, *Fā-Hien . . . his Travels.*

There is little doubt that the society thus glimpsed through the eyes of an observer not predisposed to favour must have been one of the happiest and most serene any country has boasted of. For the flavour of life at its best in Gupta times, however, we can turn to one of the longest and certainly the most beautiful of the Gupta inscriptions, the famous lines from Mandasor recording the building and later the restoration of a Sun temple on the banks of the river, by the silk-weavers of Lāṭa. No vestige of the temple remains but its site can be visited. The inscription is not strictly a Gupta one, for although it mentioned Kumāragupta as the paramount sovereign, it is dated A.D. 474 in the reckoning of the confederation of the Mallavas, one of those ancient Indian tribes with a republican constitution in whose territory Mandasor lay. It is in the language of Kāvya, the high classical Sanskrit poetry, used alike in narrative poems and dramas, of which Kalidāsa was the greatest exponent. Bound in intricate metres, it is an extremely sophisticated form whose language is characterized by an almost incredibly abundant use of figures. Always hovering on the brink of euphuism and excessive mannerism, at its best it inter-twines all the rich threads of a great culture into an intricate texture, utterly self-contained, of surpassing richness and beauty. Here is a short passage from the Mandasor inscription describing the felicity of the life the immigrant weavers (Lāṭa is in south Gujerat) had found in their new home:

And in course of time this city became the forehead-decoration of the earth, which is adorned with a thousand mountains whose rocks are besprinkled with the drops of rut that trickle down from the sides of the temples of rutting elephants, and which has for its decorative ear-ornaments the trees weighed down with flowers. Here the lakes, crowded with *karaṇḍava*-ducks are beautiful,—having the waters close to their shores made variegated with the many flowers that fall down from the trees growing on the banks, and being adorned with full-blown waterlilies. The lakes are beautiful in some places with the swans that are encaged in the pollen that falls from the waterlilies shaken by the tremulous waves; and in other places with the waterlilies bent down by the great burden of their filaments. Here the woods are adorned with lordly trees, that are bowed down by the weight of their flowers and are full of the sounds of the flights of bees that hum loudly through intoxication caused by the juices of the flowers that they suck, and with the women from the city who are perpetually singing. Here the houses have waving flags and are full of tender women, and are very white and extremely lofty, resembling the peaks of white clouds lit up with forked lightning. And other long buildings on the roofs of the houses, with arbours in them, are beautiful,—being like the lofty summits of the mountain Kailasa; being vocal with songs like those of the Gandharvas; having pictured representations arranged in them; and being adorned with groves of waving plantain-trees.

Fleet, *Inscriptions of the Early Gupta Kings.*

The origins of the Guptas, as in the case of many famous dynasties, are obscure. They seem to have originally been either feudatory chiefs or else the independent monarchs of a small kingdom and to have ruled in Eastern India, probably including a part of Bengal. Candragupta I is the first to bear the title Mahārājādhirāja. He married a Lichchavi princess called Kumāradevī of whom the dynasty always made much. She is portrayed on coins, which bear the name Lichchavī, and her son Samudragupta is always referred to in the dynasty's genealogical account as the 'daughter's son of the Lichchavī' whereas no mention is ever made of the family of any of the other Gupta rulers' mothers. This importance accorded to Kumāradevī probably indicates that the alliance provided the Guptas with an increase in their territory which may have formed the base for their future expansion. The Lichchavis, of course, had been the rulers of republican Vaiśāli in the Buddha's time and at this time there was a dynasty of that name ruling in Nepal. We do not know to which family Kumāradevī belonged, nor in fact do we know anything else about Candragupta I. In fact we are not even certain that the Gupta era, which starts in A.D. 318 or 320, actually commenced with either his accession or his coronation. It might celebrate the date of the coronation of Samudragupta.

It is astonishing to see the Lichchavis reappear on the scene. In fact, in their obscure way, they seem never to have left it. Small mountain tribes with republican institutions, such as the Swiss, seem to be the most durable of all political entities. Not that their antiquity appears to have conferred much esteem upon them; it has been argued that the Guptas felt they had gained significantly in status by the marriage to a Lichchavī princess and hence flaunted the connection but according to Manu, of considerably earlier date but held in great esteem in the Gupta period, they were merely considered to be degraded Kṣatriyas.

One thing is certain, for all the tenacious ways in which they had survived, the Lichchavis now finally disappear. So do the other such tribal or clan units which were one of the aspects of early India. The Gupta age sees the emergence, or at least the first record of many things which still exist in India today, from types of dress and physical types (see Pl. 129) to modes of worship; at the same time it sees the final dissolution of the early India.

Considerably more is known about Samudragupta, the greatest of his line, largely because of the famous Allahabad inscription which contains a long *praśasti* by one of his ministers. He was a great warrior and, although it is no longer possible to identify some of the kings he overthrew, a picture of his conquests emerges none the less. He actually conquered, something rare in Indian history, a large part of India. The

dynasties were overthrown and the territories placed directly under Samudragupta's administration. As a result, Samudragupta himself ruled over almost all of Bengal in the east. In the north, the boundary of his empire ran along the edge of the foothills approximately to Lahore. From there a line running almost due south nearly to Sāñcī formed the western boundary of Samudragupta's territory, whence it ran eastward along the Vindhyas. Most of Rajputana and the upper Punjab are mentioned as being in the hands of feudatories, as well as Nepal, the modern Assam, and eastern Bengal. In addition, Samudragupta mounted victorious expeditions into Mahākośala and down the east coast as far as Kāñci, defeating the Pallava king. Samudragupta's performances of the *aśvamedha* (horse sacrifice) were no idle boast. He was also said to be not only a great patron of learning but a poet and muscian himself and the fact that he is shown on one of his coins playing a musical instrument lends weight to this claim.

Recent evidence seems to confirm the existence and brief reign of Rāmagupta (see notes to Pl. 20), although he is not usually included among the Imperial Guptas. While fighting against the Śakas he is said, according to a literary tradition, to have been defeated and his army surrounded. To save his life, he surrendered his queen to his Śaka adversary. His younger brother Candragupta II was so outraged at this dastardly act that he slew him and, in an act of great daring, penetrated the Śaka camp in disguise, killed the Śaka king, and rescued Rāmagupta's queen whom he then married. How much truth resides in the story is not known; its infamous character would, it is true, account for Rāmagupta being excluded from the Gupta genealogies. At any rate, Samudragupta's grandson, Candragupta II, succeeded him. One of his epithets shows that he was a staunch Vaiṣṇava, and Viṣṇu figures appear on many of his coins, as well as on those of his father. Here again it is significant that all the Guptas appear to have been staunch supporters of the Brahmanical faith. Candrugupta II, who had a very long reign, was also a great conqueror, and his was the crowning achievement of Gupta arms, the defeat and expulsion of the Śaka rulers of Gujerat and Kathiawar, the Western Kṣatrapas. This foreign line, with their capital at Ujjain, had endured for over three hundred years. The Gupta Empire now extended to the Arabian Sea and consisted of all North India with the exception of the extreme north-west. This conquest is particularly significant. It seems to have occurred in the latter part of Candragupta's reign and to have been the occasion for a long stay in Mālwā of which we will later see the fruits. This movement westward, culminating in the shifting of the capital from Pataliputra to Ujjain, is of the greatest importance. For one thing, it placed the Guptas athwart the principal trade-routes from the Western world; equally important, it placed them in control of the regions which had been, for the last three centuries, in the forefront of artistic development in India.

Kumāragupta had a long reign of approximately forty years. It appears to have been peaceful, with one exception, and the fact that he handed on the Empire to his son was no mean achievement. We know nothing whatsoever about him or his reign, except that he performed an *aśvamedha* and was a great devotee of Kārttikeya. On his coins, the peacock is often substituted for Garuḍa. He was succeeded, possibly after some trouble, by Skandagupta, whose mother was probably not the chief queen. Already as crown prince he appears to have scored a victory over the Huns and his great victory over them as king stands as the greatest achievement of his reign, this and the fact that at his death the Empire was still intact. Deterioration in the coinage suggests that the strain of war was being felt by the Empire but the fact that great works were still undertaken, such as the rebuilding of the dam of the great reservoir at Girnar in Kathiawar, at the very western extemity of the Empire, testifies to the continued vigour of Gupta rule.

The Huns whose depredations are usually credited with fatally weakening the Gupta Empire are otherwise of little or no importance to Indian history. After

Skandagupta's death they seem to have renewed their incursions and there is an inscription of one of their rulers, Toremāṇa, who seems to have had his base in Gandhāra, as far east as Eran, in the Sāgar District of Madhya Pradesh. His son, Mihirakula, may have even extended his conquests and, in the first half of the sixth century, his rule extended to Gwalior. The later Imperial Guptas, though capable of resounding victories over the Huns, saw the Empire diminished and weakened. How much was due to the rise of turbulent feudatories or vassals, like Yaśodharman or the Vākāṭaka Hariṣeṇa, who annexed Mālwā, or whether it was the weakened power of the Guptas which allowed these rivals to arise is difficult to say. Already in Budhagupta's time, a few years after Skandagupta's death, ruling chiefs in such centrally located regions as Allahabad District, Rewah State, and Mahishmati, on the Narmadā, seem on occasion not to have acknowledged the suzerainty of the Guptas.

The reigns of the five great Gupta kings extend from *c.* A.D. 320 to A.D. 467, but the dynasty is considered to have continued to rule through a series of brief, obscure, and even controversial reigns to the mid-sixth century. There is such a thing as a Gupta style, which emerged and came to a flowering during the reign of the Gupta kings and to a large extent it was co-extensive with their dominion. Artistic styles do not exactly follow dynastic history, however; a style may survive a dynasty for decades or even a century or two, and the Gupta period in sculpture and architecture has on occasion been extended to as late as A.D. 650. This appears unjustified. Although the Gupta style continued to influence later styles for centuries, it had undergone extensive modifications by then, and flourished, in necessarily altered forms, as much outside the former Gupta dominions as inside them. On the other hand, to terminate the period with the death of Skandagupta, *c.* A.D. 467, ignores the fact that at Sārnāth some of the greatest of all Gupta sculptures are dated in the reign of one of his successors. Little or nothing, moreover, has survived which can with certainty be attributed to the first thirty or so years of the dynasty and it would consequently seem most arbitrary to end the period with the reign of Skandagupta, who was not even the last Gupta king. A date of A.D. 550, when the Guptas seem to have given up all Imperial pretensions, allows one to include a number of temples and individual works in a style which, though different from that of most of the fifth century, is yet totally impregnated with Gupta ideals. The Gupta period as a whole may then be divided into an early Gupta period, extending, depending on the region, well into the fifth century, a Gupta period proper, and a late Gupta period beginning in the west perhaps as early as the second quarter of the fifth century but considerably later in the east. Works undertaken after the middle of the sixth century are then considered to belong to the post-Gupta period.

The antecedents of Gupta sculpture are well known. In the first centuries of our era, under the patronage of the Sātavāhanas, a forceful style of sculpture had been evolved which is known through the reliefs on rock-cut caves in the western Deccan and Konkan. To the east and somewhat later, under a branch of the same family, a related style evolved in works carved from the white limestone of certain parts of Andhra, of which the finest to have survived are the railings and revetments from the great *stūpa* at Amarāvati, at the mouth of the Godāvari. This, with the gateways of the *stūpas* at Sāñcī, represents the culmination, after many centuries, of early Indian sculpture. At about the same time as this final flowering, sculpture commenced to be produced in great quantities at two widely separated sites, the city of Mathurā and the region of Gandhāra, both within the great Empire of the Kuṣāṇas, a dynasty of Central Asian origin notable for their eclecticism. Sculpture from Mathurā is at the outset in a style very similar to late Sātavāhana work, whereas Gandhāra sculpture is a provincial Roman art in the service of Buddhism, but both are of supreme importance in the development of Indian sculpture. Mathurā art soon evolves into a highly distinctive style and in its later productions, highly debased although they are, a groping towards the

Gupta style can be clearly discerned. A considerable number of the works considered to be late Kuṣāṇa may in fact belong to the early Gupta period.

Many of the favourite Gupta motifs such as the acanthus frieze, the laurel-wreath moulding, the vine scroll and T-shaped door-jambs first appear, it is well to remember, in Kuṣāṇa sculpture from Mathurā. Obese dwarfs with particularly thin legs, so characteristic of Gupta sculpture, first make their appearance as attendants in scenes figured in the panels of certain Mathurā door-jambs. These scenes depict the same sophisticated urban life whose reflection imbues so much of Gupta art. Large, almost life-sized terracottas first appear in the Kuṣāṇa period, later to become, although in a far more sophisticated style, one of the chief glories of Gupta art. Gandhāra and Mathurā both claim the credit for the creation of Indian iconography, but, with a minor exception or two, Gandhāra sculpture is exclusively Buddhist. At Mathurā, on the other hand, Hindu images do appear, though relatively few in number, and with them the principal elements of later Śaiva and Vaiṣṇava iconography. This is sometimes carried over unchanged into the Gupta period (see Pl. 16 and Notes). Most of the elements of the Gupta style can thus be found in the Kuṣāṇa period from Mathurā as well as in the Westernized art which flourished in Kṣatrapa-dominated Rājasthān, Gujerat, and Kathiawar in the first centuries A.D. As for most great periods in the history of art, however, to trace the developments which led to them is not to account for them and the same holds good for the great achievements of the Gupta period.

The Gupta period has been interpreted as a manifestation of Indian cultural nationalism, after centuries of foreign influence. There seems little point in denying this: the Gupta period is quintessentially Indian and will determine the development of Indian culture for centuries. Yet both Mathurā and Gandhāra were permeated with influences from the Graeco-Roman world and it is a curious fact that certain of these only appear to surface at this late date. The typical small flat-roofed Gupta stone temple with its peristylar facade has been associated with Greek origins. The Western Signs of the Zodiac first appear in sculptural form in the Gupta period (Pl. 37) and the introduction of Western astronomical and astrological concepts, as found in a work significantly named the *Romaka Siddhānta*, probably dates from the Gupta period or a little earlier. A particular type of hair-style, which a recent scholar has traced back to Hellenistic times, if not to Attic Greece, appears on many Śiva images at this time. Finally, there is the Gaḍhwā lintel, which seems to be permeated with Attic grace although the time-lag, of some eight centuries, precludes any direct influence. The answer to this extremely complex question is no doubt the gradual acclimatization of Western Classical ideas and forms in India during the centuries that preceded the Gupta period, culminating in contacts with the late Classical Western world through Palmyra and Syria, a process of acculturization so thorough that, in the Gupta period, these influences were at the same time completely absorbed and could, like a genetic throw-back, produce occasional startling reminders of the centuries of contact.

Gupta sculpture in stone consists of a small but important number of rock-carvings in Central and Eastern India, and a very considerable number of individual images, Buddhist and Hindu, originally installed in shrines or placed in niches, although surviving examples can only be a small fraction of the total production. The first large sculptural compositions, such a feature of later Indian sculpture, first appear in the Gupta period (Pls. 12, 103, 104). The iconography of a multitude of gods and figures is determined once and for all during the Gupta period, to allow later of only occasional innovations and local variants. It is in the Gupta period, it would seem, that Hindu stone shrines commenced to be built in great numbers, with a corresponding increase in the need for images. Gupta architectural ornament, notably pillars and their capitals and the elaborate surrounds of doorways, marks the high point of such work in India. Sculpture in terracotta, providing both the images and the architectural ornament for

the brick temples which were also being built in great numbers, reaches a size and manifests a *brio* and a sophistication to which work in this medium has rarely if ever attained. Bronze images were made but very few have survived which can be unquestionably assigned to the Gupta period and now that the great Sultanganj Buddha is generally thought to be a later work, sculpture in bronze cannot be considered a major aspect of Gupta art.

The Gupta style, particularly in its early phase, is a combination of the earthy and the dainty, in Goetz's phrase, of strength and elegance, of the sublime and the grotesque. Out of all these paradoxes stems its unique flavour. In the later period the paradoxes tend to be resolved into a uniquely graceful, harmonious, and cohesive style, well exemplified by the small dwarf out of whose navel rises the vine scroll on the door-jambs of several Gupta temples. Already a unifying link between the beautiful and the grotesque, in one of the later temples the vine motif actually spreads to the body of the dwarf and the vegetable and the human coalesce (Pl. 106). In the late Gupta style, the bodies grow more slender and sinuous and the immense vigour of early Gupta figures yields to mannered poses. So too, the boldness of scale which characterizes much early Gupta sculpture disappears. Alone, certain architectural ornaments increase in size but at the expense of losing their earlier refinement. The period of equipoise between the paradoxes of the early Gupta style, fascinating but none the less unresolved, and the too easy reconciliations and permutations of the late style, is a brief one, but it produced some of the greatest works of art the world has ever seen.

What is it ultimately that characterizes the Gupta style? The answer is perhaps twofold: a turning inward, an ability to communicate higher spiritual states, which distinguishes Gupta and post-Gupta sculpture as well as that of all those subsequent schools in South-East Asia which owe their origins to India, from any other sculpture in the world, and which has left its mark on Indian sculpture to this day. The other is an elegance, a stylishness, a *brio*, to which little in world art can approximate. The reason is probably the quality of the civilization it reflects. In Goetz's words: 'The Gupta age represents the classic phase of Indian civilization in so far as it aspired to create a perfect, unsurpassable style of life.'

Eastern Mālwā and Central India

If there is a common denominator to the Gupta sculptural style, it is here that it is to be found, and particularly in the rock-cut sculptures of the Udayagiri caves. Owing much to earlier Mathurā, the style of these sculptures also has much in common with that of eastern Uttar Pradesh. It is indeed fitting that this should be so, for the Udayagiri cave sculptures, badly disfigured and subject to continuing deterioration as they are, have the unique distinction of being the only works which can be personally associated with a Gupta monarch. Not that any of the three inscriptions dedicating caves or sculpture at Udayagiri (two of Candragupta II, one dated in A.D. 402, and one of Kumāragupta dated A.D. 426) records a royal donation but one of them is by a minister of Candragupta II who states that it was in attendance upon his king that he, a man of Pataliputra, had come there. The nearest, then, that we can actually come to visualizing an Imperial Gupta monarch is here, amongst the low hills and wide plains of Central India. Candragupta II must almost certainly have walked, surrounded by his retinue, along the narrow road that runs past the caves and made his devotions there. His presence here is usually explained by the eventually triumphant campaign he conducted against the western Kṣatrapas and their capital Ujjain. Vidiśā and its vicinity, including Besnagar less than three miles away, Sāñcī and lesser Buddhist centres nearby, had of course been a centre of religious and artistic activity for centuries.

All the caves are Hindu and at ground level, with the exception of a single Jaina one which is half-way up the north-east end of the hill. One has been fashioned, by means of a free-standing stone portico and columns, into one of the typical small flat-roofed Gupta shrines; remains or traces of columns and entrance porches can still be seen before several other caves (Pls. 3 and 14). Two of the 'caves' are not caves at all, but large sculptured panels in the rock. There are also numerous other small panels, particularly in the *défilé*, and a number of gods and goddesses cut into the rock. Only one cave, No. 19, has a simple arrangement of four interior pillars and a sculptured ceiling. Otherwise they are simple cubical or near-cubical cells, empty and unadorned except for a *liṅgam* or an image of the divinity against the back wall.

Although the Udayagiri caves are of little importance architecturally, it is here that the elaborate carved doorways in the Gupta style, a feature of the complex caves soon to be excavated at numerous sites in the Deccan and the Konkan, first appear (Pls. 5, 6 and 7). Here also appears, for the first time, in a particularly simple and attractive form, the celebrated Gupta scroll-and-leaf decoration (Pls. 5 and 6).

The images are fairly evenly divided between the Śaiva and Vaiṣṇava pantheons. Perhaps the most widespread type in the Gupta period is the four-armed Viṣṇu with his cylindrical crown (*kirīṭa mukuṭa*) standing stiff-legged (*samapāda*) (Pl. 8). Note the quatrefoil pattern on the crown, the lion head with pearl festoons, and the tuft-like projections of the band behind the head which held the crown in place. The lower two hands hold the club and the *cakra* (wheel or discus): the weapons are frequently personified, as here. The chest is massive, the navel deeply sunk, in a distant echo of the early Mathurā Kuṣāna style; in contrast, the Gupta sculptor shows a great fondness, amounting to a mannerism, for *bouffant* swatches of drapery and delicately crinkled tabs, bow-ends, or lappets.

The predominant Śaiva images are *liṅgams* and figures of Kārttikeya, like the superb *ekamukhaliṅgam* in Cave 4 (Pl. 9) and the fine standing Kumāra of Cave 3 (Pl. 10). The two heads have the best-preserved faces of any of the Udayagiri sculptures. Even then, a considerable effort is required to reconstitute a visual picture of them as they were originally carved. The faces were very full, the lower portion nearly semi-circular, the eyes large, almond-shaped, *à fleur de peau*, with heavy upper lids; the eyebrows, arched, were represented by a narrow, raised ridge which may have continued unbroken above the nose. This last is a late Mathurā Kuṣāṇa feature. The lips appear to have been fleshy.

The powerful chest can best be seen in the Kārttikeya image. The lower legs, feet slightly apart, knees bent almost backward, also recall the typical Mathurā stance; on the other hand, the tight cylinder of the thighs tapering to the relatively slender waist, recalls the Nāgarājas of Sāñcī (Pl. 40) and the Narasiṁha in Gwalior and seem to be typical of eastern Mālwā. So does the particularly heavy torque and the rather archaic-looking armlets, with their rosette-like tops. Although the central peak is missing, Kārttikeya is depicted as *triśikhin*, i.e. with his hair divided into three strands. In a similar style are a fine pair of doorkeepers (Pl. 11).

The great panel of the Boar incarnation of Viṣṇu (designated Cave 5, although it is in no sense a cave) is the only one of the Udayagiri sculptures which is widely known (Pl. 12). In fact it is one of the most widely illustrated of all Indian monuments. This is doubtless due in part to its size; it measures 7 m. by 4 m., and no other bas-relief panel in India is as large. Only the Kirātārjuniya, at Māmallapuram, in South India, which occupies one whole side of a giant boulder, surpasses it in size. Colossi are not in the Indian spirit, and the long rows of identical figures occupying most of the ground are equally exceptional. So is the carrying over of the central motif on to the sides of the great niche cut out of the rock.

Not that the central figure is in any way unusual. Viṣṇu's Boar incarnation, raising the earth, in the form of a maiden, from the primeval waters, bizarre as it may seem to non-Indian eyes, is one of the most popular myths of manifestation and constantly represented in sculpture from the Gupta period onwards. There are two versions: the entirely theriomorphic one (see Pl. 24), and the one where the god is depicted as a man with a boar's head. For the latter the pose here at Udayagiri is the invariably accepted one: the left knee bent as he steps forward and upward, the goddess held up in the crook of the left arm, the right hand placed on his hip in an exultant pose of power and achievement. *Nāgas* (serpent deities), creatures of the waters, do obeisance. Here at Udayagiri, a unique attempt has been made, moreover, to extend and amplify the scene and give literal expression to more of the accompanying myth and symbolism. On either side of the central figure stretch, in low relief, row after row of identical figures, *ṛṣis* (sages) and celestial beings. The panel's originality of conception does not stop there. An ambitious water imagery is attempted, with incised wavy lines representing water, rows of lotuses, and amongst the waters a solitary male figure, probably the personification of Ocean, a minor mythical figure. But in an even more unusual effect, unique in Indian sculpture, the imagery is carried over on to the narrow sides of the panel. Here, below some celestial musicians, the wavy lines of water divide into the two great rivers of the Madhyadeśa, the heartland of the Gupta Empire, with their tutelary goddesses, Gaṅgā and Yamunā, placed against them. They are distinguished respectively by the *makara*, a mythical water-beast, and the tortoise on which they stand. When the waters reunite, with the figure of Ocean amongst them (Pl. 13), the scene vividly evokes Kalidāsa's description of the two great rivers as the brides of Ocean.

There is one figure who remains unexplained, the badly mutilated sculpture of a man on his knees behind the worshipping *nāga* (Pls. 14 and 15). Unfortunately his face

is gone. A similar figure kneels in the same position in the mediocre and smaller but otherwise comparable panel of Viṣṇu asleep on the serpent Ānanta in the *défilé* (Cave 13). The iconography of neither of these extremely common images calls for such figures. Is it too far-fetched to believe that they represent Candragupta II, as the donor?

It is a great pity that at least two sets of the Mothers (*Sapta Mātṛkās*) have been totally destroyed. Fortunately three images of Durgā as the Killer of the Demon Buffalo remain, though in varying states of preservation. The Durgā image is notable as the first Hindu image to achieve a fixed iconography at Mathurā in the Kuṣāṇa period. One of the Udayagiri examples, outside Cave 17, adheres very closely to this earlier form (Pl. 16). Another is very badly worn but it shows an even more faithful retention of some of the more characteristic Mathurā features, the animal with its body rearing up against the goddess, one of her arms pressed stiffly down on its back. Even the multiple bangles on her wrists are relics of an earlier time. The better-known Durgā outside Cave 6, on the other hand, shows both animal and goddess in a quite different pose, one moreover which was henceforth to prevail (Pl. 17). It is a fine, spirited portrayal of the youthful goddess. These two images are evidence of at least two styles at Udayagiri, although they may have co-existed in time.

Further evidence of the existence of various influences in the sculpture of the vicinity has recently come to light with the discovery of a head of Viṣṇu found at Besnagar nearby (Pls. 18 and 19) and now in the Cleveland Museum of Art. The shape of the *mukuṭa* or crown and the ends of a cloth band sticking out on either side are marked idiosyncrasies already noted in identical form on the Viṣṇus at the caves. The face, however, appears to be rather different, with vestiges of the pursed mouth and the parrot-like eyes of the later Kuṣāṇa style at Mathurā.

Most important of the recent discoveries are the three, practically identical, seated Jina figures (Pl. 20) recently dug up at Vidiśā and bearing largely similar inscriptions in the reign of Rāmagupta. The historical authenticity of this personage as the short-lived successor to Samudragupta, murdered and supplanted, with some justice, by Candragupta II, has long been debated but these new finds tend to confirm the obscure Rāmagupta's right to this niche in history and consequently a date of approximately A.D. 380 can be attributed to the sculptures. There are certain mannerisms which one connects with late Kuṣāṇa Jinas but all in all the statues are far closer to the fifth-century Jinas from Mathurā. Allowing for local characteristics, these figures, if one allows them a date of *c.* A.D. 380, would fit fairly well into the chronology of stylistic development, albeit a very hypothetical one, at Mathurā. This is important for it shows that as regards stylistic development Mālwā was not notably behind Mathurā in time. Confirmation that bases of Jina images with all the same features existed at a fairly early date in eastern Mālwā is provided by the defaced and barely recognizable images, so far unpublished, in the Jaina cave at Udayagiri.

Eran is today a tiny village 80 kilometres north-east of Sāñcī, but coins and inscriptions found there show that it was a place of some importance in Gupta times and earlier. The principal Gupta antiquities stand grouped together on a shelterless plain half a mile west of Eran (Pls. 21 and 22). They consist of the remains of four or five small shrines, a monumental pillar surmounted by the *cakra* and figures of Garuḍa, a huge theriomorphic image of the same god in his Boar incarnation, and a Narasiṃha (Man-lion) image, whose ruined shrine may still be discerned. A superb Boar image, this one in human form, is now in Sāgar but almost certainly came from one of the temples on the site.

The column was dedicated in A.D. 485, in the reign of Budhagupta, by a local king and his younger brother. Monumental pillars standing alone have a long tradition dating back at least to Maurya times. Gupta pillars, of which the one at Eran is the finest example still standing, unquestionably show an archaizing tendency such as the

retention, although in modified flattened form, of the bell capital. At Eran, however, the resmblance ceases there: whereas Maurya columns were round, the Budhagupta column has a square shaft turning into a chamfered one. The capital is surmounted by a huge square abacus with a pair of addorsed lions on each side, those on adjacent sides sharing the same head. Above the abacus a large *cakra* surmounts a curiously shaped stand, against which are placed a pair of two-armed figures standing back to back (Pl. 23). One would expect them to represent Viṣṇu since the inscription refers to the god Janārdana, a name of Viṣṇu, but they bear none of the attributes of Viṣṇu, neither crown nor *vanamāla*, neither conch, club, nor discus. They wear their hair dressed in curls in typical Gupta fashion but surmounted by a top knot, and hold a serpent. As a scholar has recently pointed out, it is undoubtedly Viṣṇu's vehicle, the bird Garuḍa, which is depicted here. The strange stumplike projections of the *cakra*'s stand are probably meant to be wings. A hint of the grotesque in the human faces would be consonant with this identification; so are the serpents.

The giant Boar (Pl. 24) was dedicated, so an inscription of great historical importance informs us, by the younger of the pair of brothers who dedicated the great column. It is thus unlikely to date from long after the year A.D. 500. In the inscription the Hun leader Toremāṇa is given as the paramount lord, and it is one of the principal pieces of evidence for the date of the Hun incursions, as well as showing the extent of their penetration into India. The Boar incarnation in this, the entirely animal form, is both the earliest and the largest of a type which had a considerable vogue in later times. The body is always covered with row on row of miniature figures, said to represent the sages (*ṛṣis*) who took refuge amongst his bristles. The conception is presumably the same as in the great Boar *avatāra* at Udayagiri (Pl. 12), the figures simply transferred from the ground of the sculpture to the body of the deity. The goddess, Bhūdevī, clings to one of his tusks.

The splendid Narasiṁha image (Pl. 25) originally stood in the sanctum of the little ruined Gupta temple on the north-west corner of the site. He still has the extremely wide shoulders and correspondingly broad flat head of examples at Udayagiri, although his hips are narrower. The temple in question, although only one or two pillars still stand, is essentially complete and could probably be reconstituted by the process of *anastylose* from the numerous well-preserved blocks piled near and around it (pilasters, columns, architraves, door-jambs, etc.).

Undoubtedly the finest piece of sculpture from Eran is the anthropomorphic image of Viṣṇu as the Boar, (Pl. 26), in an exceptional state of preservation and now in the Sāgar University Museum. The little figure of Bhūdevī is recognizably in the same style as the figure standing by the great theriomorphic Boar, even to the highly idiosyncratic way in which the arm looped around the tusk is treated and which gives it the impression of being made of rubber. In both Boars the emphasis is on the cylindrical snout, with the mouth shown as a straight slit. The Sāgar Museum figure also has close stylistic links with the Garuḍas atop the Eran column. This is particularly noticeable in the way in which cylindrical forms are handled. Note the predilection for this shape, displayed even in the accessories, the rope-like girdle of the Boar and the hose-like form of the serpent held by Viṣṇu. The treatment of the hands placed on the hips is almost identical. But where the Viṣṇus are clumsy in a provincial way, the Boar achieves a superb boldness which makes it one of the finest of all Indian sculptures.

Carved in the side of a cliff a couple of miles from Badoh-Paṭhārī in the same region are a rather badly damaged group of seated Mother goddesses (Mātṛkās) (Pl. 27) presided over by an ithyphallic Śiva (Pl. 28). Beside them is a fairly long inscription which mentions an otherwise unknown Mahārāja Jayatsena. On the far left (proper), easily recognizable by her emaciation, is Cāmuṇḍā (Pl. 29); otherwise the various members of the Septarchy are not easily identifiable either by attributes or symbols

Pl. 30). They are principally remarkable by the variety of their head-dresses and the severe way in which they sit bolt upright in 'European fashion' on their individual benches. A certain grotesqueness is heightened, in several cases, by abnormally short legs. Only Śiva, the leader of this grim crew, appears more relaxed and his wig-like head-dress, so typical of the early Gupta period, even lends him a certain urbanity. He is very close in style to the Udayagiri cave figures, and the faces of the Mātṛkās, very round and full, with large wide-open eyes, also recall these figures. With their markedly provincial characteristics, it is difficult to say whether this group are earlier or later than the Udayagiri sculptures. At Udayagiri, the Mātṛkās beside Cave 6 have unfortunately been all but obliterated, partly, at least, by the action of water.

There is, however another group of Mātṛkās, said to have come from Besnagar, in the Gwalior Archaeological Museum. These superb but fragmentary and often savagely mutilated Mātṛkās constitute one of the most important groups of indubitably Gupta sculptures to have survived (Pls. 31 and 32). Sitting on elegant thrones with baluster-turned legs, their full round breasts are already stylized into perfect spheres and faint smiles hover on the one or two faces which have not been mutilated. At the same time, they are strongly individualized by their varied and extravagant coiffures. Comparison with the Badoh Mātṛkās (Pls. 29 and 30) is instructive. Certain apparently localized styles of dress survive in the Besnagar group, and the conception is identical, the demonic goddesses sitting bolt upright on their thrones in the same slightly menacing pose, but the Besnagar sculptor has managed to convey their proud and virginal aspect in a way quite beyond the capacity of the Badoh carvers. Whether the awkwardness and crudeness of the latters' work is simply provincialism, or whether a considerable gap of time separates the two groups it is difficult to say but the Besnagar goddesses would seem to belong to a slightly later phase than the Udayagiri rock sculpture.

Corresponding to the Besnagar Mātṛkās in degree of stylistic development is a sadly damaged Viṣṇu in the Gwalior Museum, also said to be from Besnagar (Pl. 33). Certain features link this figure very closely to similar sculptures at Udayagiri, the crinkled ends to the belt, the shape of the torque, with the śrīvatsa below it, but the huge flowered vanamāla and the soft fleshy treatment of the smiling face indisputedly belong to a later date. This sculpture and the Besnagar Mātṛkās may best be assigned, until further evidence is available, to the second quarter of the fifth century.

The Gujari Mahal, at the base of Gwalior Fort, a former princess's palace which now houses the Archaeological Museum, contains one of the finest collections of sculptures from Central India, many of them from the environs of Vidiśā. A much-battered Narasiṃha image there, probably the earliest in India, is said to come from Besnagar. The ends of his belt are crinkled, which relates him without any doubt to the sculpture in the Udayagiri caves. From what remains of attendant figures on the base, they must have been ayudhapuruṣas.

Undoubtedly the crowning figure of a monumental pillar is the intriguing sculpture from Pawāya, consisting of an addorsed pair of figures, with a cakra rising between their heads (Pl. 34). The nearest parallels are the Garuḍas atop the Budhagupta column at Eran (Pl. 23) and there is some evidence that Viṣṇu is also represented here. The right hand is in abhaya, turned slightly inward and backed by a cushion-like support, in the manner of Kuṣāṇa Buddhas from Mathurā. The faces, with exaggeratedly arched eyebrows indicated by raised lines, are reminiscent of Mathurā figures of the Kuṣāṇa period, but here the resemblance ends. The crown has no parallel elsewhere, and in style neither the rest of the face nor the body, slender and unaccented, can be related to either late Kuṣāṇa or early Gupta sculptures. Yet there is little doubt that this is an early sculpture, probably one of the few sculptures that can be confidently assigned to the fourth century. It may be considered to be in a local style. Its find-place, Pawāya, the ancient Padumavati, was a place of considerable importance in the first centuries of this era.

The Archaeological Museum, Gwalior, contains a number of crowning elements from monumental pillars of the Gupta period, of which one, from Pawāya, has just been mentioned. Also from Pawāya, is a superb fan-palm (*tāla*) capital (Pl. 35). The most interesting is a lion capital with the Signs of the Zodiac on the abacus in unmistakeably Gupta style. Because of this the capital was considered Gupta until recently when it has been convincingly shown that the capital is Maurya, the abacus recut (Pl. 36). The twelve houses of the sun, as opposed to the twenty-eight *nakṣatras* of the moon, are a recognized importation into Indian astronomy and astrology. Usually considered to have taken place in the early centuries of our era, this representation, which clearly belongs to the fifth century, is the earliest datable manifestation. The representations are clumsy adaptations: human figures with a crab, a scorpion, or a *makara* instead of a head (Pl. 37). Gemini are figured as a man and a woman, a typical Indian loving couple (*mithuna*), and it is interesting to note the identification of Capricorn and the *makara*. Solar disks (against which are shown seated figures) and triple circles, all probably of Western astronomical origin (cf. the Gaḍhwā lintel), separate the zodiacal figures.

A number of statues from the Gupta period have been found at Sāñcī. Pride of place must go to the four seated Buddhas inside the processional path of the great *stūpa*, one at each of the four entrances. They are splendid, large sculptures but unfortunately the head of the principal figure is missing on all but one (Pl. 38), whose large round face with its great three-quarter-shut eyes and a smile of beatitude hovering around its lips makes it one of the finest of all Buddha images. The large eyes, with their almost bulging lids, have been seen in sculpture from Mathurā, probably of the fourth or even fifth century, and the composition of the stele ultimately derives from the Katrā-type Buddha of Mathurā in the Kuṣāṇa period. The roundness of the face however, and the features of an attendant figure of one of the other Buddhas are related to the Udayagiri cave figures (Pl. 39). If these figures are indeed those referred to in the nearby inscription of A.D. 451, it shows eastern Mālwā, like Mathurā, to have been in advance, as regards stylistic development, of regions further east.

The two Nāgarājas now in the Sāñcī Museum (Pl. 40) are near equivalents to the Udayagiri cave sculptures, although lacking their vitality, and probably date from the same years. Three other standing figures in the Museum—all Bodhisattvas—are later, perhaps from the early sixth century. One can be identified as Vajrapani (Pl. 41), although both arms and most of the legs are missing. It is a fine sculpture almost fully in the round. Holes drilled in the 'pleated fan' *śiras cakra* or nimbus, perhaps to hold a copper extension, lend some weight to the theory that it may be the figure atop a pillar mentioned in an inscription. The other two Bodhisattvas, a pair, are a little lumpy and recall Ajantā sculpture.

Mathurā

The site of Mathurā has several claims to a pre-eminent position in the history of Indian art. Nowhere else in India, in a fairly restricted area, has sculpture in great quantities been found dating from Śungā times until the late medieval period, almost all of it recognizable as the product of local workshops because of the stone, a red sandstone with buff spots or striations. During the Kuṣāṇa period (late first to third centuries A.D.), Mathurā and Gandhāra, the two great centres of sculpture in the Kuṣāṇa Empire, had both played vital and in some ways very similar roles in the development of Indian sculpture. At these two places and nowhere else—one an ancient town and its surroundings, the other a region—stone sculpture was first produced in large quantities in India. Yet strangely enough, neither Gandhāra nor Mathurā (most of the ancient sites at the latter lie beneath the present city) can boast of a single surviving monument of note, such as the great *stūpas* of Sāñcī and Amarāvati; what is more—the inevitable concomitant of such large-scale production—much of the sculpture is of relatively poor quality. Again, it was at Mathurā and in Gandhāra that the first Buddha images were produced, apparently more or less independently, and that a real iconography was first developed. Here the similarities cease. In Gandhāra, art was, with a few rare exceptions, in the service of Buddhism, whereas at Mathurā, although Buddhist and Jaina images predominate, the first theistic Hindu images make their appearance in this period. Again, possibly because of its purely Indian aesthetic as compared to the essentially foreign style of the Gandhāra school, Mathurā sculpture of the Kuṣāṇa period had a *rayonnement* unique in the whole history of Indian sculpture. Products of Mathurā workshops have been found in Gandhāra and as far away as Bengal and the Nepalese *terai*. The characteristic Mathurā style was equally pervasive. At Sārnāth, local copies were made of such famous imports as the great standing Buddha of Friar Bāla, and at Kauśāmbī, also in the eastern Madhyadeśa, what appears to have been a local school is none the less essentially a variant of the Mathurā school.

At its finest, sculpture from Mathurā of the Kuṣāṇa period is superb: the style a naturalism as closely observed as in the finest Egyptian sculpture, but more full-blooded. Exactly when the Kuṣāṇa style at Mathurā was at its peak is not known. It appears to decline twenty or thirty years after the accession of the great Kaniṣka, but it may well have reached its zenith before his reign commenced. The dates proposed for Kaniṣka I's accession range from A.D. 78 to A.D. 144 and even later. While the history of the Kuṣāṇa style at Mathurā is still obscure, it seems clear that a fairly brief maturity was followed by a long decline. The style having lost its vigour, pure stereotypes appear. There are no more works on a monumental scale. Influences from Gandhāra make an unmistakable and, initially at least, disastrous appearance. The great bulk of later Mathurā Kuṣāṇa sculpture consists of Jaina images, commissioned or perhaps simply bought by the donors whose names are more often than not included in donative inscriptions. Plate 42 shows one of the rare examples which has retained its head—the figures on the base, which vary in composition, represent the donors, either individually or in typical groups. The crudeness of their execution is astonishing. The image itself is less crude but on the whole it is a sadly debased style at the end of a long and temporarily

exhausted tradition. Yet there are already elements foreshadowing the mature Gupta style. The head is covered with large snail-curls. The halo, plain except for scallops at the borders in the earlier period, now bears a fair burden of ornament, including a central lotus-rosette and a pearl band. The treatment of face and body, moreover, is completely at variance with the powerful naturalism of the early Kuṣāṇa period. The body and limbs, and particularly the chest, are simply an envelope for breath (*prāṇa*). There is no hint of bone or sinew and the ears are quite disproportionate. The heavy, raised eyebrows and the exaggeratedly wide upper lids are hallmarks of the later Kuṣāṇa style, but the lower part of the face already hints at the 'spiritual' countenance of Gupta Buddhas and Jinas.

Another sculpture (Pl. 43) shows the direct influence from Gandhāra which can be seen in certain late Kuṣāṇa Buddhas. Not only is a mat of kuśa grass indicated on top of the throne but the folds of the *saṁghati* are asymmetrically draped across the chest as was invariably the fashion with Gandhāra Buddhas. The decoration of the halo is even more advanced, for the pearl- or foliage-band, with rosettes upon it, is a Gupta feature. If one can speak of a transition-style at Mathurā, then surely it is illustrated by these two figures. They bear, like so many of these Buddhas and Jinas, a one- or two-digit date but there is as yet no undisputed way of relating these dates to the Christian era or even to that of Kaniṣka, whose commencement date is itself still undetermined. The most likely calculations place them, however, in the mid-third century.

Even though most of it falls within the Gupta period, the fourth century A.D. is everywhere practically a blank as regards dated images, and no less at Mathurā than elsewhere. The famous seated Buddha from Bodhgaya (Pl. 44), dated in the year 64 of an otherwise unknown King Trikamala and now in the Indian Museum, Calcutta, may be a fourth-century work and has been widely assumed to be an import from Mathurā. A Gupta era datum, i.e. 320 + 64 = A.D. 384, is plausible enough. It seems unlikely, however, that it is from Mathurā. The curious juxtaposition of the body—which is both iconographically and stylistically closely related to the finest Mathurā Buddhas of the Kuṣāṇa period—with a head having the brooding contemplative face which was only achieved in the Gupta period, points to an origin in the eastern Madhyadeśa, where the influence of the Kuṣāṇa style remained strong until the fifth century, as seen in the Mankuwar Buddha. Whatever its origins or its date, it is one of the greatest achievements of the Indian sculptor. It also occupies a unique position as the sole surviving work from one of the two or three pivotal periods in the long history of Indian sculpture, that of the change from the early naturalism which reached its full maturity at Sāñcī in some of the western caves and finally in Kuṣāṇa Mathurā, to the idealism of the Gupta period, with its tendency, inevitable in India, to abstraction. As Stella Kramrisch remarked long ago, it is 'the earliest image, in a truly spiritual sense', in that it signifies what its name implies. The body still has the exuberant vigour of Kuṣāṇa sculpture at its best but the inward-looking face perfectly expresses the subordination of all manifested reality to the pure world of spirit. The spiritual achievement implied in the latter, allied to the vigour of the body, perfectly expresses the world-subduing conquest achieved by the great yogin.

There is only one piece of Mathurā carving unquestionably dated in the fourth century. This is the small figure at the base of a pillar dated A.D. 381 (Mathurā Museum 29.1931). The small nude figure bears a staff and probably represents a mendicant form of Śiva. Large-bellied and dwarfish, its stylistic qualities are somewhat blurred by these grotesque effects but it appears to be in the Gupta style. A few other sculptures from Mathurā can reasonably be assigned to the fourth century on stylistic grounds. One is the standing male figure bearing a purse (Mathurā Museum 18.1506). It has several obvious features of the Kuṣāṇa style, but the jewellery belongs to a later period and the treatment of the chest, with its swelling curves mounting to over-broad, almost circular shoulders is strongly reminiscent of the figures at the Udayagiri caves.

The first, and indeed the only important sculpture from Mathurā with a Gupta date is a seated Jina figure from the Kaṅkālī Ṭīlā and dated A.D. 432/433 (Pl. 45). There have been major changes since the seated Jinas of the Kuṣāṇa period. The base is long and narrow, with couchant lions at either end. They are quite different from the lions in the same pose during the heyday of the Kuṣāṇa style, proportionately much smaller, decorative, not monumental, and with their heads turned facing backward. In the centre is a discus or *cakra* in profile (the circular wheel) on a low pedestal. A pair of devotees, male on the proper right, female on the proper left, kneel on either side, their hands in *añjali* (the gesture of obeisance or greeting). Characteristically, they are presented in three-quarter view. The style is totally different from that of the figures on the bases of Kuṣāṇa statues. The Jina figure itself is also very different from similar figures of the Kuṣāṇa period. The curious wide-hipped and high-waisted effect, which appears to tilt the crossed legs forward and downward, as well as give an odd eunuch-like appearance to the figure, is characteristic of many such Gupta images.

Unfortunately, the head and halo of this dated Jina are missing but a virtually intact image (Pl. 46) with a very similar base, although perhaps a couple of decades later, furnishes a good example of these fifth-century seated Jinas from Mathurā. The head is characteristic of the rather hard style of Buddha and Jina heads, of which detached examples abound from the fifth century at Mathurā. The eyes are inordinately long. The tear-ducts are marked by a characteristic down-turning. The lips are full, forming into a characteristic *moue*. The halo is in the developed Gupta style: the round wreath-like element bears three rosettes, and the foliage-band is laterally cut. This particular image is placed against a throne-back with rampant leogryphs (*vyālas*), of typical Gupta type, but another of these images (State Museum, Lucknow, J119) has subordinate figures on either side as in the Katra type Buddha of the Kuṣāṇa period, except that they are raised above the base, instead of standing on a lower level.

The stylistic transition from late Kuṣāṇa images at Mathurā to these Gupta figures reveals some apparent contradictions. In the first place, the lions now face outward, as in earlier Kuṣāṇa images, whereas the later ones faced forward. Possibly an archaizing tendency, so frequent in Indian art, led to the re-adoption, though in a very different style, of the older type. Some light is shed on this process by a couple of fragmentary images, or one where the base alone survives (Lucknow Museum, J71). Although the lions face forward, the bases are low, as in the Gupta images, completely containing the lions, and the subsidiary figures, with the wheel, are in the Gupta mode. The Mankuwar Buddha, of course, presents such an arrangement (Pl. 55). Finally, after the long Kuṣāṇa decline, which produced, at its worst, the most mis-shapen and ungainly statues ever made in India, there is the sudden resurgence to the self-confidence, vigour, and sophistication of these Gupta images. Some of the vigour of the best Kuṣāṇa work is retained in these works from Mathurā, as compared to their Sārnāth counterparts, and the late Kuṣāṇa figures—even at their most mis-shapen—revealed a groping towards a new style, but the actual transformation, as in all major changes of style in art, cannot be accounted for according to the usual processes of stylistic change.

The greatest achievements of Mathurā sculpture, however, in the Gupta period, are the great standing Buddhas, of which, among many mutilated figures, only two have survived relatively intact, one now in the Mathurā Museum (Pl. 47); the other in the President's Palace in New Delhi (Pl. 48). They are both nearly two metres tall. They stand stiff-legged (*samapāda*), the left hand holding up a portion of the outer robe (*saṃghati*), while the right, missing in both cases, presumably made the gesture of 'do not fear' (*abhaya*). The heads are framed by huge decorated haloes. Contrary to the Sārnāth practice, the pleats of the *saṃghati* are delineated, an echo from Gandhāra; so also is the asymmetrical arrangement of the pleats across the chest and down the front of the body. Neither image is dated: the only dated standing Buddha from Mathurā, a debased

figure, is from A.D. 549, and they are obviously much earlier. The rather flat vegetal scrollwork, as well as the rosettes are remarkably reminiscent of similar work around the doorway of Cave 4 at Udayagiri (Pl. 5), which almost certainly dates from the very earliest years of the fifth century, if not before. The exaggeratedly broad shoulders also belong to an earlier tradition. The only other clue to the date of this image is the base and feet, all that remains of another such figure, with very similar kneeling devotees (Mathurā Museum 64.14), which is dated A.D. 445. The evidence thus strongly suggests that these great standing Buddhas of Mathurā take precedence, in point of time, over the Sārnāth Buddhas. The New Delhi image is probably the later of the two. The foliage of the halo, more elaborate and more deeply cut, the palmetto motif, and particularly the shape of the petals of the innermost lotus rosette all point to the later Gupta style. With less exaggerated shoulders, it is altogether more suave, and the face has none of the rather slick formalism which characterizes so many of the surviving Gupta Buddha heads from Mathurā.

Unquestionably the finest Hindu sculpture from Mathurā to have survived is the Viṣṇu (Pl. 49), the legs unfortunately missing, of majestic presence. By now the crown consists entirely of centre- and side-rosettes linked by loops of pearls, with a central portion of Gupta-type volutes and foliage. This was to be the form taken by Viṣṇu's crown henceforth at Mathurā. A number of Śiva *liṅgams* of the period have survived, some bearing a single and some four faces of the god or his manifestations. Undoubtedly the most powerful of these is the detached head (Pl. 50) now in the Ashmolean Museum, Oxford. In spite of its damaged condition, it conveys an impression of massive power which probably attests to an early fifth-century date. The etched moustache also suggests a relatively early date. Hindu stone images of the period are fairly plentiful, although generally quite small. Many, badly worn, have been falsely attributed to the Kuṣāṇa period. One of the few, however, to be in sufficiently good condition to reveal the typical Gupta crispness is the small seated Sūrya in the Ashmolean Museum (Pl. 51). Some of the Viṣṇu images (of which there is a marked preponderance), already slender-waisted, presage the late Gupta style, with their broad faces and markedly thick lips, although they may well be prior to A.D. 500. An iconographic type, the *caturvyuha mūrti*, with lion- and boar-heads at each side which was to have considerable vogue in the north-west and Kashmir, first makes its appearance here.

The eastern Madhyadeśa and Sārnāth

It is one of the ironies of Indian history that while the Mauryas and the Guptas, the two great indigenous Imperial powers, both arose in Eastern India and extended their sway thence westwards and over most of the rest of India, major artistic influences in India, with minor exceptions, have always travelled from west to east. The first two or three centuries of the Christian era had been no exception. At Sārnāth, major works like Friar Bāla's great standing Buddha were actually imported from Mathurā and proceeded to inspire local works in the Mathurā style of the Kuṣāṇa period. Saṅkiśa, Śrāvastī, and the other holy places of Buddhism were similarly dependent on the workshops of Mathurā for their Buddha images. Two or three seated Buddhas from Kauśāmbī have survived, but while they are not imports and represent a recognizable local style, it is but a variant of the Mathurā Kuṣāṇa style. From the style of the figure on its base, Rajgir Neminatha seems later than the reign of Candragupta II and the inscription is not conclusive. The now vanished Maniyar Math sculptures, in a simliar style, were undated. The British Museum's standing Buddha (Pl. 52) may yet be the earliest surviving work in the Gupta style from the eastern Madhyadeśa.

Kauśāmbī had been a flourishing centre in Kuṣāṇa times and even earlier. Beside the Buddha figures already mentioned, the largest Kuṣāṇa terracotta to have survived, the seated Hārītī, was unearthed there. In addition to these, however, there is the enigmatic Śiva-Pārvatī dated in the Year 139 (Pl. 53). This has been variously interpreted as being in the Śaka era, i.e. A.D. 78 + 149 = A.D. 237, in the Gupta era, i.e. A.D. 320 + 139 = A.D. 459, and in the Kalachuri era, i.e. A.D. 248 + 139 = A.D. 387; the quality of the sculpture precludes it being archaistic to the extent inherent in a late fifth century date and a Kalachuri era dating would be unexpected to say the least. On the other hand, it is generally accepted that the dates of the Māghas at Kauśāmbī, roughly coeval with the great Kuṣāṇas, refer to the Śaka era. The date of this Śiva-Pārvatī image may consequently be considered to be A.D. 237 and thus pre-Gupta. The image still shows strong marks of the Mathurā Kuṣāṇa style, particularly in the chest of the male figure. The hair arranged in large strands and the stiffly outstretched legs confirm the close relationship between the styles of Kauśāmbī and Mathurā in Kuṣāṇa times, while the excessively archaic head-dress of the goddess recalls an even earlier time. The placing of male and female figures of approximately the same size side by side doubtless owes something to the Gandhāra Pañcika-Hārītī images and ultimately to Roman tutelary deities. The Kauśāmbī Śiva and Pārvatī have thus every right to be considered one of the rare pre-Gupta or transitional sculptures which have survived elsewhere than in Mathurā. The faces are perhaps the most distinctive feature and the one which sets the figures off from known Mathurā pieces. Sharing the same facial features, the same treatment of the legs, likewise ithyphallic, the standing Śiva now in the Los Angeles County Museum (Pl. 54) is none the less in a different style and probably of a slightly later date, for there is a strong fore-taste of the Gupta style in the imposing size and splendidly crisp and realistic treatment of Śiva's weapons.

The seated Buddha, from Mankuwar, near Allahabad (Pl. 55), and dated A.D. 449, is the earliest dated Buddha from the region. It is astonishingly archaic, with the right

hand held low in *abhaya*, the lions on the base facing forward in the manner of late Kuṣāṇa images from Mathurā. These features associate it far more closely with Mathurā, and of an earlier day, than with the Gupta Buddhas from Sārnāth. So do the full lips and heavy features of the face. The Mankuwar Buddha is strong evidence for the persistence, in eastern Madhyadeśa, of stylistic influences from the west until the mid-fifth century.

The only other unquestionably dated object from the region is the pillar with an inscription of A.D. 478, from Varanasi and now in the Bharat Kala Bhavan there (Pl. 56). The capital is a plain example of the familiar vase-and-foliage type: in fact it differs little from the one inside Cave 19 at Udayagiri. There is a small relief-figure, relatively plain and crude, set in a miniature niche, on each of the four sides: they depict three forms of Viṣṇu (Pl. 57), including a Vāmana (Pl. 58), and a Narasimha, and also a female, probably Lakṣmī. As in the earlier figures from Udayagiri, these are heavily built with broad and massive bodies; the *cakra* placed on a stand is also an early feature. The column-base from Kutari, in the Allahabad Museum, has similar figures but more detailed and less crude in execution. The *ayudhapuruṣas* of the Harihara (Pl. 59) should be noted, with their mannered gestures, as well as the pleated *dhoti* of the Hari side of the figure, already crudely indicated on the Bharat Kala Bhavan column Narasimha, and the stylized rocks under the Vāmana (Pl. 60).

Two Viṣṇu images from Allahabad District, one from Unchdih (Pl. 61) and the other from Jhusi (Pl. 62), a suburb of Allahabad, are the oldest Hindu images in the Gupta style from the region. The latter is probably the earliest, with its rather brutish face and the *cakra* on a pedestal rather than represented by a *cakrapuruṣa*. The hands held in a low position is also an early feature and the body still retains some of the vigour of early Kuṣāṇa figures. The legs are particularly straight and stiff, a relic of the Mathurā style shared by the image from Unchdih. Both also share an identical mannerism, the little fold of cloth indicated by a swelling at the top of the *dhoti* and the way in which the sexual organ and the fold of cloth between the legs are indicated. Both of the images are relatively small. The Unchdih figure, the larger, has a distinctively Gupta physiognomy, with elongated almond-shaped eyes, and a smile hovering about the lips. The torso, with its exaggeratedly broad shoulders recalls, in plastic feeling, some of the late Jinas from Mathurā (see Pl. 42). The upper hands are raised higher, and the halo is of considerable size. An interesting feature is the 'pleated fan' type *śiras cakra* or halo behind the head, perhaps the earliest occurrence of this rather mysterious but later very widespread feature. The tab floating out from the head, on the other hand, is none other than a persistent remembrance of the ends of the Greek diadem.

The most impressive of the fifth-century Hindu sculptures, admittedly few in number, which have been found in the region is the huge Kṛṣṇa Govardhana (Kṛṣṇa holding up the Govardhan mountain) from Varanasi (Pl. 63). The figure alone must originally have measured over two metres. The arms, but not the hands, are modern replacements and the face is badly damaged but it is still none the less an extraordinarily imposing image, and the largest known free-standing figure of the Gupta period. The face can still be seen to have been very full and round, similar in many respects to those at Udayagiri, with round wide-open eyes (Pl. 64). Kṛṣṇa wears the ornaments and crowns of a young prince, usually reserved for statues of Kārttikeya (one of whose names is Kumāra or prince), notably the necklace of tiger's teeth (*vyāghra danta*) and the low crown. The latter can be seen in the seated Kārttikeya figure from the same area and a somewhat later date (Pl. 65).

The great achievement in this part of India during the Gupta period, however, indeed the greatest works produced anywhere during the age and perhaps never equalled before or since in Indian art, are the Buddhas from Sārnāth. The site of the deer-park where the Buddha preached his first sermon after having achieved enlighten-

ment at Uruvilva (Bodhgaya) or, in the parlance of Buddhism, set in motion the Wheel of the Law, was one of the sacred sites of Buddhism and endowed with monuments and religious establishments since earliest times. During the Kuṣāṇa period, as we have seen, the influence of Mathurā at Sārnāth was all-powerful, whereas the few sculptures from the Madhyadeśa which can be assigned to the fifth century, including only two dated ones, suggest both that the influence of Mathurā prevailed for a long time and that the region lagged behind Mathurā and its environs and even parts of Mālwā in stylistic development. Little or no sculpture has been found which might be considered as foreshadowing the great flowering at Sārnāth. This sudden and apparently strictly localized development has been linked, at least initially, to the rise of Mahāyāna Buddhism and a particularly active local movement centred on Sārnāth itself. While there is much to be said for this view, it implies a lack of any connection between the sculptors working for the Buddhist establishments and those employed elsewhere in the neighbourhood. A glance at two sculptures from Varanasi, the Kṛṣṇa Govardhana just described and the other a standing Buddha (Pl. 66), will dispel this illusion. It should be remembered that Sārnāth is only ten kilometres from Varanasi; what is more, the Buddha in question is very similar to others found at Sārnāth, although possibly a little earlier than the dated images. Yet there is a marked similarity in the treatment of the navel, the slight bulge of flesh above the top of the *dhoti*, and even the flanks of the two figures. The rest of the figures and the two faces are utterly different and the treatment in the Buddha is drier, but then the Kṛṣṇa is probably half a century or so earlier. There seems no doubt that we are in the presence of a single tradition and the differences are due to a development in time, and to the differences in the subjects depicted: a withdrawn and utterly spiritual being on the one hand, and a powerful young folk hero and god on the other.

If at times fate seems to have conspired to see that invariably the most important works on Indian art are either undated or, if dated, then with the crucial digit missing or some other obstacle to their interpretation, such as references to an unknown king or era, three Sārnāth Buddhas, of the very highest quality, provide a most welcome change, for they bear incontestable dates, one A.D. 474 (Pl. 67), the other two of A.D. 477 (Pl. 68), and so as there can be no possibility of error, the first explicitly states that it was made in the reign of Kumāragupta II, the second in that of Budhagupta. These statues, which are all in the mature Sārnāth style, leave little doubt that the great achievement represented by the Sārnāth Buddhas cannot be earlier than the second half of the fifth century. Plate 69 shows another example, whose halo has survived intact.

The unique quality of these sculptures has been perceptively described by Professor Rosenfeld. 'The bodies have an extraordinary quality of weightlessness and equipoise, mainly because their plain surfaces allow the various parts of the bodies to blend freely one into the other. The faces, although damaged, preserve a benign expression, the eyes cast downwards as though in introspection—a flawless spiritual state untouched by egotism, passion, delusion, anxiety or doubt, just as the body itself is unmarred by the blemishes and imperfections of an ordinary mortal.'

A seated Buddha figure (Pl. 70) is probably the best-known work of the Sārnāth school, both because of its excellent state of preservation and 'the appropriateness of its iconographic content to the Sārnāth sanctuary'. The Buddha is seated in *padmāsana*, the meditative pose *par excellence*, his hands in the *dharmacakra mudrā*, the hand-position indicative of teaching or preaching. Below the throne, with its baluster-legs, a number of Buddhist monks kneel in worship on either side of a *cakra*. In Buddhist terms, the *cakra* symbolizes the Wheel of the Law, which was set in motion when the Buddha preached his first sermon in the deer-park at Sārnāth. A certain stiffness in the torso and a lack of vitality in the vegetal creepers of the halo suggests that this, perhaps the most

often reproduced of all Indian sculptures, is a slightly later work, when the classical period at Sārnāth had passed its peak.

Gaḍhwā is a picturesque site south of Kauśāmbī and some forty kilometres south-west of Allahabad. Here, where the last stone outcroppings of the central Indian tableland reach to within a few miles of the Jumna, an eighteenth-century fort (hence the name Gaḍhwā or Gaṛhwā) built on the bed of a stream encloses some ruins and an abundance of medieval sculpture. In addition, a number of fifth-century inscriptions (Candragupta II, Kumāragupta, and possibly Skandagupta) have been found there and, in a pink sandstone of a finer grain than that of the other remains, fragments of panelled door-jambs and a lintel broken into three pieces. The preponderance of human figures, to the exclusion of architectural or decorative motifs, distinguishes these fragments from all other remnants of doorways, while the quality of the sculpture, in fact the whole vision inspiring these carvings, is such as to guarantee them a unique place amongst surviving Gupta sculptures.

The lintel, in its entirety, measures 4 metres (Pls. 71 and 72). It consists entirely of divinities and human figures, often in large and complex groups, and yet for all the complexity with which individual figures are portrayed in relation to each other, the over-all arrangement is a simple one. In the centre stands a many-armed figure, probably Viṣṇu Viśvarūpa (Pl. 73), towards which lines of figures on either side wend their way. At one end of the lintel there is a round medallion with Sūrya, the sun god, in his chariot depicted head-on and at the other end, proper left, a man and woman seated on the crescent moon, Candra, the moon, and his consort. The only variation in this simple scheme is on the proper right where the processional figures are halted, before they reach the central image, by figures bearing gifts issuing from a hall where brahmins (or mendicants) are being fed.

Next to the Sūrya disk two noticeably large men, one with a sword resembling a Nepalese *kukri* at his belt, stand conversing. Next is a man carrying what appears to be a large bale on his head (Pl. 74). He brings up the rear of the procession which consists of men carrying other loads either on their shoulders or with carrying-sticks, and apparently attended by a larger man, with a great mop of hair and again, over his shoulder, a *kukri*-like sword (Pl. 75). Leading the procession are two figures, over one of whom a parasol is held by an attendant. He is obviously a figure of importance. His hands would have seemed to have been joined in *añjali*. Next to him, a figure whose head-dress would seem to include an *uṣṇīśa*, but probably simply a top-knot, appears to be making a symbolic gesture (*abhaya* or *tarjani?*) with his right hand. At his feet a much-damaged kneeling figure sits on its heels, leaning forward with both hands on the ground beside it, while a pair of figures issue forth from a building to greet the leaders of the procession. The smaller of the two leaning forward may have been about to present a gift, while the larger one, looming up behind him, carries one of the Nepalese-type swords over his shoulder.

Next comes the most distinctive feature of the lintel with its scene of people in a building, probably a sort of *dharmaśāla* or pilgrim's hall. Inside, figures apparently naked from the waist, seated on little pallets, are being fed. The food is being poured into bowls by what appears to be a fully-clothed female figure, wearing a distinctive head-covering coming down under the chin, like a balaclava (Pl. 76). The way in which an interior scene is indicated, by showing the commencement of the outer cornice with its *chaitya* arches and terminating it abruptly, as by a vertical stroke, is unique in Indian art.

On the other side of the central Viṣṇu, the figures constitute an unbroken procession, but such is the variety, some playing musical instruments, some bearing food or gifts, some holding up a canopy, men, women, boys, and girls, that any hint of monotony is avoided (Pls. 77 and 78). Indeed, in the variety of poses and rhythmic relations

between the figures, this frieze is unequalled in all of Indian sculpture. There is a poignancy about it, moreover, which somehow seems to match in feeling that other great evocation of a religious procession in Keats's 'Ode'.

The lintel is in many ways as mysterious as it is beautiful. First of all, did it belong to a Hindu or Buddhist monument? The simple unadorned costume worn by many of the figures suggests a monastic, i.e. Buddhist setting. On fragments of door-jambs which probably belonged to the same edifice as the lintel, none of the figures, including the *dvārapāla* and the Gaṅgā, is specifically Hindu or Buddhist. The one exception is the many-armed Viṣṇu in the centre of the lintel and, in view of his existence and the prominent place given to him, the original building must be considered Hindu. The question of foreign influence does arise: some of the poses are quite unknown in earlier Indian sculpture, notably that of the little maiden holding up a canopy pole, her arms hanging down by her side and hands clasped low in front. The women wear skirts or draped cloths nearly to their ankles. Although Sūryas are well known to early Buddhist monuments, astronomical and astrological figures tend to suggest a Western Classical origin, particularly if they are encompassed in circular disk-like medallions (see Pl. 37). And what of the probable date of this masterpiece? Most of the faces are either badly worn or have been purposefully defaced, and jewellery or other ornaments, whose treatment often provides a fairly precise clue to date, are never indicated. The figures are simply draped, the men wear short *dhotis* and a sash. Some appear quite nude, like the lovely flute-player with his back turned. Only the Viṣṇu, in a hieratic pose, allows itself to be compared with other sculptures. He has the sturdy body and excessively wide and rounded shoulders that we have seen on other sculptures in eastern Madhyadeśa and Central India (Pls. 8, 57, 62). The fragments of *stambhas* (Pl. 79) both at Gaḍhwā itself and in the Lucknow museum, provide more stylistic evidence, though we should remember that some of these *stambhas* may not belong to the same doorway as the lintel. In general they would appear to be earlier than the doorways of the late Gupta temples at Deogarh, Bhumara, and Nāchnā-Kuṭhārā. Perhaps the most evident sign is the strong pictorial and story-telling element which still endures, recalling Kuṣāṇa doorways and lintels at Mathurā. In the later doorways, the lively and varied scenes in the panels of the door-jambs have been replaced in every case by *mithuna* figures. Similarly, the vegetal creeper-motifs on the sides and dividing some of the panels belong to the earlier Gupta type. Lest, however, one be tempted to place the Gaḍhwā doorway as early in stylistic evolution as the sculpture of the Udayagiri (Vidiśā District) caves, one should point out that certain features which mark the sculpture of the later Gupta temples mentioned above are also present here, such as the hair arranged in curls cascading down on one side of the head (figure on one of the jamb fragments) and the Gaṅgā with her *makara*, and shaded by a parasol. Perhaps a date in the latest quarter of the fifth century is most likely to be correct. A number of stelai from Sārnāth have survived, divided into panels, with Buddhist scenes; the one illustrated (Pl. 80) is in a charming style not unlike that of the Gaḍhwā lintel but more naïve.

The periphery: Ajantā and Western India

The criterion for including a sculpture or a school of sculpture in this book has been whether or not it was found within the geographical limits of the Gupta Empire at its greatest extent during the fourth and fifth centuries. This method of deciding what sculpture to include, and the use of the term Gupta to designate it, appears to have been vindicated by the general similarity of style shown by these sculptures. That such a style can be detected over such a large area enables us to speak of a Gupta style, and even, in what appear to be its purest or most distinctive manifestations, of a metropolitan Gupta style. In cases where local or provincial variations manifest themselves they are none the less strongly influenced by this metropolitan style.

Sculpture continued to be produced, none the less, in certain areas outside the limits of Gupta dominion during the fourth and fifth centuries. Much of what is commonly accepted as Gandhāra sculpture, stone as well as stucco, probably dates from as late as the fourth and even fifth centuries, although, in the absence as yet of an established chronology for late Gandhāra sculptures, this cannot be affirmed categorically. Certain similarities of ornament and hair-styles, for instance, between Gandhāra figures and sculptures from Central India of the fifth and even sixth centuries are striking. The influence of Gandhāra on the Gupta Buddha figure, though complex, is indisputable. The style of Gandhāra, none the less, remains essentially alien to Gupta and indeed to Indian art and it would seem unjustified to include any of its productions in a survey of Gupta art. Although this is less true of the early art of Kashmir, as well as certain figures from the north-west, which are not in the Gandhāra style—notably the potstone figures—these works are very limited in number and few if any can be assigned with confidence to the fifth or even sixth centuries.

If there seems to be consequently no warrant for the inclusion here of sculpture from Gandhāra and the north-west, this is not the case for Vākāṭaka art. The Vākāṭakas were not feudatories of the Guptas, although allied to them by marriage, and Ajantā lay outside the boundaries of the Gupta empire. It now seems, however, that most of the sculpture there belongs to the end of the fifth century and was thus coeval with the zenith of the Gupta style. Architectural elements, such as pillars and doorways, are highly decorated and show a close relationship to contemporary Gupta work (Pls. 81 and 82). The sculpture, however, is of indifferent quality, the Buddhas generally uninspired and rather lumpy (Pl. 83). The well-known Nāgarāja and his queen are attractive figures (Pl. 84) but somewhat lifeless. The pair of flying Vidyādharas from Cave 16 (Pl. 85) perhaps show the style at its most inspired. The great works at Ellora, Aruangabad, and Elephanta undertaken under the aegis of the Kalachuris reached great heights, but none of them can be attributed to the fifth century or even the early sixth, and they represent another major stylistic movement, which belongs to the post-Gupta period.

In a different category fall a fairly large number of sculptures from places in southern Rājasthān and northern Gujerat, notably Śāmalāji (a few miles from the Devnimori *stūpa*). The art of these regions during the fourth and fifth centuries should technically be included in Gupta art since they fall within the confines of the Gupta

Empire. True, they were only conquered at the end of the fourth century, when Candragupta II overthrew the last of the Kṣatrapas of Ujjain. What makes the art of these regions substantially different, however, from the rest of Gupta art is probably not so much the late inclusion of these outlying areas into the Gupta Empire, but the fact that they had been subject to foreign dominion, and indeed under the same rulers, for three or four centuries, longer than any other portion of India proper. Be that as it may, these statues, most of them in a greenish-blue slate known locally as *parevā*, are in a most distinctive and particular style. While they bear some of the hallmarks of the Gupta style, theirs is a unique one whose peculiarities make it difficult to determine their exact age. None of them is inscribed or dated or can be associated with a dated monument.

They are notable for their small size, unusual elaboration, and sophistication in composition (they usually include attendant figures) as well as decoration, and have marked associations, stylistic and iconographic, with the north-west and Gandhāra. The heads are round, with smiling eager faces, and a series of folds are clearly delineated around the neck. In the male figures, a line is usually shown under the breasts. They invariably wear a very simple type of armlet, contrasting with the elaboration of their head-dresses, but the most distinctive feature of costume, although not invariably worn, is a heavy rolled sash in which a second sash is looped down from the principal one. The folds of the long *dhoti* are treated with sculptural overtones, a memory of Gandhāra. The iconography echoes, on the one hand, the Gandhāra regions, and at the same time, in its elaboration and sophistication, suggests comparison, not with fifth-century but with sixth- and even seventh-century sculptures elsewhere, and even with certain Early Western Cālukya works.

One important figure from Sāmalāji (Pl. 86) unquestionably belongs to an earlier period, a headless and armless fragment of noble proportions. It is on a larger scale than usual, and the modelling of the powerful torso reminds one of early Yakṣa figures, yet the sash is depicted in the same idiosyncratic way as in many later Sāmalāji figures. A second figure, of Viṣṇu (Pl. 87), has been adduced, in conjunction with a head from Kutch, as evidence of a Kṣatrapa school of sculpture which would seem to have been stylistically in advance of sculpture anywhere else in India. These figures, particularly the second, are problematical, and it would seem better to reserve judgement on their date until more evidence is available, and to judge the bulk of Sāmalāji sculpture, which has almost no stylistic link with these pieces, on its own merits.

The most important sculptures from Sāmalāji include a number of standing Śivas (including probably a pair of Śaiva *dvārapālas*), of which one is illustrated (Pl. 88). The languid grace of the figure contrasts with the stiffness and awkward position of the bull against which it is placed. The general elements of the composition and the lion-skin betray a north-western origin, while the treatment of the drapery shows specific Gandhāra influence. Another Śiva standing against a bull is provided with dwarf attendant-figures, not *ayudhapuruṣas*.

A fine group of Mātṛkās in the same style has been very badly damaged. The best preserved is a fine four-armed Cāmuṇḍā (Pl. 89). The severed head held in her left hand shows marked Hellenistic influence. Another fine figure in the same group is the standing Skanda (Pl. 90), holding a lance in his right hand and a rooster in his left. This is originally a western and north-western type, although examples exist from Mathurā. The only element which can be said to be common to these figures and those of the Madhyadeśa is the little roll down of the *dhoti* below the navel, seen in the Unchdih and Jhusi figures (Pls. 61 and 62).

The persistence of Gandhāra-style drapery and elements taken from that style link the figures to what are thought of as earlier modes and styles. Other features, such as the elegant *déhanchements*, elaborate crowns or hair-dressings, and a general elaboration, as

well as a rather developed iconography, would, anywhere else in India, indicate a sixth-century date for these figures. Was Western India simply in advance, stylistically, of the rest of India—a theory for which Devnimori provides some confirmation? The most assiduous advocate of Śāmalāji sculpture, and indeed of a whole Kṣatrapa and Early Western School, places them around A.D. 400.

Almost certainly later in date are a particularly fine group of Skandamātās (Pls. 91 and 92) and a Mātṛkā (Pl. 93) from Tanesara-Mahādeva, south of Udaipur. The former are the finest and best preserved examples of a number of figures from sites in this region which show a standing woman with a child and without the attributes of a Mātṛkā. These Madonna-like groups convey the spirit of motherhood as do no other Indian sculptures and these softly modelled, rather sentimentally depicted women, with their sweetly smiling faces and graceful poses, are perhaps more easily assimilable to Western European standards and tastes than any other works of Indian art. The Mātṛkā, almost certainly Kaumarī, is probably unique, for the four-armed goddess is shown with the unmistakably enlarged abdomen of a pregnant woman. Realism of this sort is very rare in Indian sculpture.

The Late Gupta Style

Towards the end of the fifth century, and perhaps earlier, in Mathurā and the west, a marked change took place in the depiction of the human body. The body grows more slender and sinuous, rarely standing any more in the rigidly erect postures of earlier Gupta work. Instead, there is almost always a marked *déhanchement*. The shoulders are no longer massive and exaggeratedly broad. The faces become fleshier, with fuller and fuller lips, and sometimes even a negroid cast of feature. Conversely, the decoration around the splendid doorways which are one of the great achievements of Gupta art becomes progressively more coarse, accessory figures become extremely mannered, weapons and symbols tend to lose the striking individuality of earlier Gupta art. Idiosyncrasies which marked the earlier sculpture disappear and new particularities of costume and the dressing of the hair appear at this late date: the male head-dress cascading down on one side, the wig-like style of head-dress now arranged so that the sausage-curls run horizontally right around the head, rising to a flat horseshoe on top of the head, and women's head-dresses terminating in great buns inter-twined with far more jewellery than before.

The sculpture found at Sondni and Kilchipura, near Mandasor, shows a western form of this style (Pls. 94–9). The colossal Mandasor Śiva (Pl. 100) is an impressive sculpture. The face was recut fifty years ago. The fact that the statue is ithyphallic probably means that it is not later than the middle of the sixth century. Numerous examples can be cited from Mathurā, of which perhaps the most beautiful is the Ardhanārī head (Pl. 102). The divided ear-ring, seen already in Central Indian figures almost certainly before the mid-century, suggests that here, at the fount of so much Indian sculpture, the late Gupta style may have appeared by A.D. 450 or even earlier.

No certain conclusions can as yet be reached as to when these changes took place, and the change may of course be considerably earlier in some places than others. As far as eastern Mālwā and Central India are concerned, scholarly opinion is divded between the last half of the fifth century and the first half of the sixth. Earlier scholars considered that works in this style were Gupta, *par excellence*, and placed them early; this view continues to have its adherents. The few surviving temples, all in remote parts of Central India, although undated, provide in their elaborate doorways with figures of *dvārapālas* and river goddesses, etc., probably the best evidence for comparative studies, in which French scholars have been particularly diligent. They tend to place the temples—and consequently the late Gupta stylistic features found in their reliefs— relatively late, assigning them all to the sixth century. Much depends, however, on whether or not the new and early dating for even the last caves at Ajantā is accepted and, even more difficult to evaluate, whether Ajantā, although outside the Gupta dominions, was more or equally 'advanced' than remote sites in Central India.

The great panels of the temple of Deogarh (*c.* A.D. 500) are the most important works in the late Gupta style. The reclining Viṣṇu (Pl. 103) still has the broad shoulders and powerful chest of earlier works and the face is remarkably similar to that of the great Mathurā Viṣṇu (Pl. 49). The rows of figures at the bottom strike mannered poses, however, and it is difficult not to detect an insolent playfulness, allied to the

Gupta love of the grotesque but in this context decidedly decadent, in the way the great gods ride their vehicles at the top of the panel. This is even more apparent in the disdainful superciliousness with which Viṣṇu is depicted arriving on the scene in the Gajamokṣa panel (Pl. 104). The temple at Deogarh also includes a very fine doorway (Pl. 105).

Three other temples, Nāchnā, Maṛhiā, and Bhumara, possibly built in that order a little later than Deogarh, possess little or no figure sculpture, and no large panels of the Deogarh type. Several of the doorways, however, with a great deal of figure sculpture in relief, are splendid examples of the late Gupta style (Pls. 106, 108, and 109) and a great deal of fine decorated carving survives (Pls. 110 and 111). It is interesting to note how many of the motifs date back to Kuṣāṇa days, but the elements are now treated in a rather vulgar showy way. Typical of this is the palmetto wreath, which has become fat and coarse. This is particularly so at Maṛhiā. The *vidyādharas* with upswept scarves fly along the lintels, and that amost infallible indicator of stylistic change, the *chaitya*-arch ornament, becomes more ornate and occasionally doubles itself. The vegetal scroll, the great glory of Gupta decorative sculpture, tends to become frilly and overburdened with large nodes (*parvans*). A Śaiva *dvārapāla* from Nāchnā (Pl. 107) and a fine Narasiṁha image (Pl. 112) are amongst the few examples of figures in the late Gupta style to have survived intact.

Terracottas

Terracotta objects and figures, moulded as well as hand-modelled, have abounded on the Indian sub-continent since the earliest historical period and continue to be made in great numbers even today. From Maurya times, nearly every important site in North India has yielded a large number of figures, toys, and utensils, culminating in some near life-sized figures, of the Kuṣāṇa period, such as the Hārītīs found at Kauśāmbī and Besnagar. Two heads illustrate the confidence with which terracotta was already being handled at this period. The head of a man wearing a turban (Pls. 113 and 114) shows Kuṣāṇa terracotta work at its bold and slashing—if somewhat unsubtle—best. There is also a surprising amount of realism and close observation. The head of an *asura* (Pl. 115), which is possibly early Gupta, and is identified as a demon only by his fangs, is a moving portrait full of pathos.

It was, however, during the Gupta period that the finest sculpture in this ancient and perennial medium was made, works which have never been matched in their size and technique, at least in India, and which add a whole new dimension to Gupta sculpture. Gupta terracottas consist of images in relief like the Buddhas from Devni-mori, others, almost in the round, like the Gaṅgā and Yamunā from Ahichchhatrā, which were made to be installed in the niches of brick *stūpas* or temples, as well as the elaborate architectural ornament, either modelled and applied or in the form of ornamentally moulded bricks, which adorned the exterior surfaces of these monuments. Small figures and plaques, many of them of remarkable sensitivity, continue to be made in great numbers.

The earliest monument to have yielded large quantities of ornamental terracotta work, as well as numerous Buddha figures, was the great *stūpa* at Devnimori, two kilometres south of Śāmalāji (see p. 24) in Gujerat. Inscriptional evidence combined with numismatic finds would seem to give the year A.D. 375 as the date of construction though it has been estimated that it would take something of the order of five years to build a *stūpa* of this size. A number of seated Buddhas (Pls. 116 and 117) were found originally placed around the lower portion of the *stūpa*, all of the same size and seated in the same position. Although built up in sections, they are modelled, not moulded. In certain ways, the influence of Gandhāra is strong, whereas in others the Buddhas are more closely related to those from Mathurā. One thing is certain, here in the west the Gupta style was already full-fledged by the third quarter of the fourth century A.D., although purists will insist that the art of Devnimori belongs to the western Kṣatrapa school since, when the *stūpa* was built, the Guptas had not yet conquered the region.

Even more notable than the Buddhas is the terracotta ornament, both moulded and modelled, which was recovered from the Devnimori *stūpa*: jambs, pilasters, capitals, dentils, medallions, and *chaitya* arches (Pls. 118 and 119). The decorative repertory is a richer one than either Gandhāra or Mathurā can boast. In a sense it is more classical: the beauty of the acanthus, for example, is more fully understood (Pl. 120). The laurel-leaf appears as well as the olive, and so does the bead and reel. Here is found the earliest and arguably the finest examples of the lateral-cut vegetal scrollwork (Pl. 121) which is one of the chief glories of Gupta art. Grotesque heads, as a form of decoration,

also first appear here (Pl. 122). The pot with foliage, perhaps the most Indian feature, occurs fairly frequently.

Not so much is known about the *stūpa* at Mirpur Khas, in Sind, less scientifically excavated over sixty years ago, nor can it be exactly dated. The terracotta reliefs showing Buddhas (Pl. 123) which were recovered from it are covered with a thin coat of plaster and coloured, with wheaten faces, black hair, eyebrows, and pupils, and robes of a bright foxy red. With their too small *prabhāvallis* and often drastically shortened legs, they give the impression of being rather crude provincial works. A standing figure in relief, possibly the Bodhisattva Padmapāṇi, was also found, as well as a good deal of terracotta ornament. The latter is of good quality, but somewhat drier and more abstract than the work from Devnimori (Pls. 124 and 125). This is particularly evident when the grotesque face from Devnimori (Pl. 122) is compared to the one from Mirpur Khas (Pl. 126). The latter seems unlikely to date from before the middle of the fifth century A.D.

Sites in the neighbourhood of Bikaner far in the west of Rājasthān, have produced a number of interesting terracotta plaques, now in the Bikaner Museum. Those from Rang Mahal may be called pre-Gupta or transition. In particular, a Kṛṣṇa Govardhana plaque shows Kuṣāṇa traits. On the other hand, the tree in the Dānalīlā plaque (Pl. 127) has the celery-like shape typical of the Gupta period. The woman's costume is notable, with its head-cloth and elaborate skirt, foreshadowing as it does local costumes still to be seen in Rājasthān. Of great iconographic interest is the Umā-Maheśvara plaque (Pl. 128) showing an ithyphallic three-faced Śiva with a figure springing from his head. In composition and style, the group is closely related to some unique stone images from the north-west. The date would be much in doubt if it did not seem that this plaque, of the same size and material, must be of the same date as the two mentioned above, which would probably mean the third or fourth century A.D. Of a probably later date are the plaques with large relief-figures from Badopal (Pl. 129). Here one costume appears which can be seen, down to minute details, on women in Rājasthān to this day. Yet these terracottas are certainly not later than the fifth century. A charming fragment of architectural ornament, showing a monkey's head framed with acanthus-leaves (Pl. 130) also comes from Rang Mahal.

'I have found moulded and carved brick of similar design (to those of Bhitargaon) all over the Punjab and North-Western Provinces, from Shahderi, or Taxila, and Multan on the West, to Śravasti and Garhwa in the East. . . . In the more easterly provinces of Bihar and Bengal the same causes of the want and costliness of stone gave rise both to the great brick temples of Bodhgaya and Nalanda. Even at Mathurā and Benares, within a few miles of the sandstone quarries of Rupbas and Chunar, moulded and carved bricks are found in great abundance.' A little later 'the people of Bhitargaon say that there was once a brick temple at every *kos* along the banks of the Arind river'. So Cunningham reports of his tours of 1875–6 and 1877–8. Moulded bricks and terracotta plaques have been found, as we have seen, much further west amongst the sands of Bikaner and more are constantly being reported from many sites in North India, yet only one temple, at Bhitargaon, out of the innumerable ones which must have existed in the fifth and sixth centuries, appears to have survived to the present day in anywhere near its original state.

The Bhitargaon temple (Pl. 131) stands on the verge of the tiny village of that name. It was struck by lightning at some time in the first half of the nineteenth century and it is now impossible to judge what the summit was like. Little more than vestiges remain of the large terracotta panels (Pls. 132–4), and the temple has been extensively restored in the interests of conservation. None the less, with its grotesque figures, like medieval European gargoyles, peering out from the upper storeys (Pl. 135), and its superb architectural ornamentation carried out in moulded brick, the Bhitargaon

temple, which is incidentally far smaller than it appears in photographs and drawings, measuring less than 11 metres on a side, continues to convey a great deal of the charm and beauty of these vanished temples. Both the architectural ornament, and certain revealing traits of the sculptures, which can still be discerned, closely resemble the doorway and figures of Cave 6 at Udayagiri but in slightly more developed form. It is consequently unlikely that the temple dates from much after A.D. 425 and, considering its position in the heart of the Doab, it may be considerably earlier.

Excavations at Ahichchhatrā revealed a large collection of terracotta plaques and large relief-figures from a no longer extant temple, probably dating from the mid- or late fifth century. The plaques, in an unselfconscious rather bumptious style (Pls. 136–8) present a marked contrast to the superb Gangā and Yamunā figures (Pl. 139), with their mannered elegance, the largest and unquestionably the finest Gupta terra-cottas so far known. Yet the small feminine figure on the Dakṣiṇāmūrti plaques (Pl. 140) is in the same style and it is consequently to be assumed that the subject-matter has determined the style.

A considerable number of terracotta heads, in a most distinctive style or styles, comes from Akhnur in Kashmir. They have been assigned widely varying dates but probably belong to the sixth century. Highly sophisticated, the faces range from a pouting prettiness (Pl. 141), which finds its only parallels in Asia in the terracottas from Fondukistan and certain Central Asian sculpture (although they would not be out of place in a European rococo setting), to a highly nervous kind of psychological realism (Pls. 142 and 143), which relates heads of this type to some of the stuccos from Haḍḍa in Gandhāra. Geographically, the Akhnur terracottas belong to the periphery, as far as Gupta art is concerned (see earlier section); stylistically, it is possible that further finds from the Punjab, for instance, would establish a link between them and the Gupta style but for the moment they must be considered a distinct and independent development. An even more mysterious stylistic phenomenon, also from Kashmir, are the human heads and figures, probably of an earlier date, stamped onto a large number of plaques (Pl. 144). These plaques served as risers to a continuous bench surrounding a courtyard, which was itself paved with stamped tiles bearing a wide variety of motifs, in what remains of a Buddhist establishment at Harwan.

The famous site of Kauśāmbī, which has produced so many terracottas from earlier periods, has also yielded a large number of heads from terracotta figurines. Notable among them are the head of a man (Pl. 145), in the full Gupta style, a work of enormous self-confidence, and a charming girl (Pl. 146). In contrast to these must be set the moulded heads and figures found in great numbers, particularly at Rajghat (Varanasi).

Numerous fine terracottas have been found at Bhita and other sites. The poignant seated figure of a girl (Pl. 147) is from Bhind, Madhya Pradesh. The fine example of a *makara* (Pl. 148) probably from Mathurā, was part of a frieze on a brick temple, such as can be seen at Bhitargaon (Pl. 135) and the Śiva (Pl. 149) is from Saheth-Maheth. Whatever their place of origin, whether it be Bikaner, Mathurā, Ahichchhatrā, Kauśāmbī, Mālwā, the eastern Doab, or the *terai*, an unmistakable uniformity of style marks all these works. If any doubts remained as to the existence of a Gupta style, these terracottas, from every corner of the Gupta dominions, should dispel them once and for all.

Bibliographical Note

Until now, there has been no book concerned exclusively with the art or archaeology of the Gupta period. Volumes exist devoted to individual sites or monuments of the Gupta period, as well as accounts of excavations (mentioned, where appropriate, in the Notes on the Plates), but so far comprehensive accounts of the arts of the period have not stretched beyond chapters or sections in general books on Indian history and art, or encyclopaedia articles. Of these short accounts, easily the most perceptive was written by Stella Kramrisch in the *Wiener Beiträge zur Kunst und der Kulturgeschichte Asiens* in the late 1920s. By far the most comprehensive and up-to-date, as well as highly stimulating, is Professor H. Goetz's long article 'The Gupta School', in the *Encyclopaedia of World Art*, McGraw-Hill, volume vii. It is, however, rather slanted and sometimes inaccurate in detail. Selected monographs or articles in learned journals are also mentioned in the Notes on the Plates.

Of the political and social histories, perhaps the best is still R. D. Banerji, *The Age of the Imperial Guptas* (Benares, 1933). *The Classical Age*, in the series *The History and Culture of the Indian People*, ed. R. C. Majumdar (1954), provides an up-to-date account of the Guptas, set in a wider perspective, with unusually full bibliographies. J. N. Banerjea's *The Development of Hindu Iconography* (2nd edition, Calcutta, 1959), is the standard work on Indian iconography, which it deals with both systematically and historically.

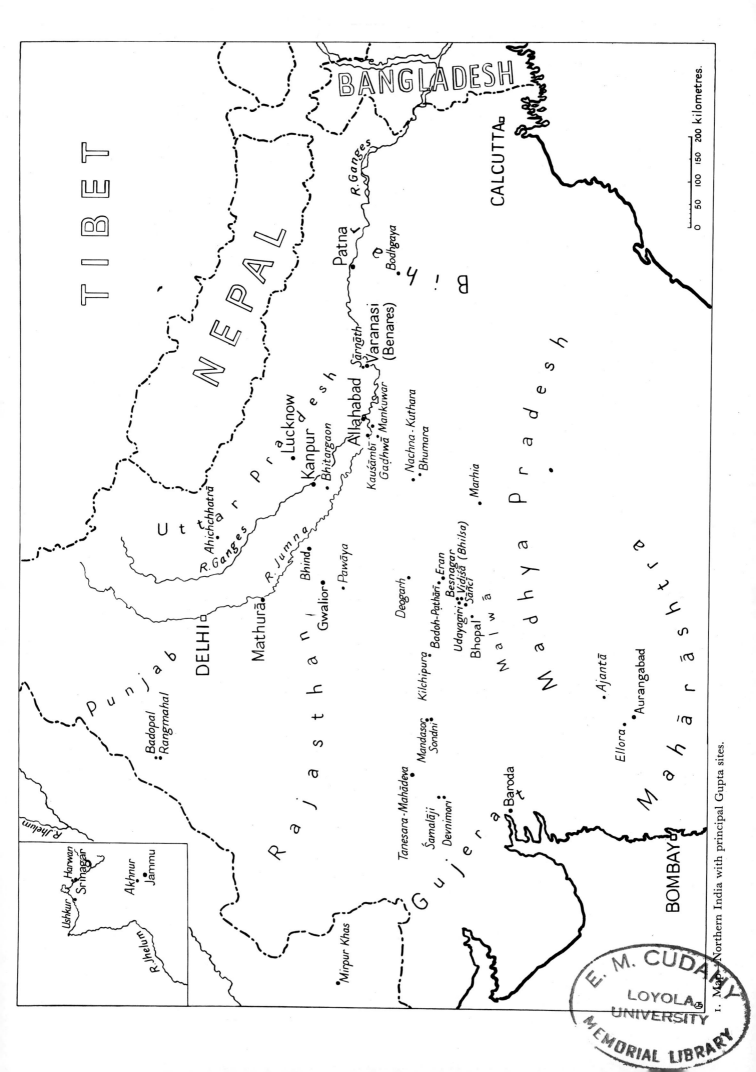

TIBET

NEPAL

BANGLADESH

CALCUTTA□

200 kilometres.
150
100
50
0

Patna
●

Bodhgaya
●

Bihar

Sārnāth
Varanasi
(Benares)

Uttar Pradesh

Lucknow
●

Kanpur
●

Bhitargaon
●

Allahabad

Ahichchhatrā
●

R. Ganges

R. Jumna

Kauśāmbī
●
Gadhwā
Mankuwar
●

Nachna - Kuthara
●
Bhumara
●

Marhia
●

Madhya Pradesh

Bhind
●

Mathurā
●

Gwalior
●

Pawāya
●

Deogarh
●

Badoh-Pathāri
●
Eran
●
Besnagar
●
Udayagiri ● Vidiśā (Bhilsa)
Sānci ●
Bhopal ●

Malwā

Ajantā
●

Aurangabad
●

DELHI □

Rajasthan

Kilchipura
●

Mandasor
●
Sondni
●

Ellora
●

Mahārāṣṭra

Punjab

Badopal
●
Rangmahal
●

Tanesara-Mahādeva
●

Śamalāji
●
Devnimori
●

Gujerat

Baroda
●

BOMBAY □

Mirpur Khas
●

R. Jhelum

Ushkur ● Harwan
Srinagar

Akhnur
●
Jammu
●

R. Jhelum

1. Map. Northern India with principal Gupta sites.

Candragupta I

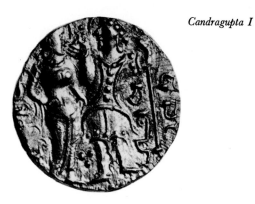 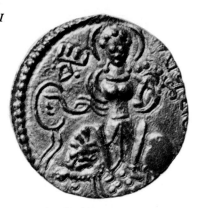

a. Candragupta I and his Queen, Kumāradevī Goddess on lion

Kumāragupta

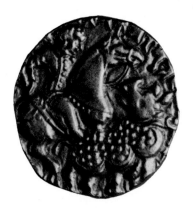 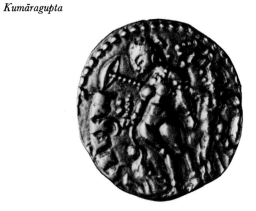

b. King hunting rhinoceros The goddess Gangā

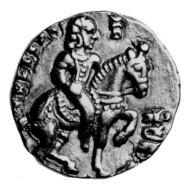 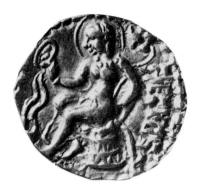

c. King riding a caparisoned horse Seated Goddess

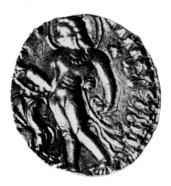 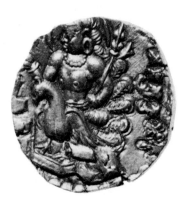

d. King with peacock Kārttikeya riding on a peacock

2. Gupta Gold Coins.

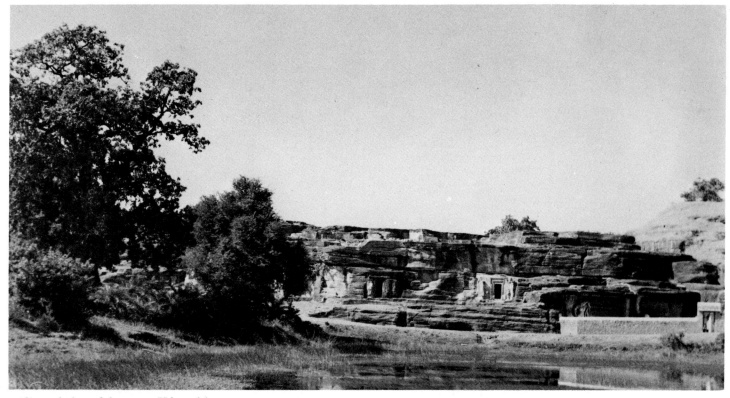

3. General view of the caves, Udayagiri.

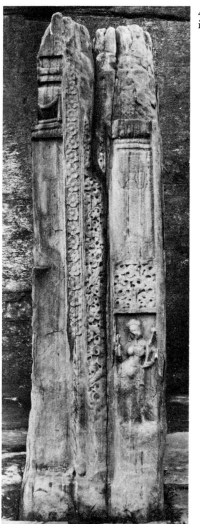

4. Remains of an elaborately carved pillar
in front of Cave 19, Udayagiri.

5. Doorway to Cave 4, Udayagiri.

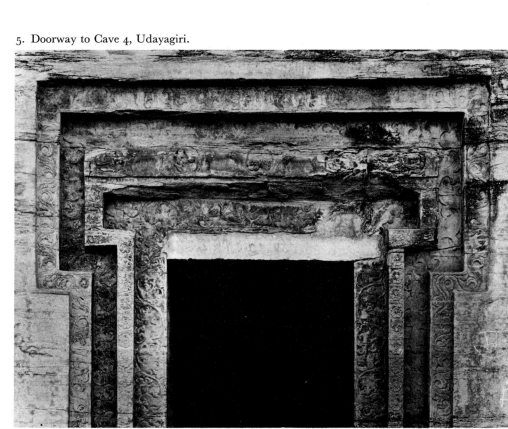

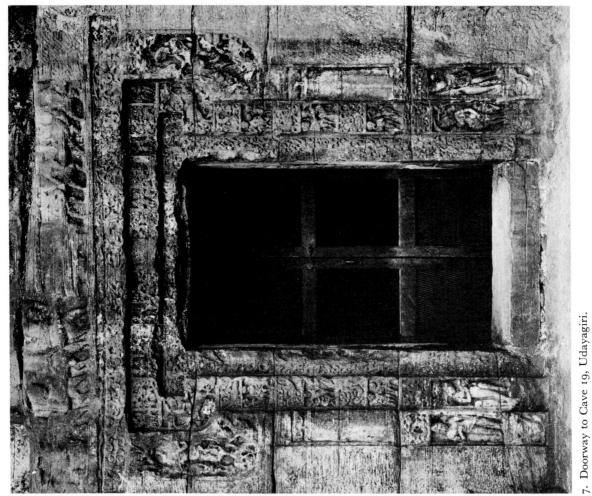

7. Doorway to Cave 19, Udayagiri.

6. Doorway to Cave 6, Udayagiri.

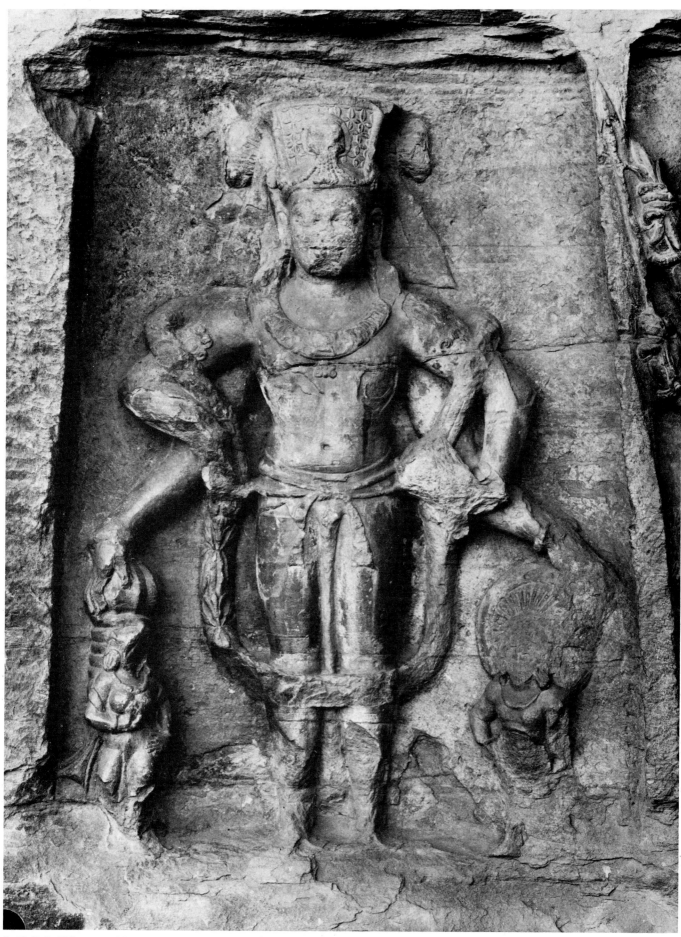

8. Relief of Viṣṇu outside Cave 6, Udayagiri.

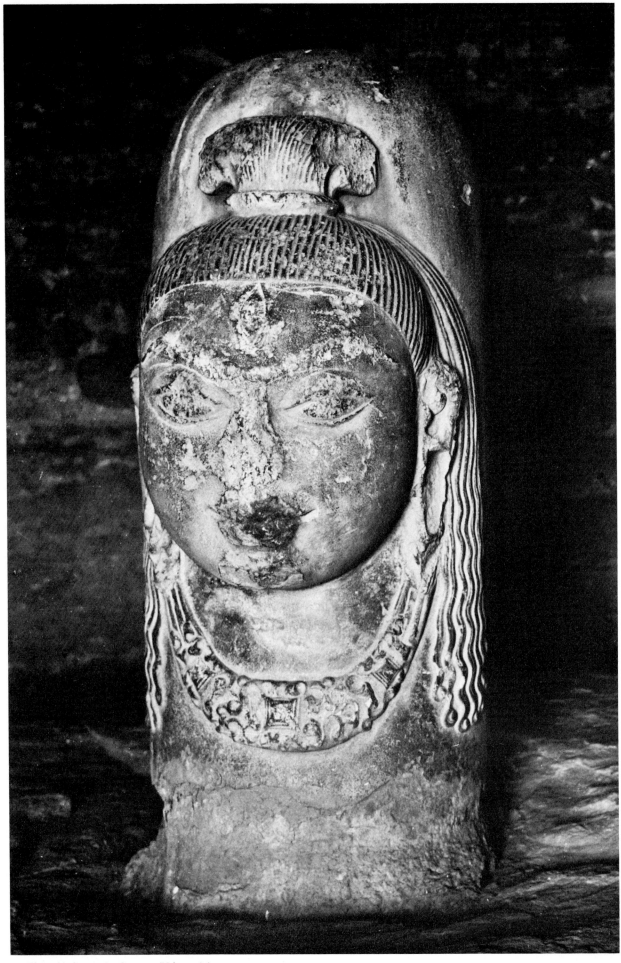

9. *Ekamukhaliṅgam* in Cave 4, Udayagiri.

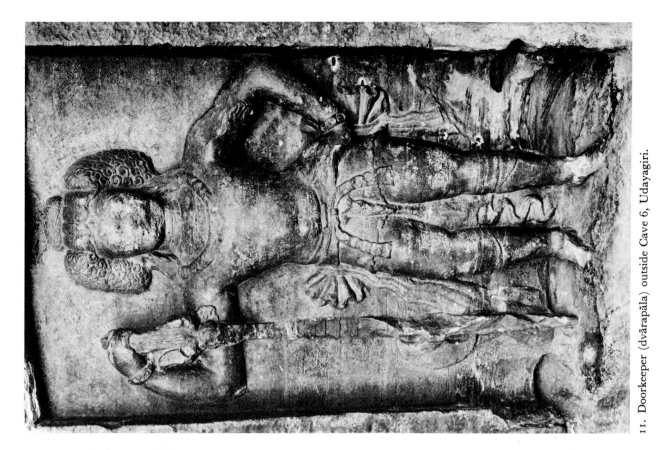

11. Doorkeeper (dvārapāla) outside Cave 6, Udayagiri.

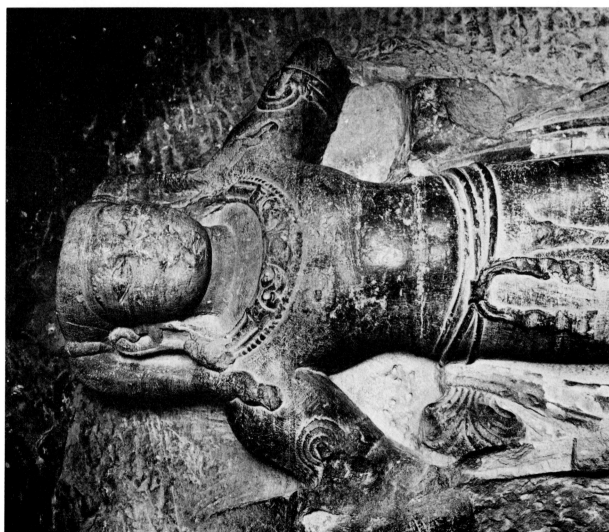

10. Standing Kārttikeya in Cave 3, Udayagiri.

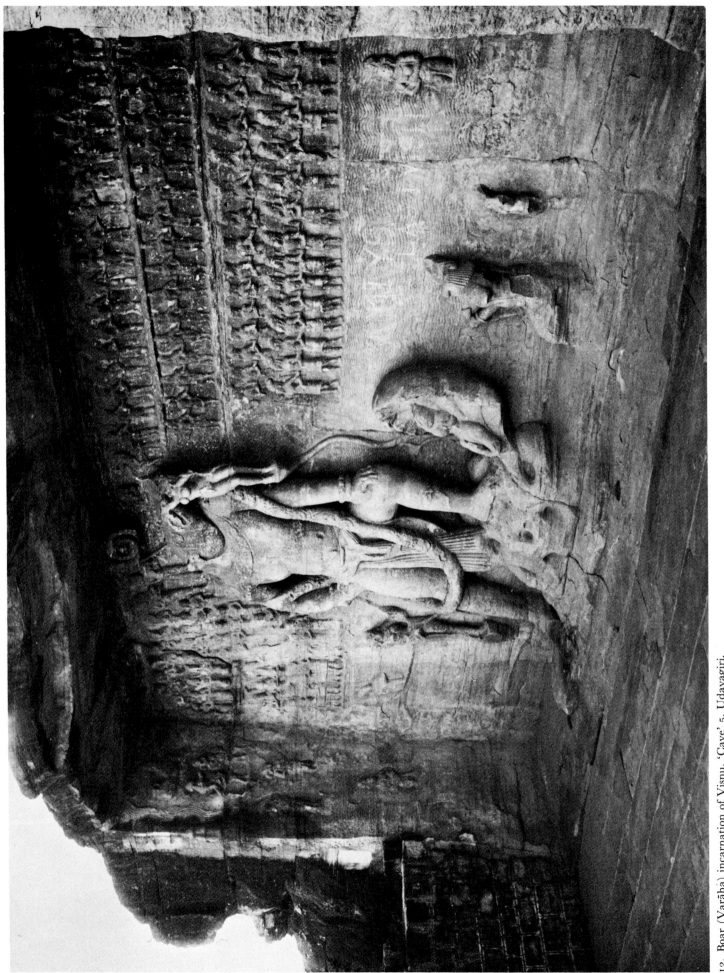

12. Boar (Varāha) incarnation of Viṣṇu, 'Cave' 5, Udayagiri.

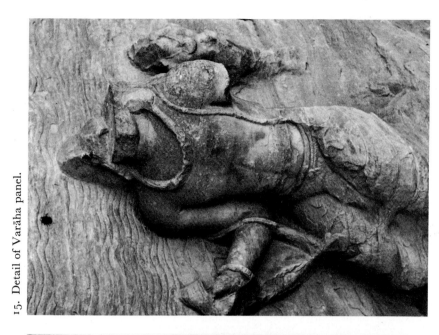

15. Detail of Varāha panel.

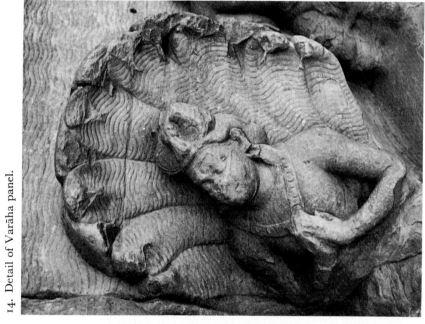

14. Detail of Varāha panel.

13. Detail of Varāha panel.

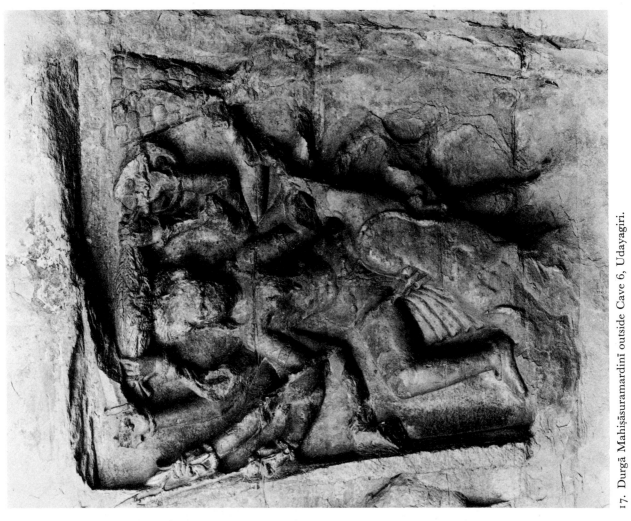

17. Durgā Mahiṣāsuramardinī outside Cave 6, Udayagiri.

16. Durgā Mahiṣāsuramardinī beside Cave 17, Udayagiri.

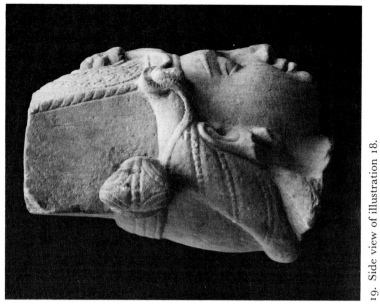

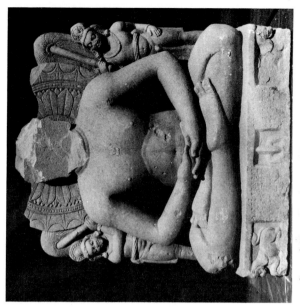

19. Side view of illustration 18.

20. Seated Jina, Environs of Besnagar, Vidišā Museum.

18. Head of Viṣṇu, Besnagar, Cleveland Museum of Art.

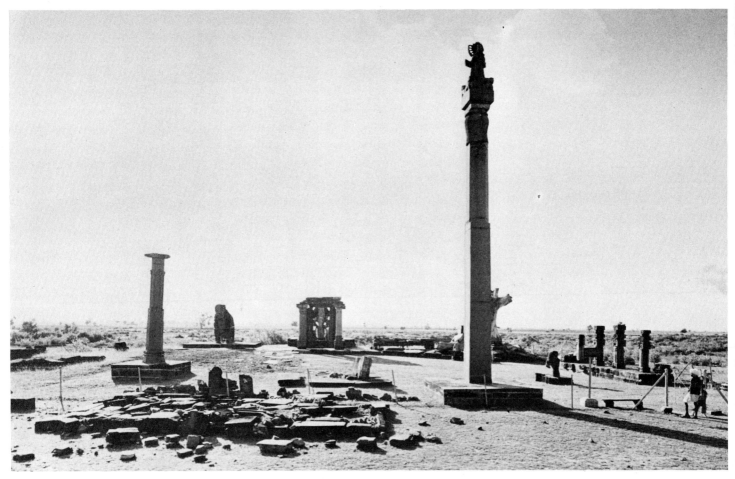

21. The site, Eran.

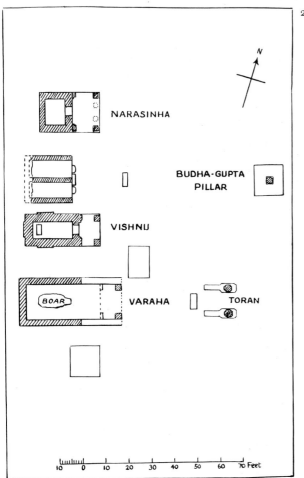

22. Site plan, Eran.

NARASINHA

BUDHA-GUPTA
PILLAR

VISHNU

BOAR VARAHA TORAN

N

10 0 10 20 30 40 50 60 70 Feet

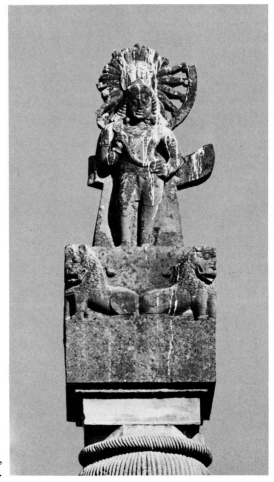

23. Capital and
surmounting figures,
of Budhagupta pillar,
dated A.D. 485, Eran.

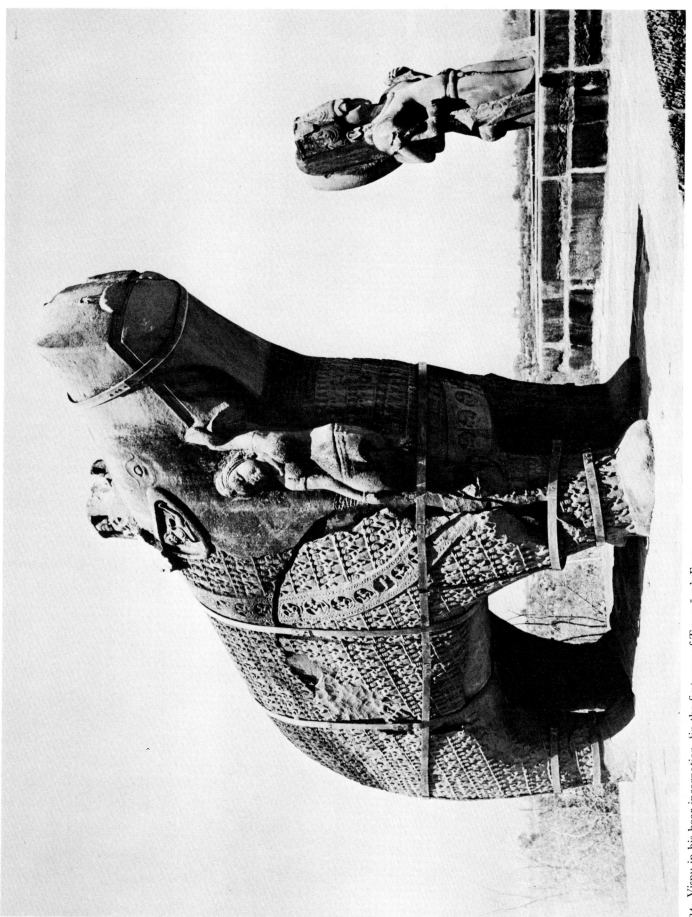

24. Viṣṇu in his boar incarnation, 'in the first year of Toramāṇa', Eran.

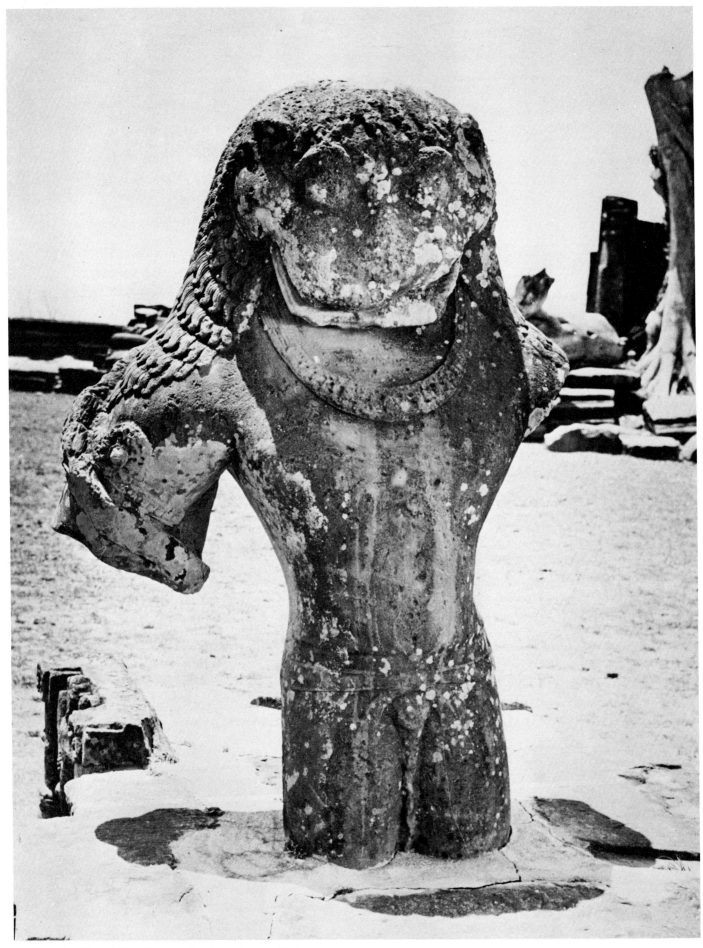

25. Standing Narasiṁha (the man-lion incarnation of Viṣṇu), Eran.

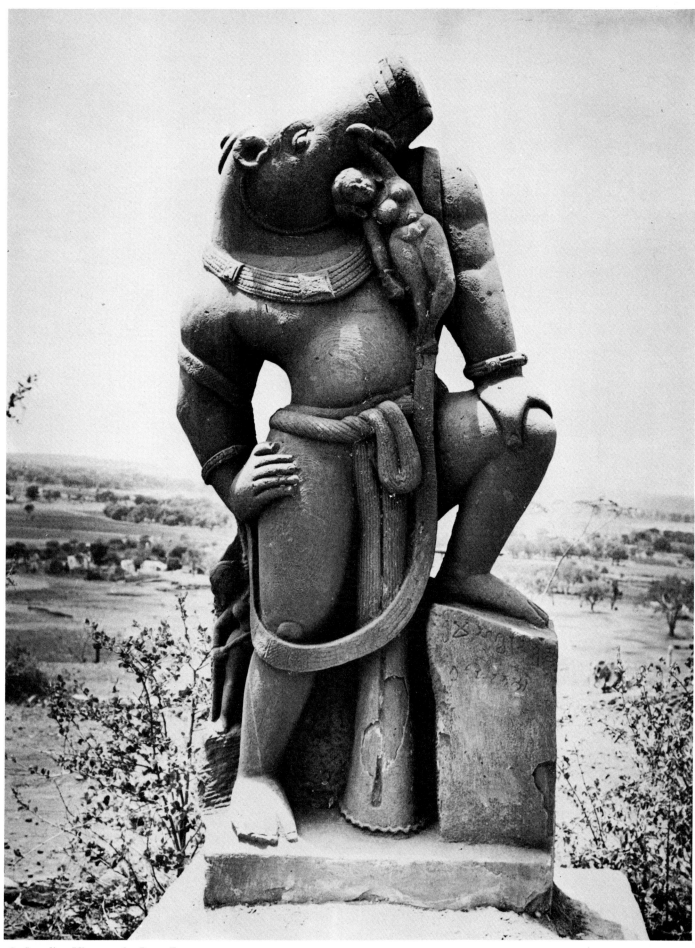

26. Standing Viṣṇu as the Boar, Eran.

27. The Seven Mothers (Sapta Mātṛkās) and Vīrabhadra, a form of Śiva, Badoh-Pathārī.

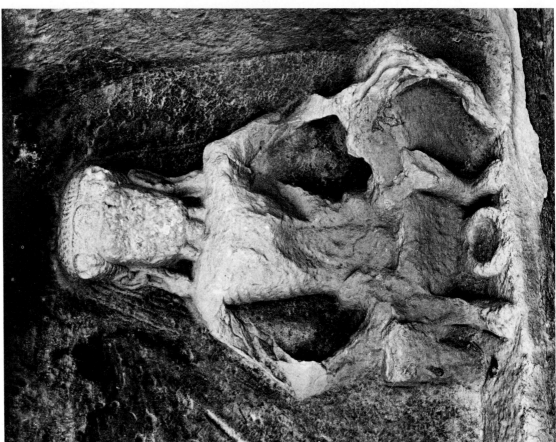

28. Vīrabhadra, a form of Śiva, Badoh-Pathārī.

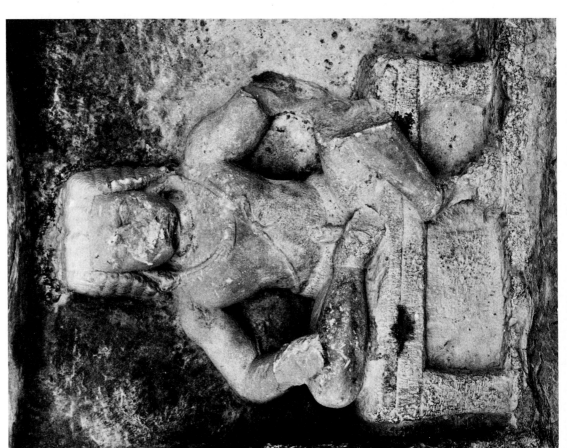

29. Cāmuṇḍā, Badoh-Pathārī.

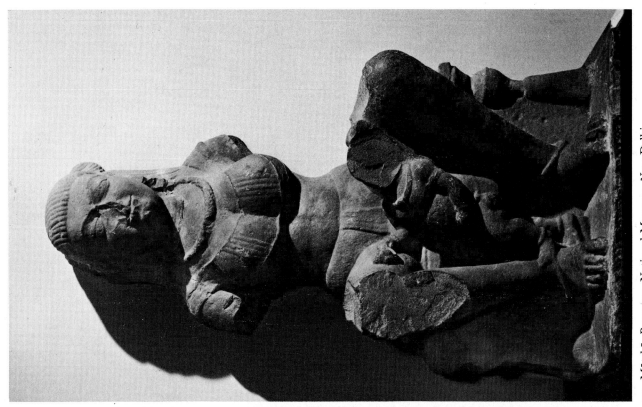

31. Mātṛkā, Besnagar, National Museum, New Delhi.

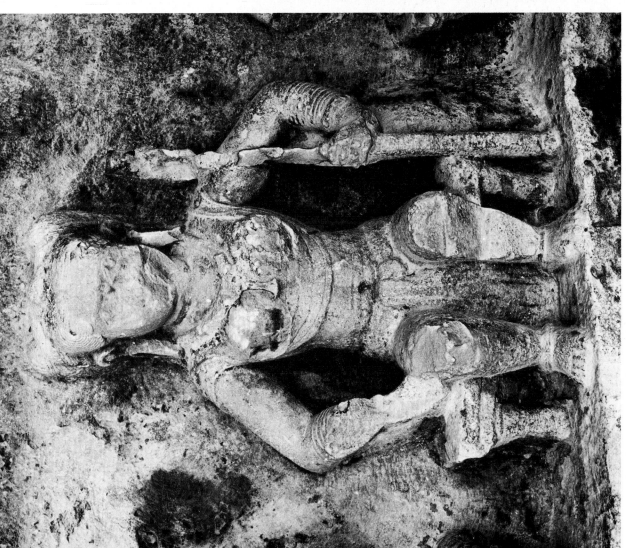

30. Unidentified Mother (Mātṛkā), Badoh-Paṭhāri.

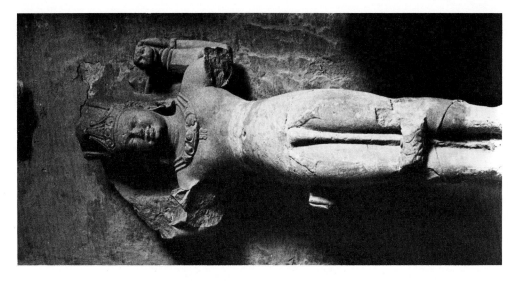

33. Standing Viṣṇu, Besnagar, Archaeological Museum, Gwalior.

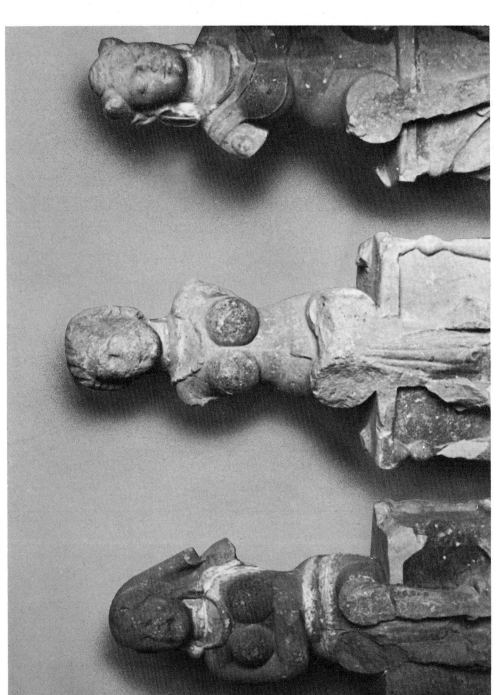

32. Three Mātṛkās, Besnagar, Archaeological Museum, Gwalior.

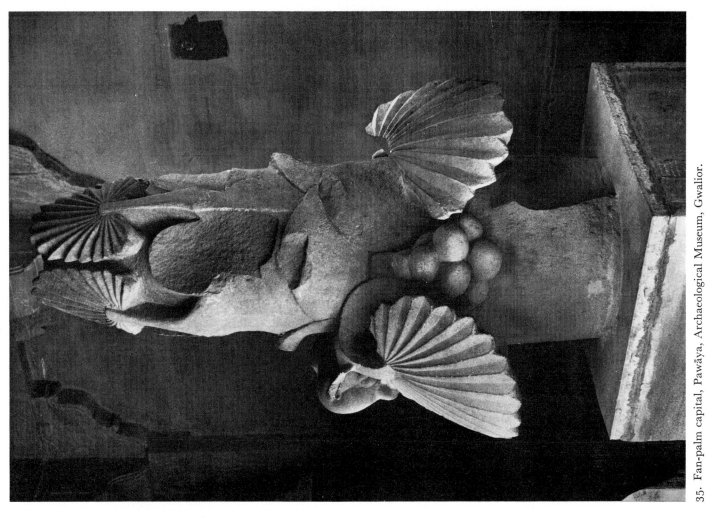

35. Fan-palm capital, Pawāya, Archaeological Museum, Gwalior.

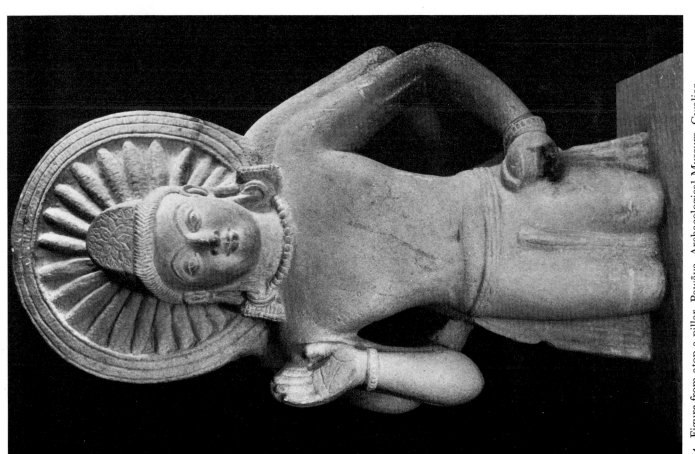

34. Figure from atop a pillar, Pawāya, Archaeological Museum, Gwalior.

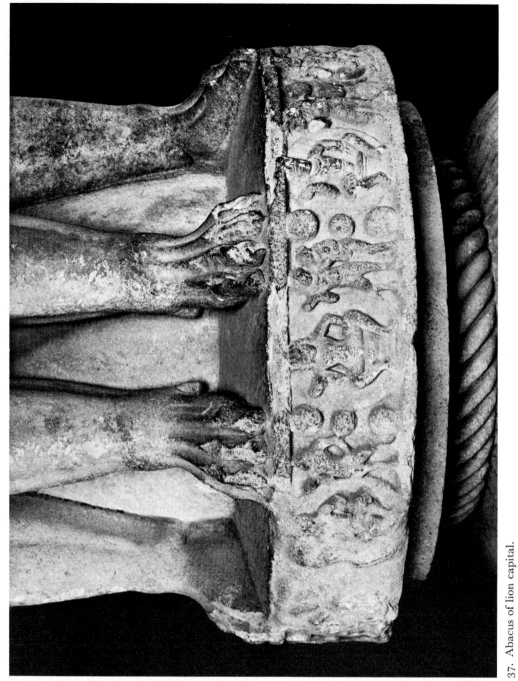

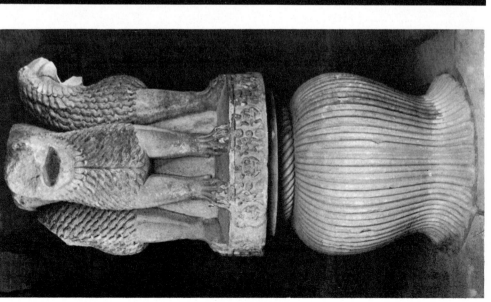

36. Lion capital Udayagiri, Archaeological Museum, Gwalior.

37. Abacus of lion capital.

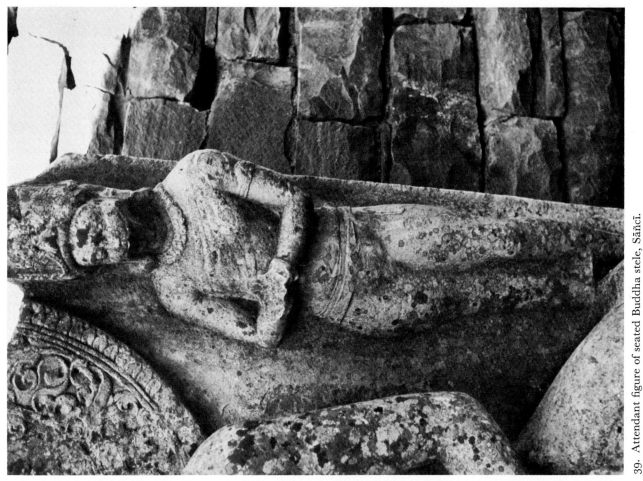

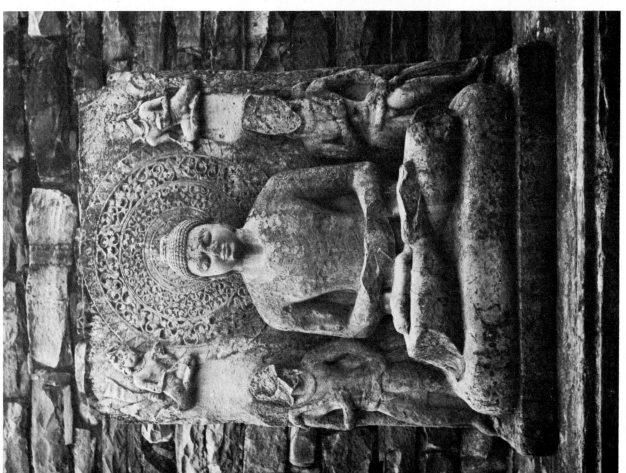

39. Attendant figure of seated Buddha stele, Sāñcī.

38. Seated Buddha stele, Sāñcī.

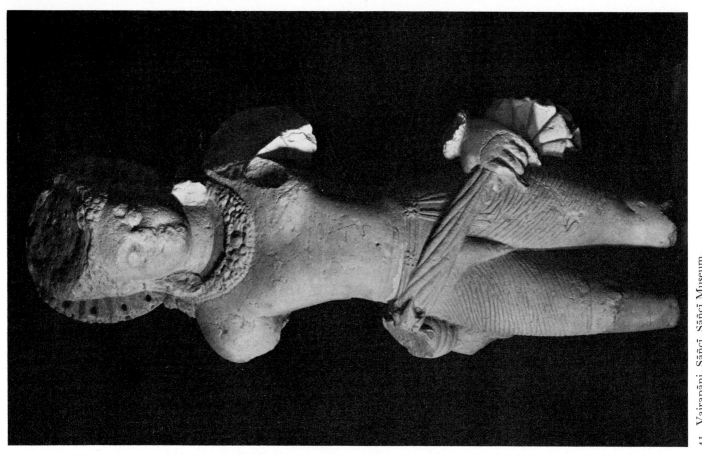

41. Vajrapāṇi, Sāñcī, Sāñcī Museum.

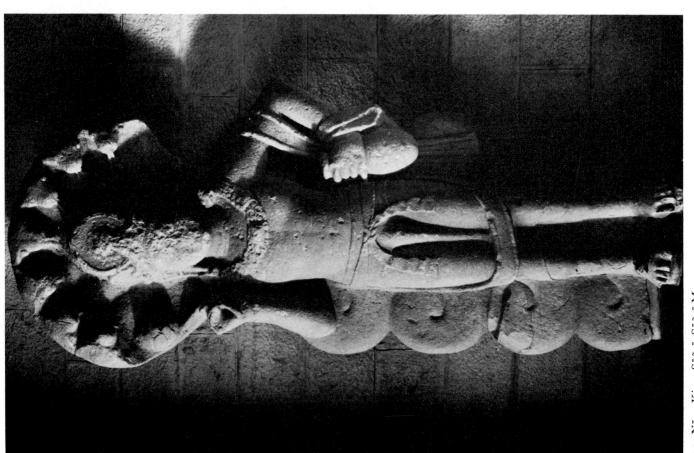

40. Nāga King, Sāñcī, Sāñcī Museum.

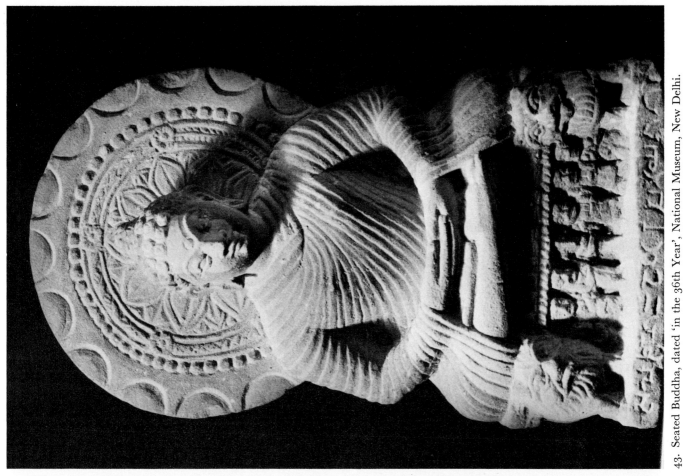

43. Seated Buddha, dated 'in the 36th Year', National Museum, New Delhi.

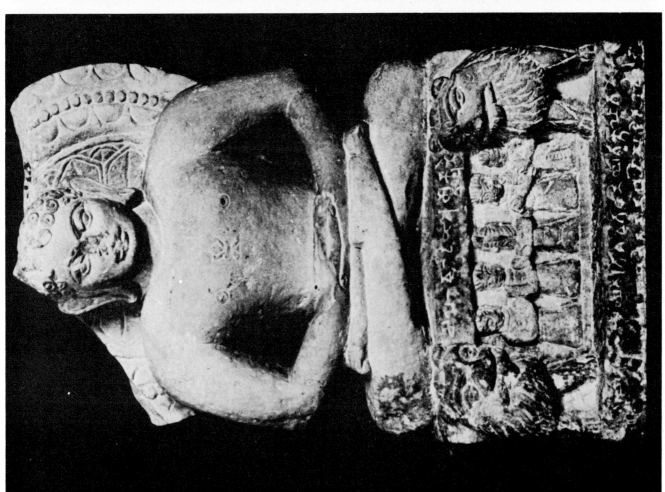

42. Image of a seated Tīrthaṅkara, Mathurā, State Museum, Lucknow.

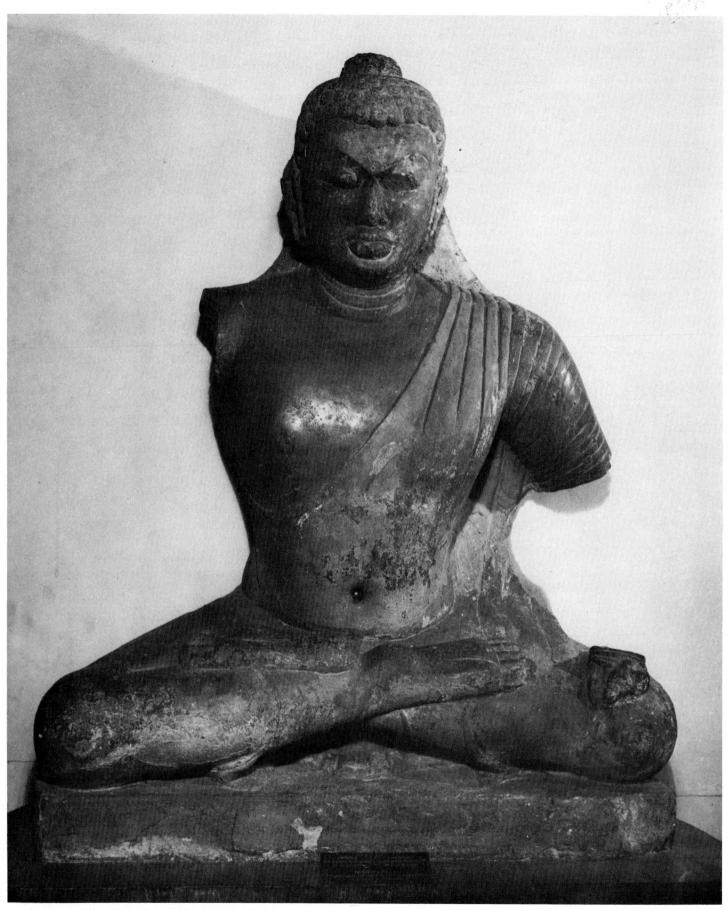

44. Seated Buddha, Bodhgaya, Indian Museum, Calcutta.

46. Seated Tīrthaṅkara, Mathurā, State Museum, Lucknow.

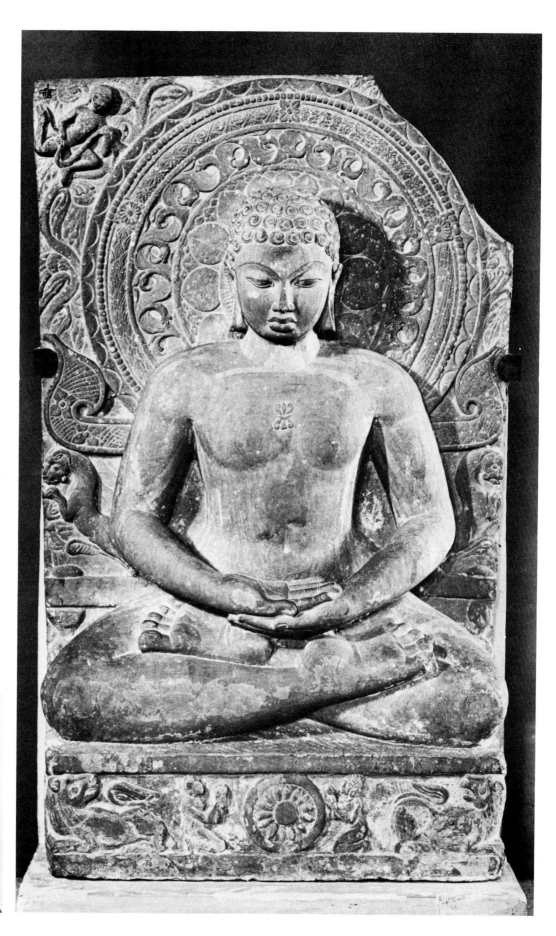

45. Image of a seated Tīrthaṅkara, dated in the Year 113 of Kumāra-gupta (A.D. 432–433), Mathurā, State Museum, Lucknow.

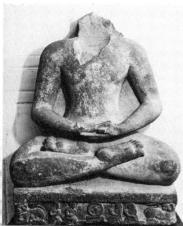

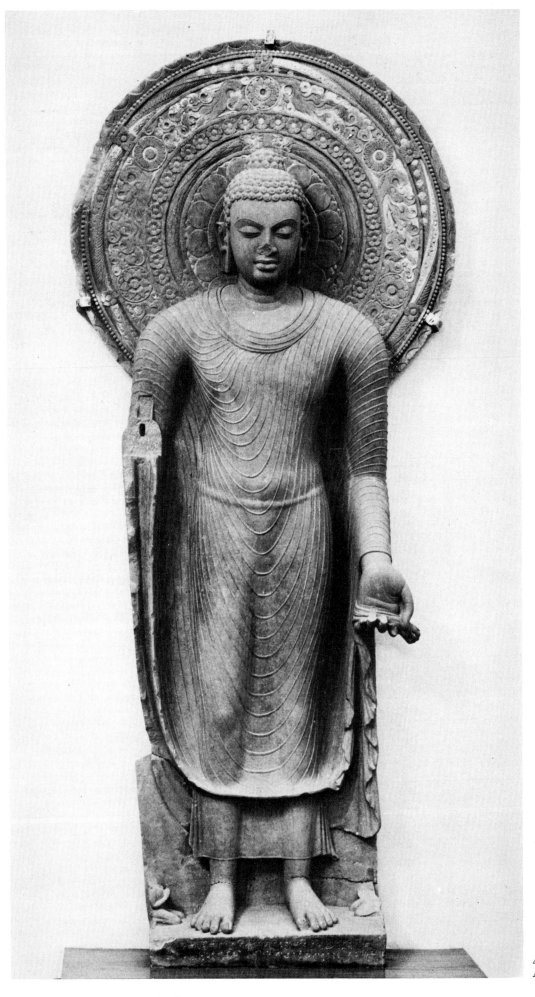

47. Standing Buddha, Mathurā,
Archaeological Museum, Mathurā.

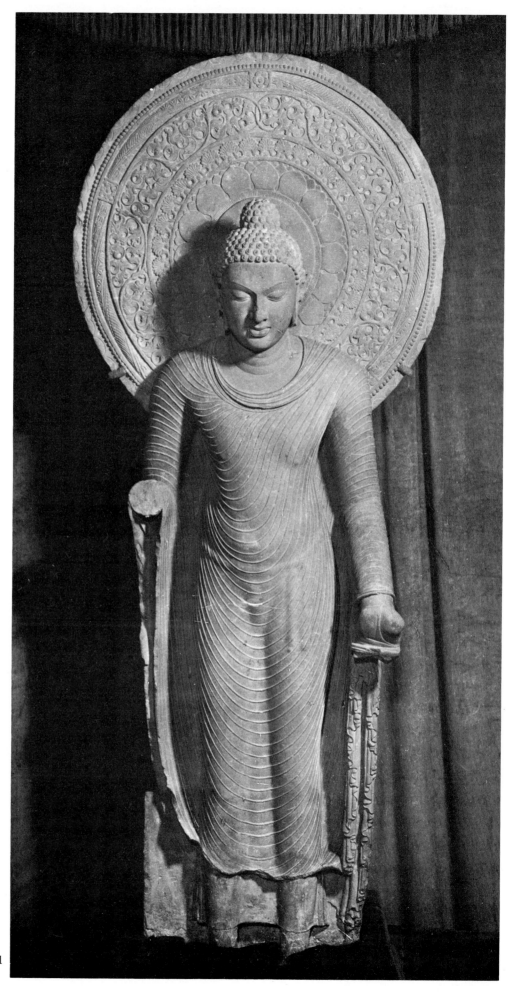

48. Standing Buddha, Mathurā, National Museum, New Delhi.

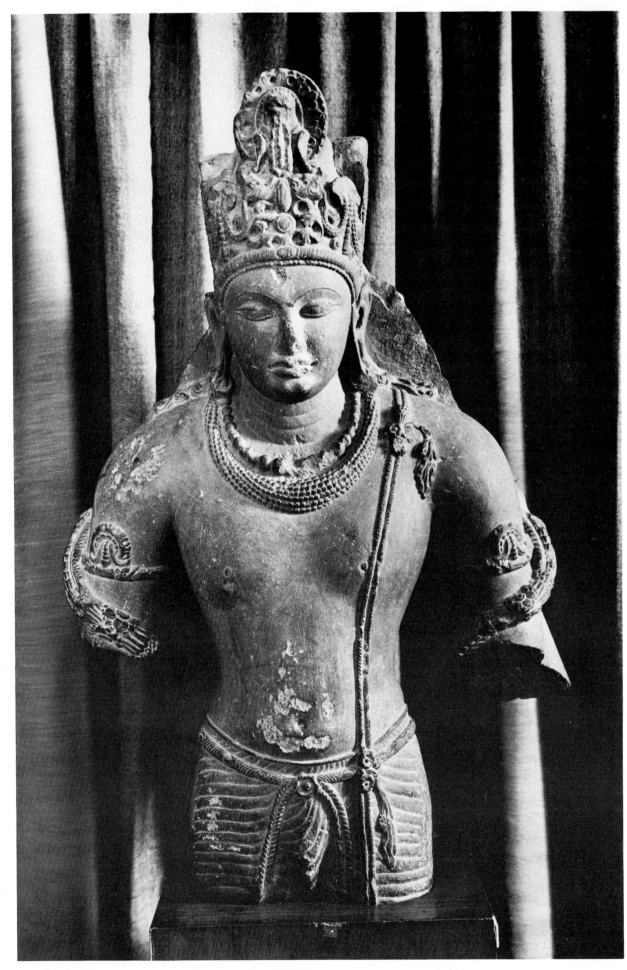

49. Standing Viṣṇu, Mathurā, National Museum, New Delhi.

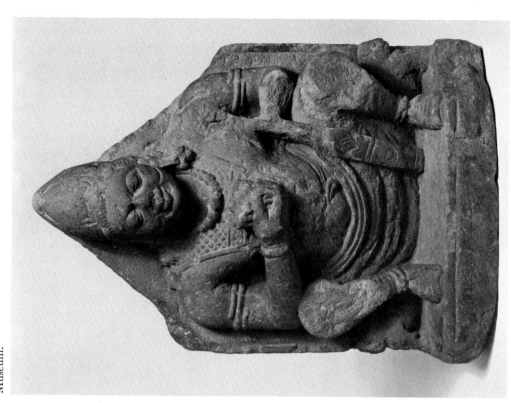

50. Head of Śiva, from an *ekamukhaliṅgam*, Mathurā, Ashmolean Museum.

51. Sūrya in the costume of a Kuṣāṇa prince, Mathurā, Ashmolean Museum.

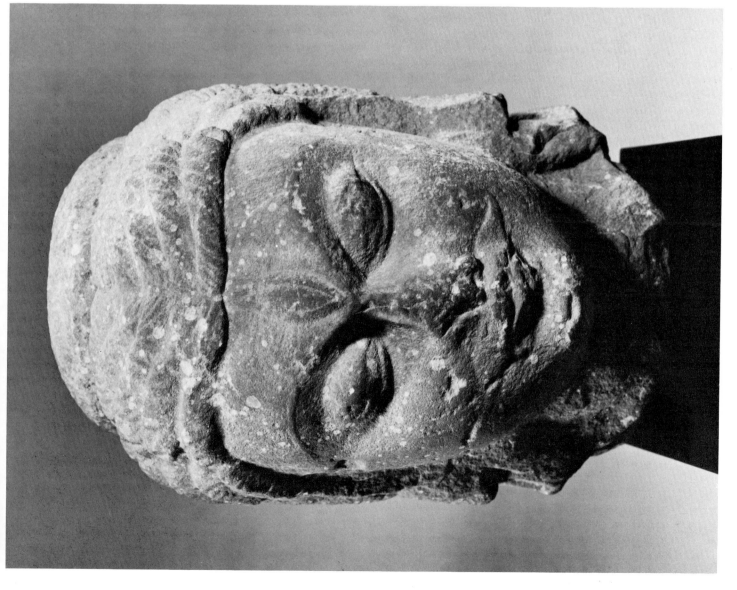

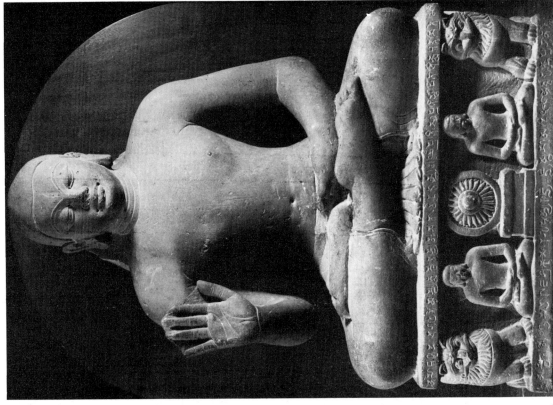

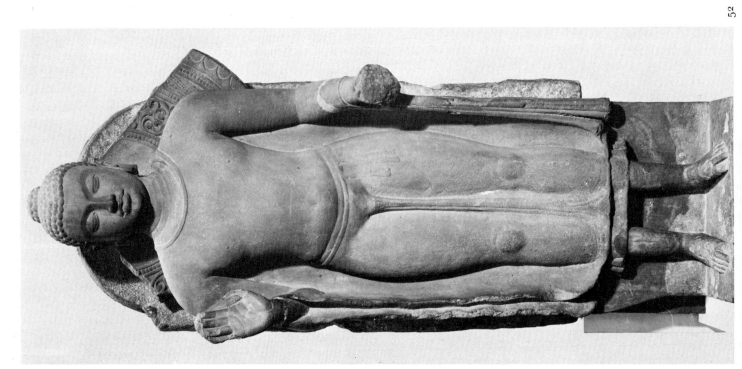

52. Standing Buddha, Sārnāth, British Museum.

53. Śiva and Pārvatī, Kauśāmbī, Indian Museum, Calcutta.

54. Śiva, said to come from Kauśāmbī area, Los Angeles County Museum of Art.

55. Seated Buddha, inscribed in the year A.D. 449 of Kumāragupta, Mankuwar, State Museum, Lucknow.

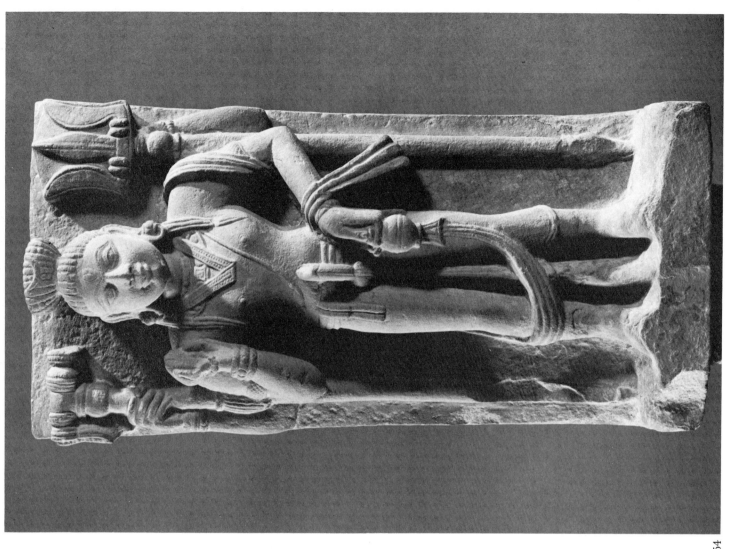

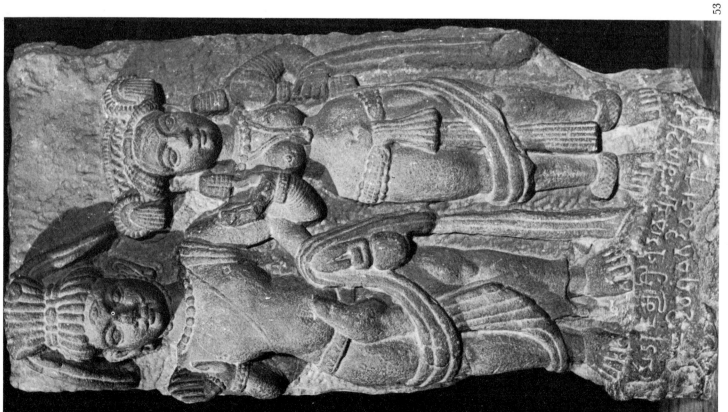

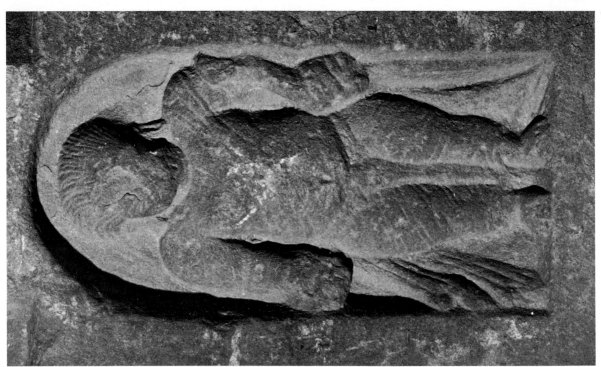

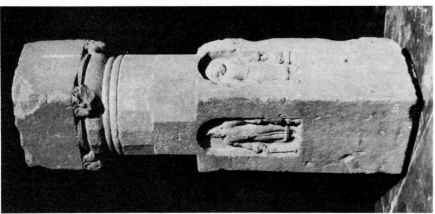

56. Pillar from Rājghat, Varanasi, dated 478, in the reign of Budhagupta, Bharat Kalā Bhavan.

57. Detail from above: Viṣṇu.

58. Detail from above: Vāmana.

60. Same, another side with Vāmana, Allahabad Museum.

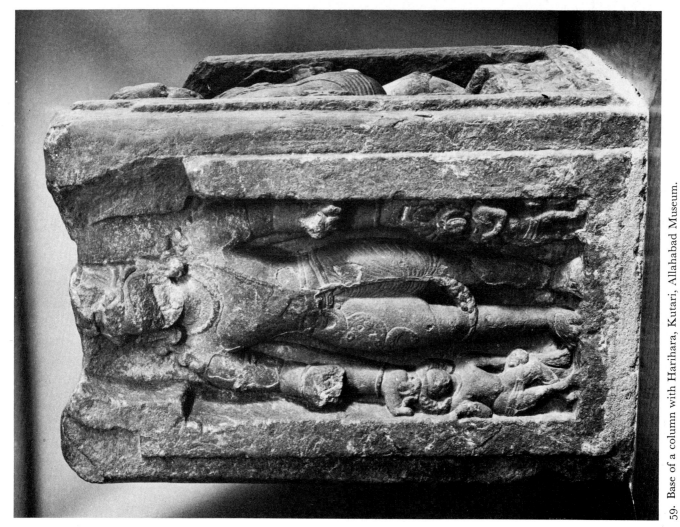

59. Base of a column with Harihara, Kutari, Allahabad Museum.

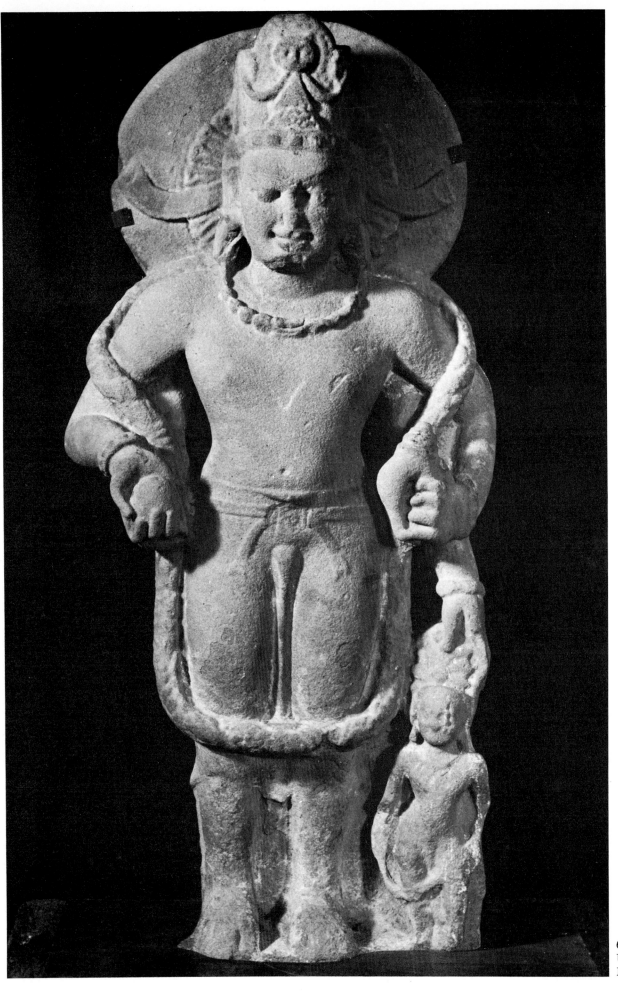

61. Standing Viṣṇu, Unchdīh, Allahabad Museum.

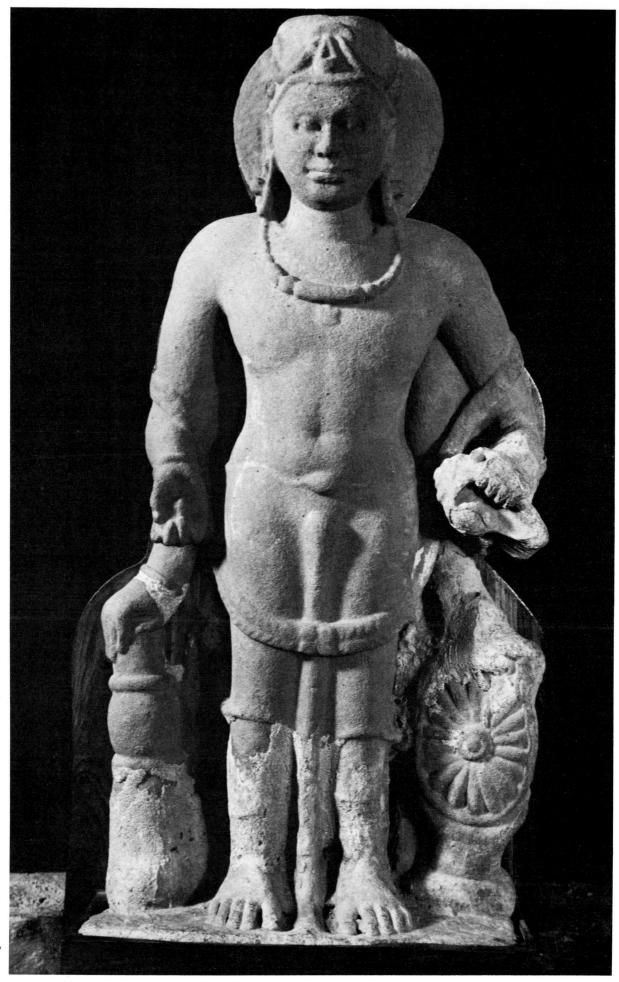

62. Standing Viṣṇu,
Jhusī, Allahabad
Museum.

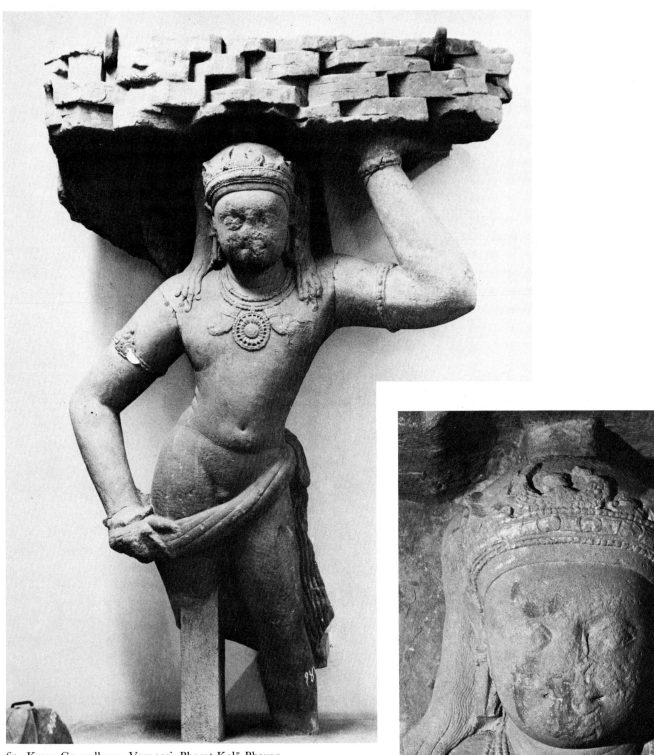

63. Kṛṣṇa Govardhana, Varanasi, Bharat Kalā Bhavan.

64. Detail of above.

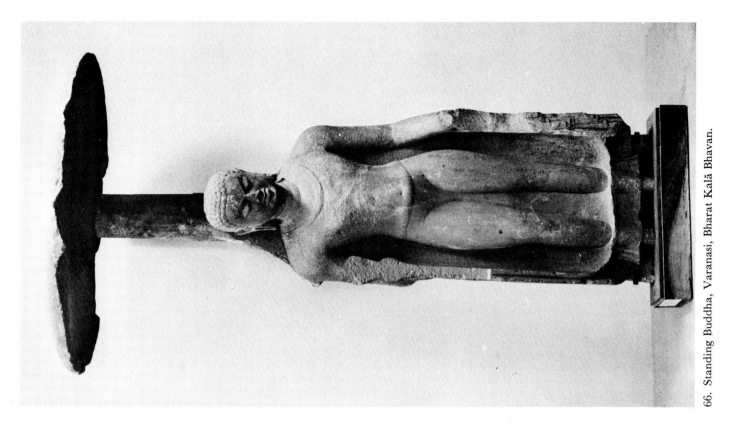

66. Standing Buddha, Varanasi, Bharat Kalā Bhavan.

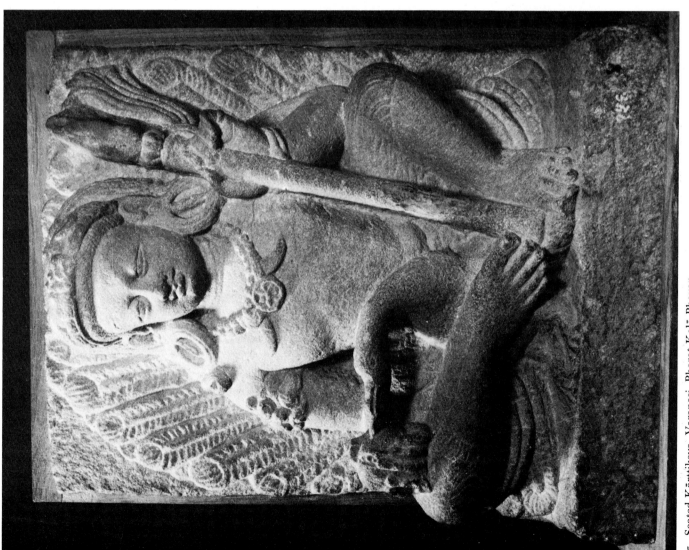

65. Seated Kārttikeya, Varanasi, Bharat Kalā Bhavan.

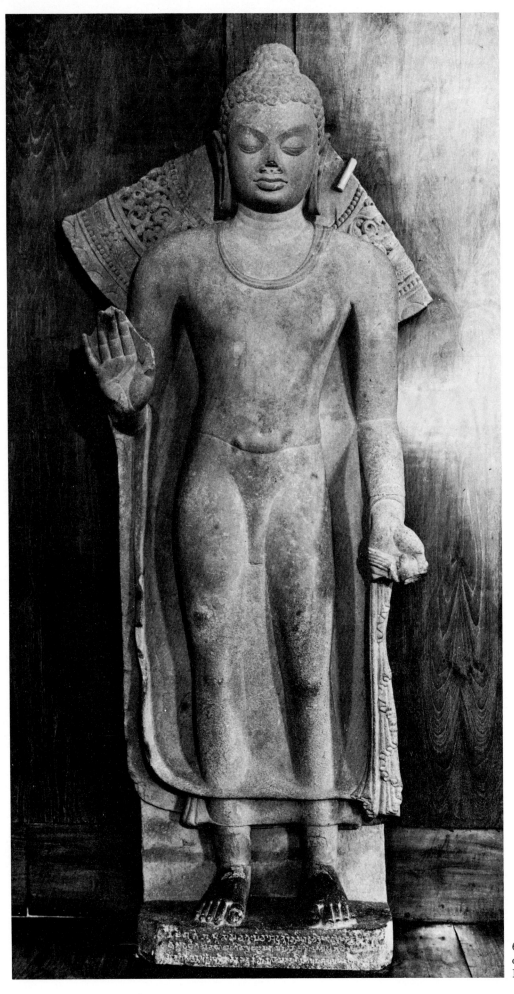

67. Standing Buddha, dated in 154th year of Gupta era (A.D. 474), in the reign of Kumāragupta II, Sārnāth Museum.

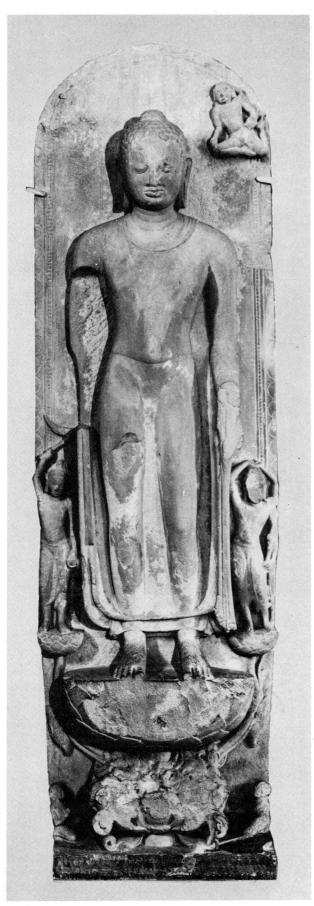

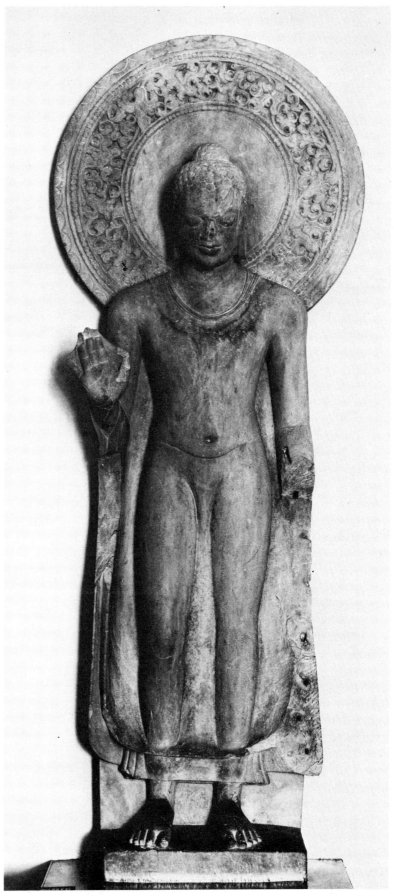

68. Standing Buddha, Sārnāth, Sārnāth Museum.

69. Standing Buddha, Sārnāth, Sārnāth Museum.

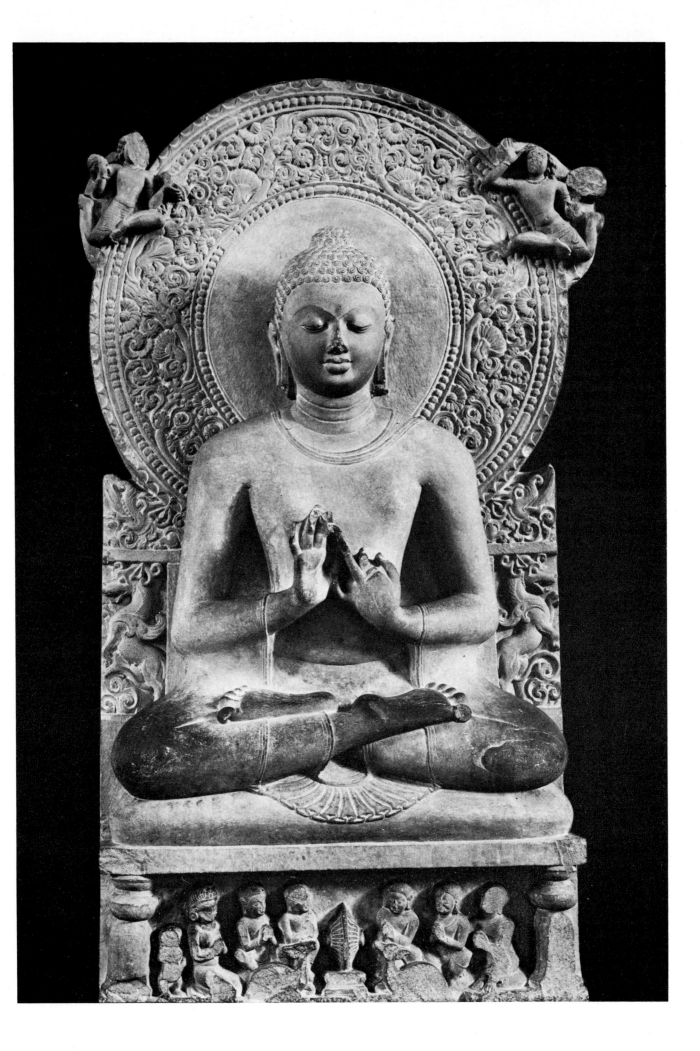

70 (*left*). Seated Buddha, Sārnāth, Sārnāth Museum.

71. Proper right portion of lintel, Gaḍhwā, State Museum, Lucknow.

72. Proper left portion of Gaḍhwā lintel (in two fragments).

73. Detail of Gadhwā lintel.

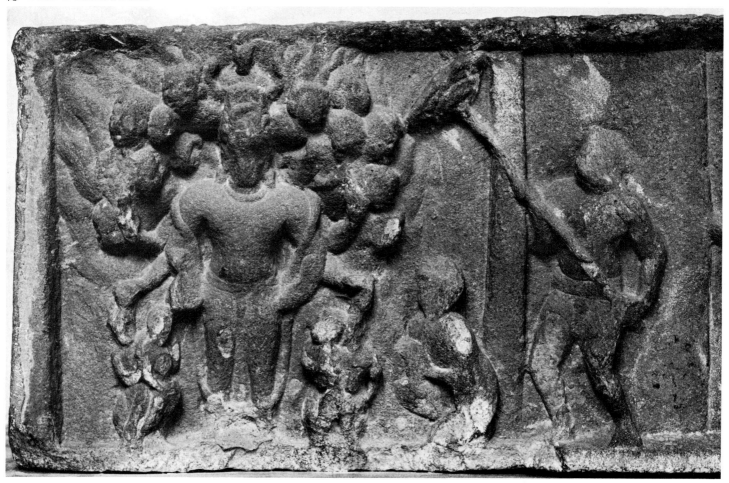

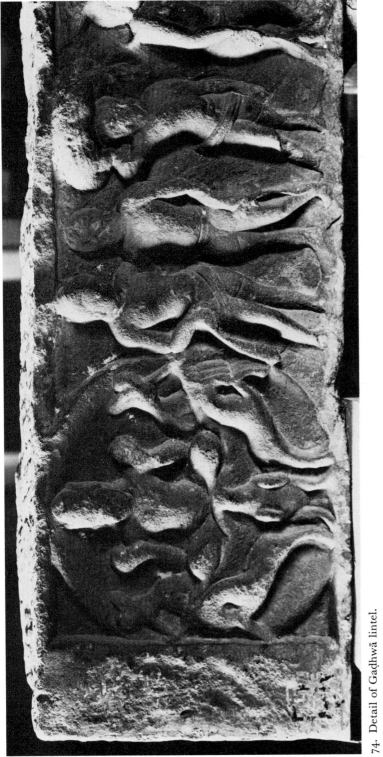

74. Detail of Gaḍhwā lintel.

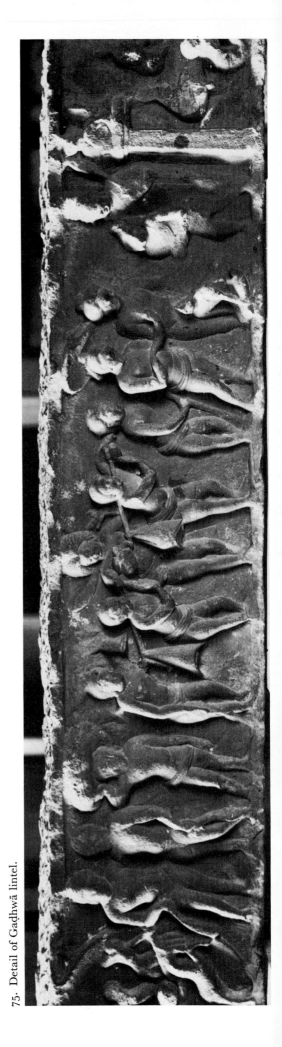

75. Detail of Gaḍhwā lintel.

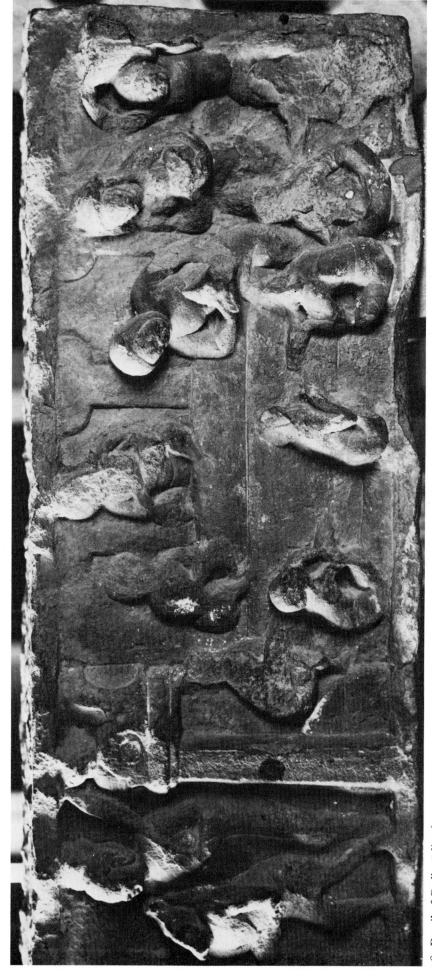

76. Detail of Gaḍhwā lintel.

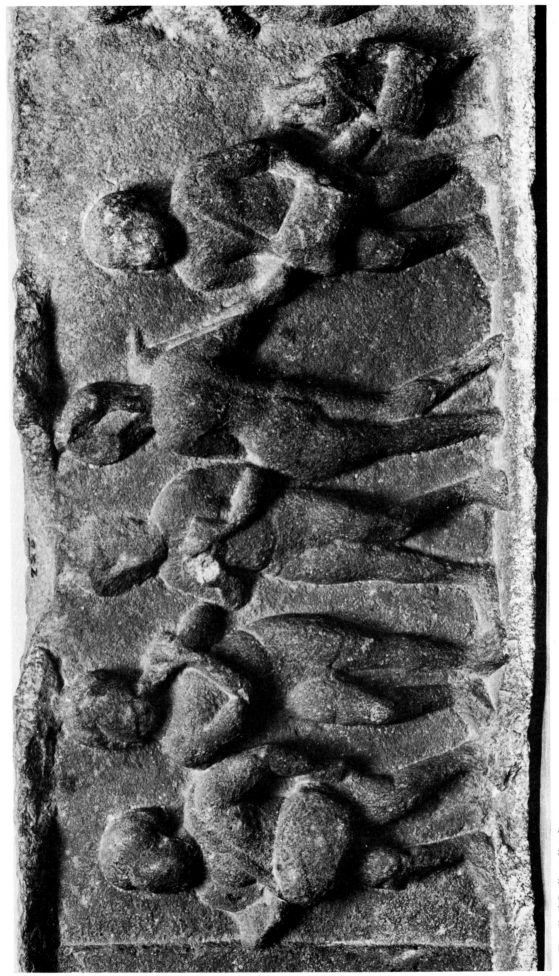

77. Detail of Gaḍhwā lintel.

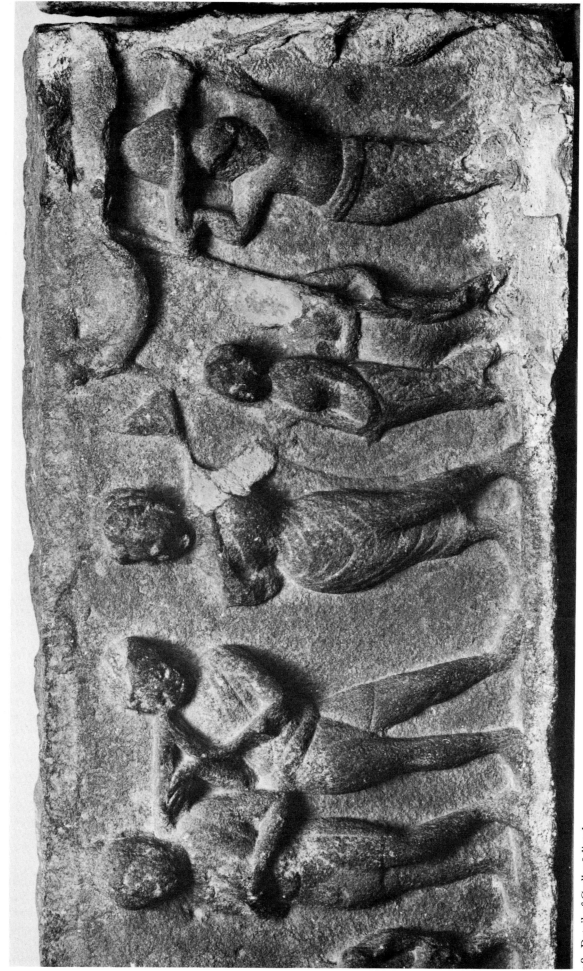

78. Detail of Gaḍhwā lintel.

79. Fragment of door-jamb, Gaḍhwā.

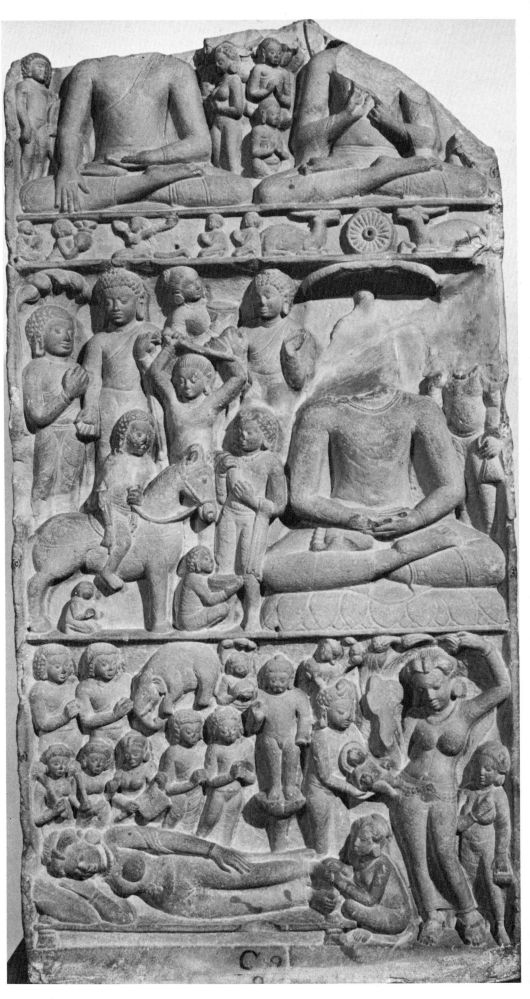

80. Stele with scenes from the life of
the Buddha, Sārnāth, National
Museum, New Delhi.

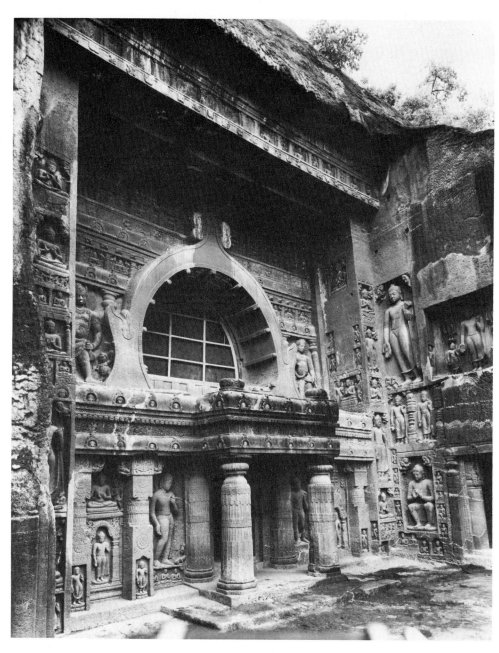

81. Facade, Cave 19, Ajantā.

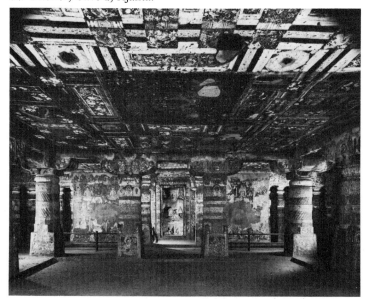

82. Interior, Cave 2, Ajantā.

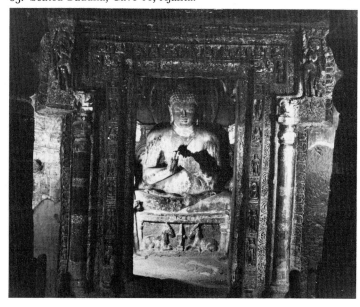

83. Seated Buddha, Cave 16, Ajantā.

85. Pair of flying figures, ceiling of front porch, Cave 16, Ajantā.

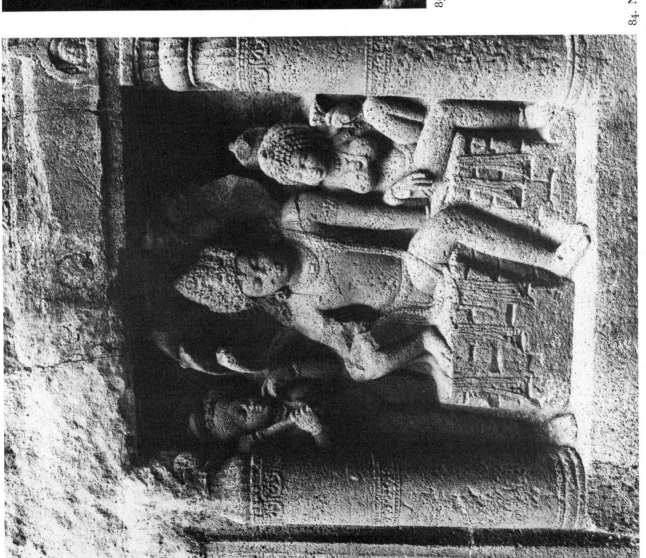

84. Nāga King and Consort outside Cave 19, Ajantā.

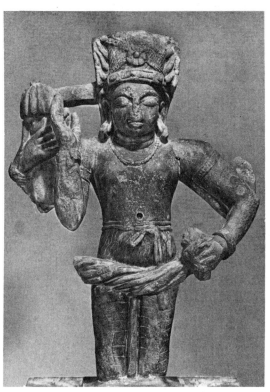

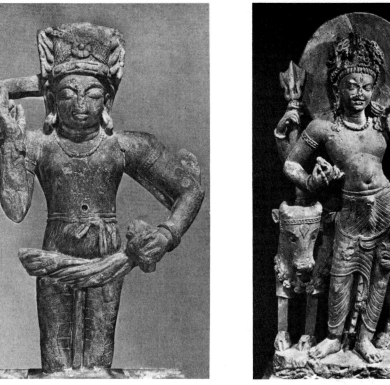

86. Male figure, Śāmalāji,
Baroda Museum and Picture Gallery.

87. Viṣṇu, Bhinmal, Baroda Museum and Picture
Gallery.

88. Four-armed standing Śiva,
Śāmalāji, Baroda Museum and
Picture Gallery.

89. Cāmuṇḍā, schist,
Śāmalāji, Baroda Museum
and Picture Gallery.

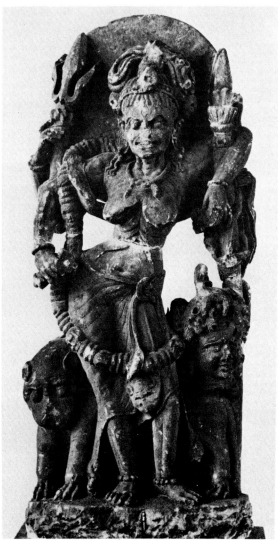

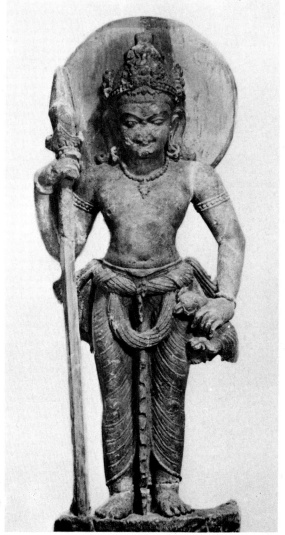

90. Kumāra, Śāmalāji,
Baroda Museum and
Picture Gallery.

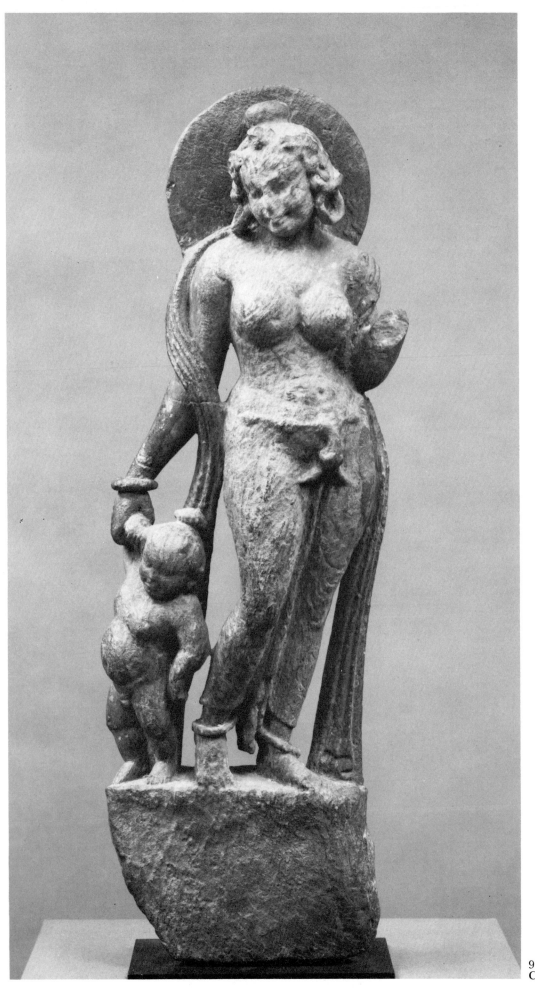

91. Skandamātā, Tanesara-Mahādeva,
Cleveland Museum of Art.

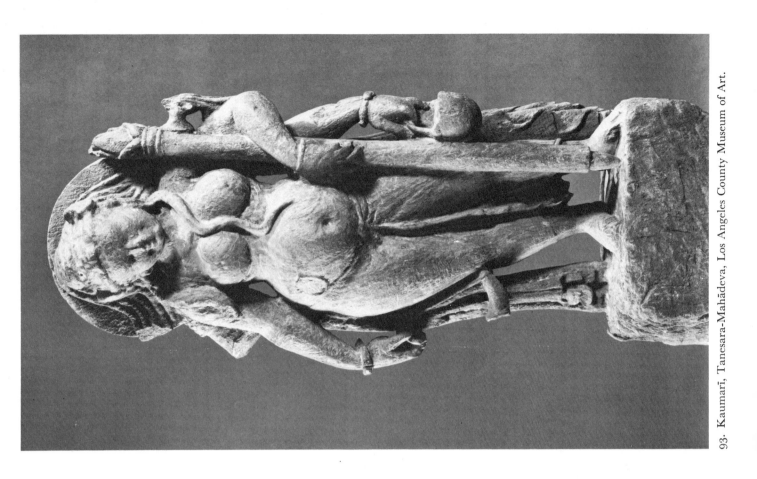

93. Kaumarī, Tanesara-Mahādeva, Los Angeles County Museum of Art.

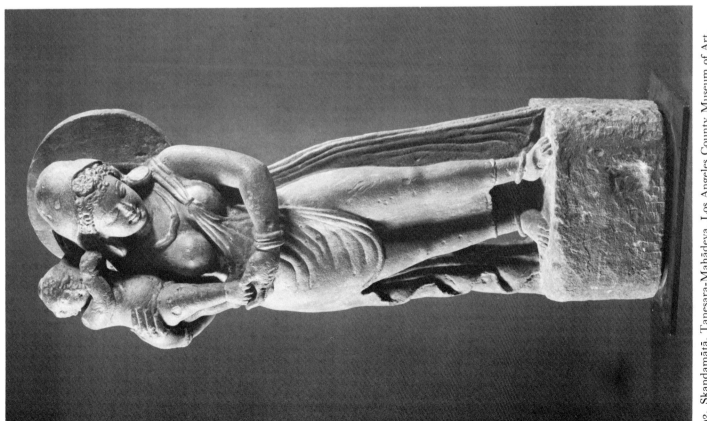

92. Skandamātā, Tanesara-Mahādeva, Los Angeles County Museum of Art.

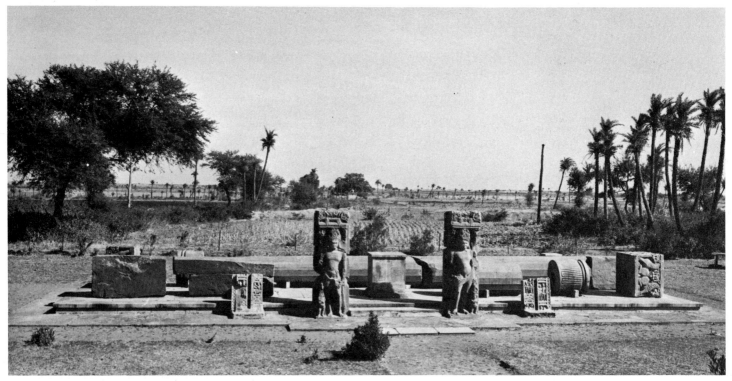

94. Yaśodharman's pillar and assorted sculpture, Sondni.

95. Doorkeeper, Sondni.

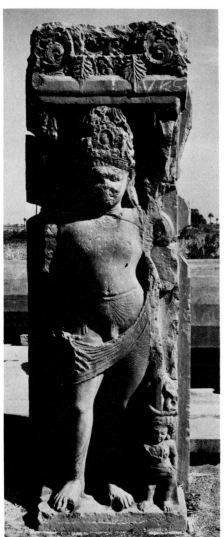

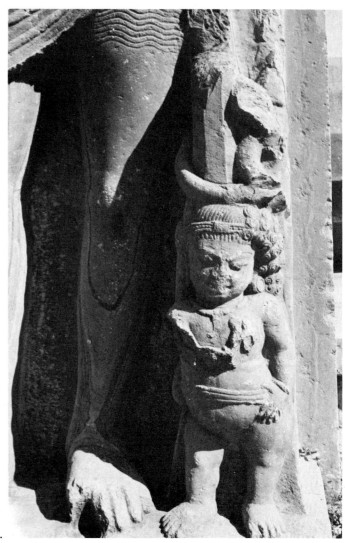

96. Attendant of a
doorkeeper, Sondni.

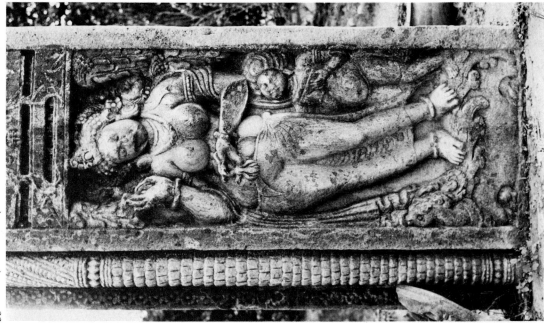

99. Same, north face, Yamunā.

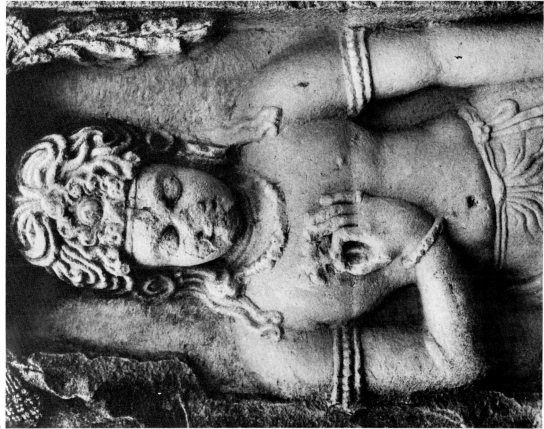

98. Same, detail.

97. Toraṇa pillar, Kilchipura, south face.

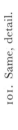

101. Same, detail.

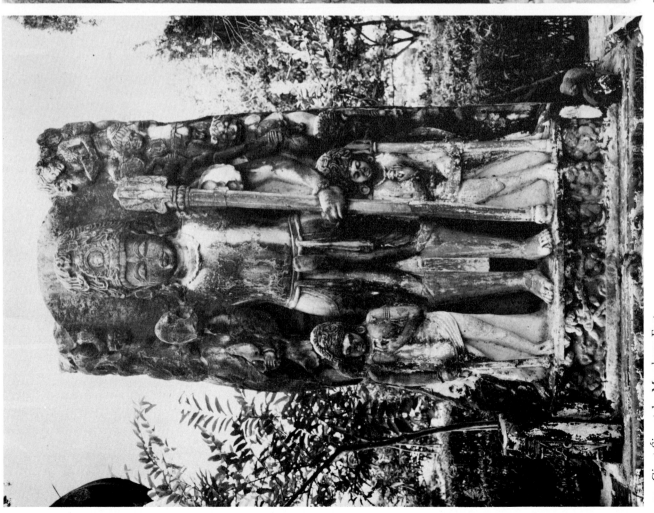

100. Giant Śiva stele, Mandasor Fort.

102. Head of an Ardhanarī (Śiva half-man and half-woman), Mathurā, Archaeological Museum, Mathurā.

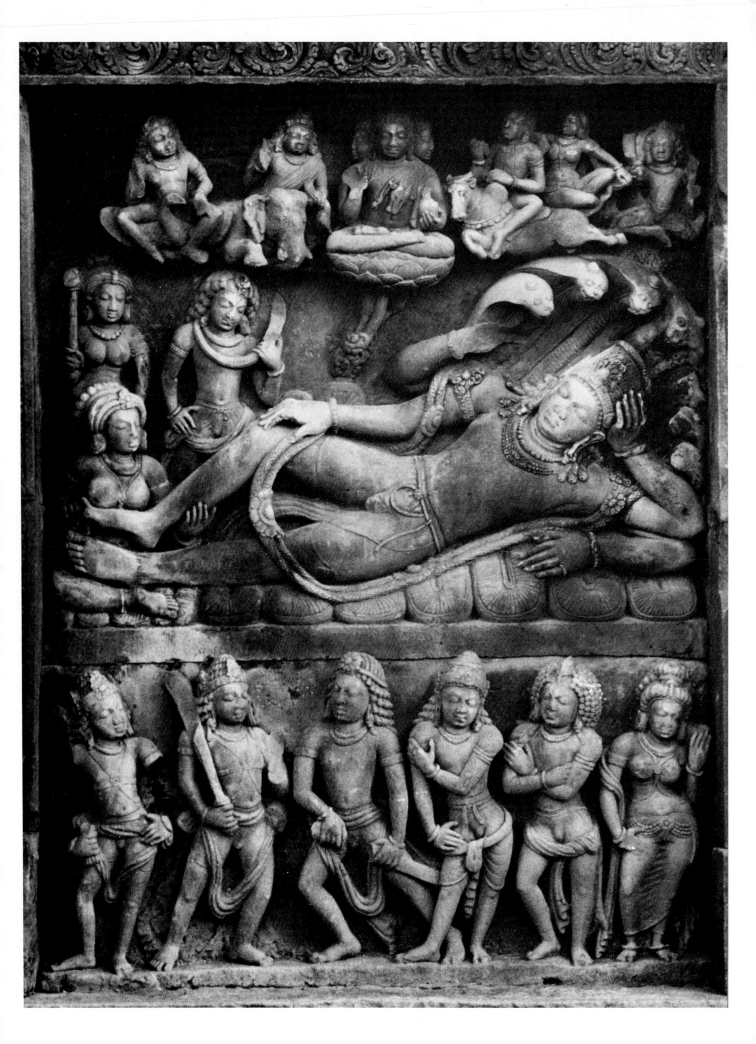

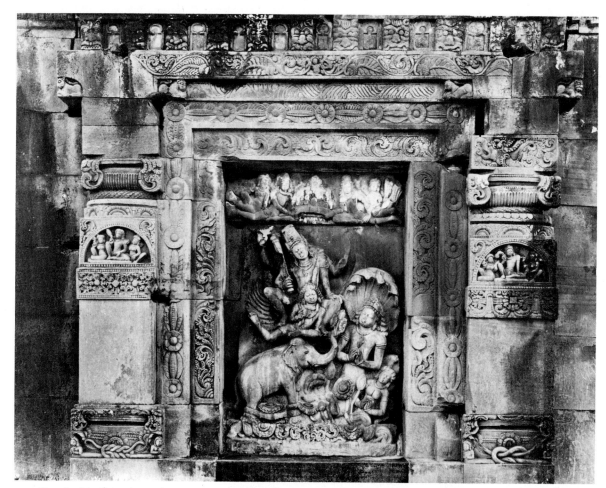

104. Panel with Gajendramokṣa
(Liberation of Indra's Elephant),
north side, Daśāvatāra Temple,
Deogarh.

105. Entrance doorway, west side of
Daśāvatāra Temple, Deogarh.

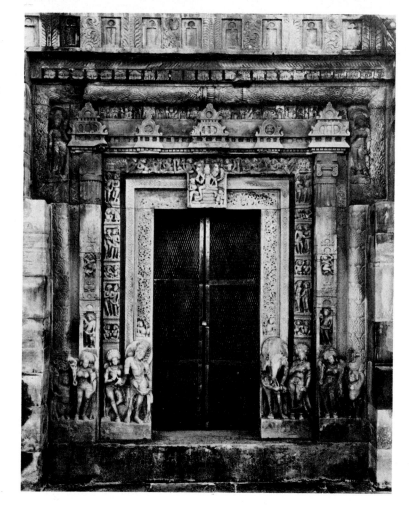

103 (*left*). Panel with Viṣṇu asleep
on the serpent Ananta, Daśāvatāra
Temple, Deogarh.

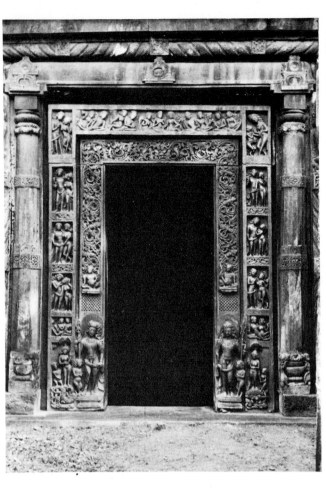

106. Entrance doorway,
Pārvatī Temple, Nāchnā-
Kuṭharā.

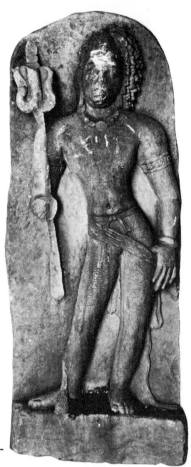

107. Śaiva *dvārapāla*,
Pārvatī Temple, Nāchnā-
Kuṭharā.

108. Part of a doorway built into the Teliya Math near
Nāchnā-Kuṭharā.

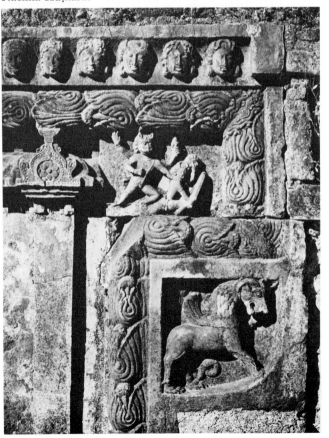

109. Doorway, Vāmana Temple, Maṛhiā.

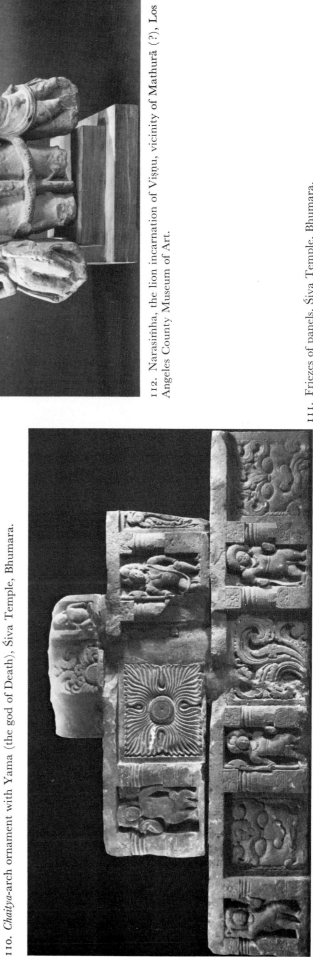

112. Narasiṃha, the lion incarnation of Viṣṇu, vicinity of Mathurā (?), Los Angeles County Museum of Art.

111. Friezes of panels, Śiva Temple, Bhumara.

110. *Chaitya*-arch ornament with Yama (the god of Death), Śiva Temple, Bhumara.

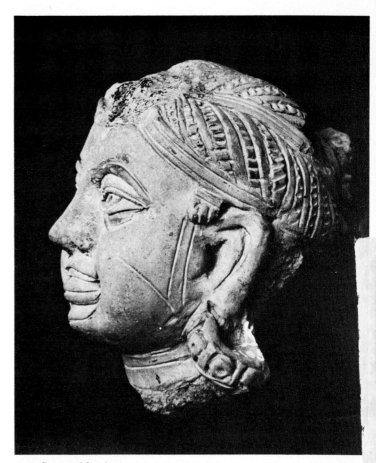

113. Head of a man, Kauśāmbī, Allahabad Museum.

114. Same, side view.

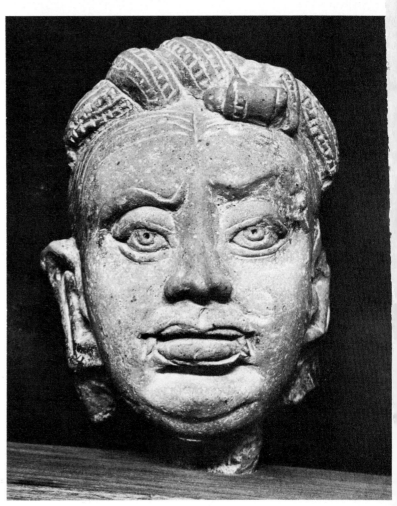

115. Head of an *asura*, Kauśāmbī,
Allahabad Museum.

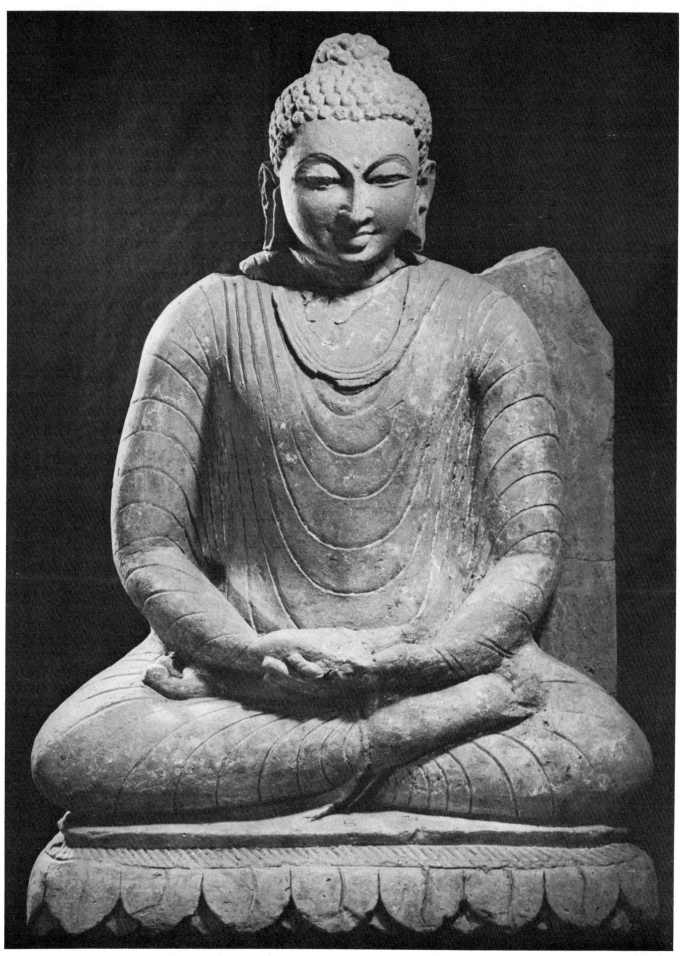

116. Buddha from great *stūpa* at Devnimori, Department of Archaeology, M. S. University, Baroda.

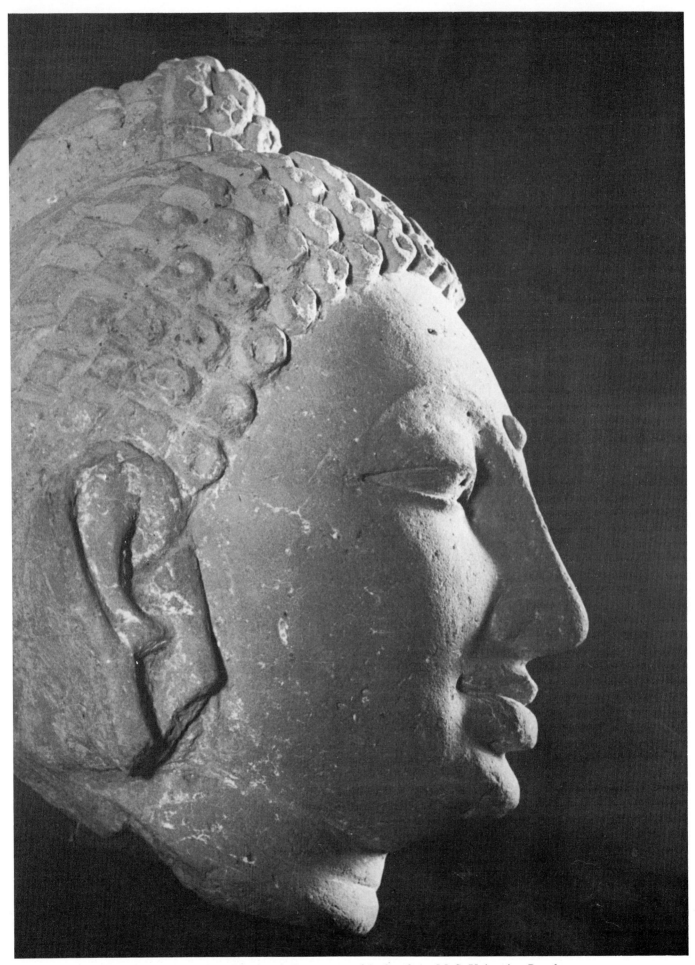

117. Head of a Buddha from great *stūpa* at Devnimori, Department of Archaeology, M. S. University, Baroda.

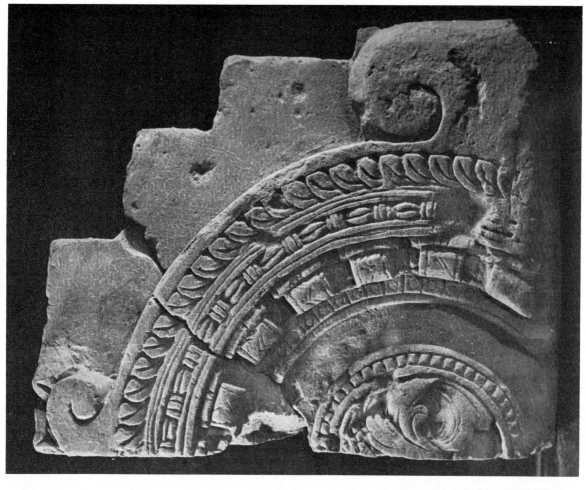

119. Half of a *chaitya* arch from great *stūpa* at Devnimori, Department of Archaeology, M. S. University, Baroda.

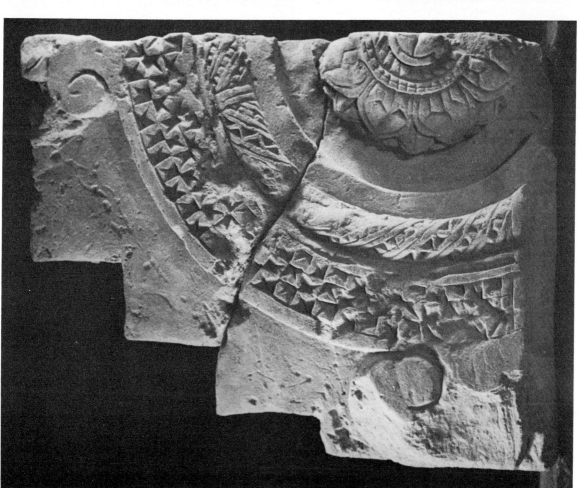

118. Half of a *chaitya* arch from great *stūpa* at Devnimori, Department of Archaeology, M. S. University, Baroda.

120. Acanthus from great *stūpa* at Devnimori, Department of Archaeology, M. S. University, Baroda.

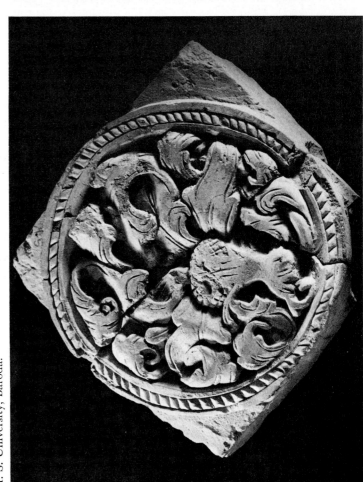

121. Large medallion with foliage from great *stūpa* at Devnimori, Department of Archaeology, M. S. University, Baroda.

122. Grotesque face from great *stūpa* at Devnimori, Department of Archaeology, M. S. University, Baroda.

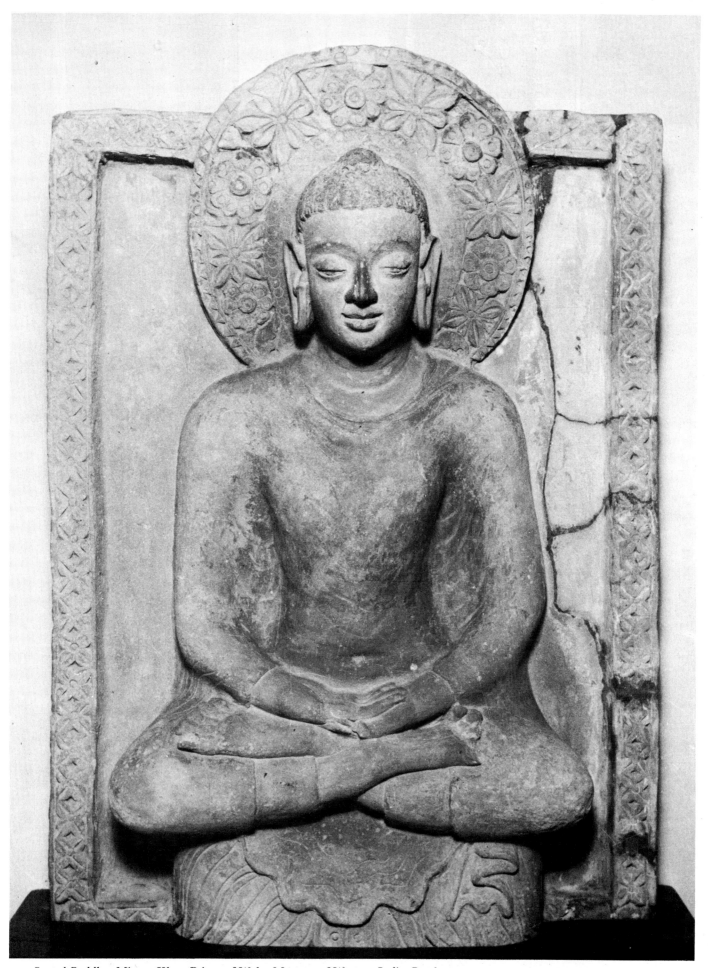

123. Seated Buddha, Mirpur Khas, Prince of Wales Museum of Western India, Bombay.

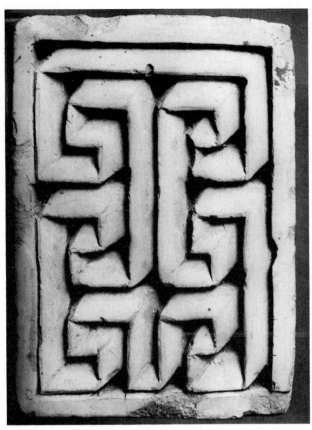

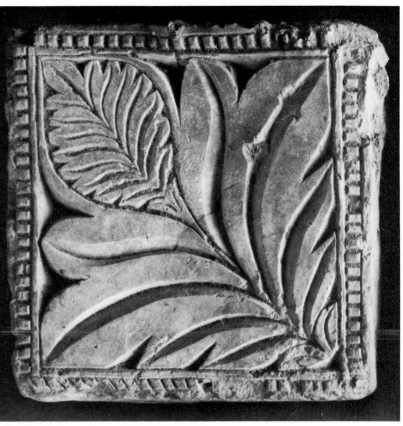

124. 'Carved brick' with meander pattern, Mirpus Khas, Prince of Wales Museum of Western India, Bombay.

125. Decorative brick or tile with acanthus, Mirpus Khas, Prince of Wales

126. Decorative brick or tile with grotesque face, Mirpur Khas, Prince of Wales Museum of Western India, Bombay.

127. Kṛṣṇa's Dānalīlā, Rang Mahal, Gaṅgā Golden Jubilee Museum, Bikaner.

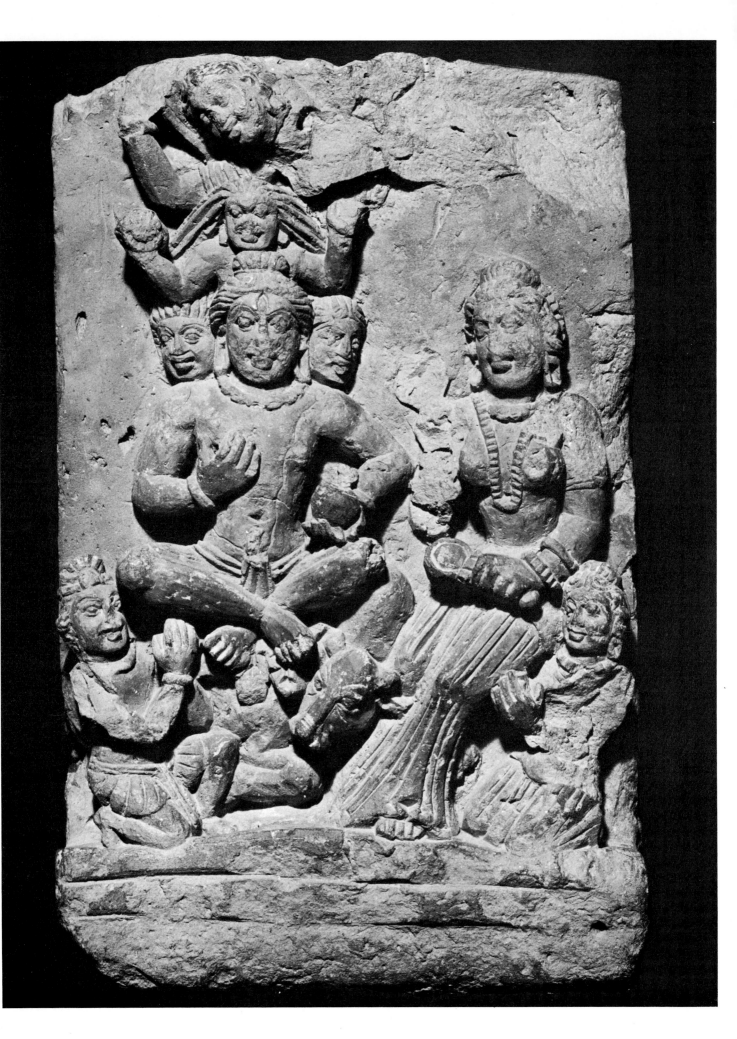

128 (*left*). Umā-Maheśvara, Rang Mahal, Gaṅgā
Golden Jubilee Museum, Bikaner.

129. Female figure, Badopal, Gaṅgā Golden Jubilee Museum,
Bikaner.

130. Fragment of Architectural Ornament, Rang Mahal, Gaṅgā Golden Jubilee Museum, Bikaner.

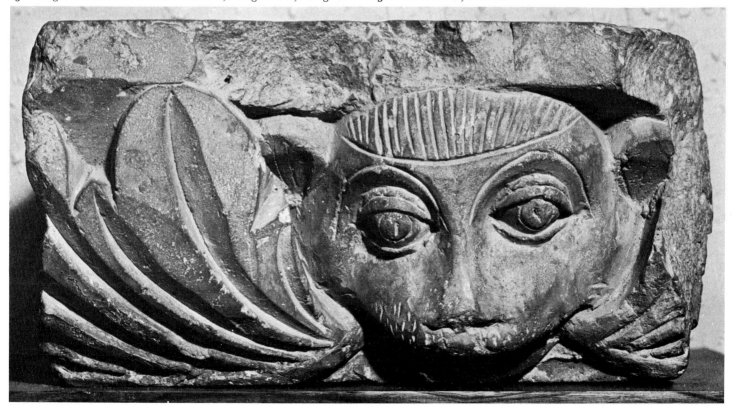

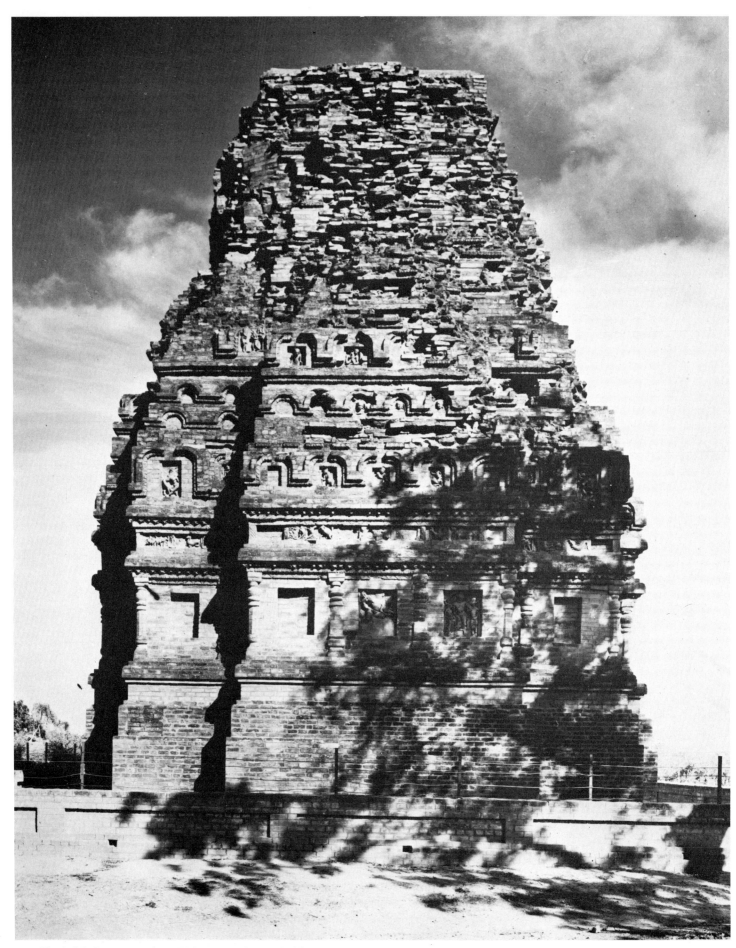

131. The brick Gupta temple at Bhitargaon, the north side.

132. Śiva and Pārvatī on Mt. Kailas, Bhitargaon temple.

133. Viṣṇu Aṣṭabhujī (eight-armed Viṣṇu), Bhitargaon temple.

134. The goddess Gaṅgā, Bhitargaon temple.

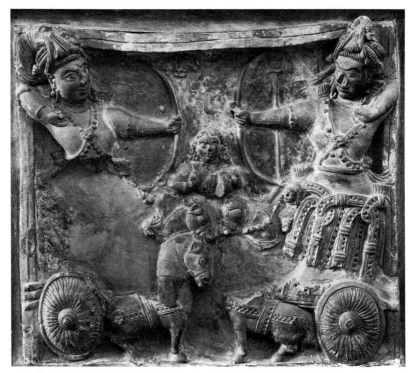

136. Two royal warriors in chariots, Ahichchhatrā, National Museum, New Delhi.

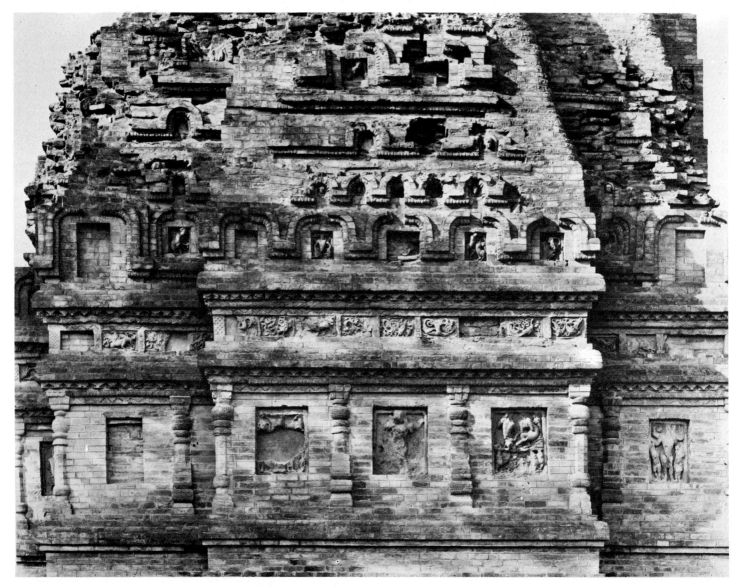

137. Śiva *gaṇas* destroying Dakṣa's Sacrifice, Ahichchhatrā, National Museum, New Delhi.

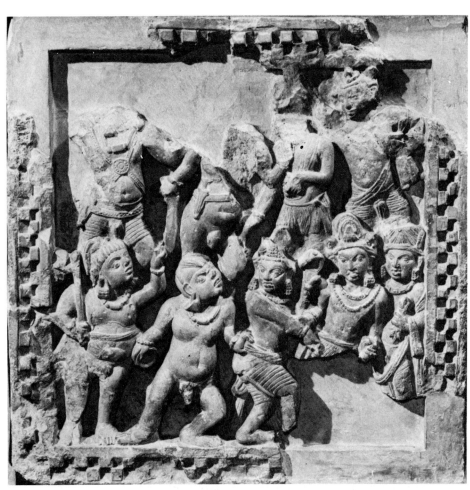

138. *Kinnara-mithuna*, Ahichchhatrā, National Museum, New Delhi.

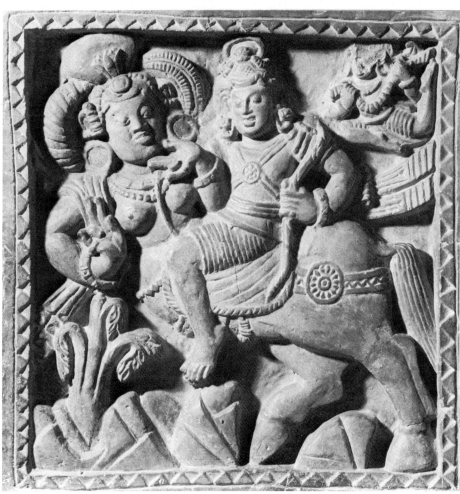

135. (*left*). Bhitargaon temple, the south side.

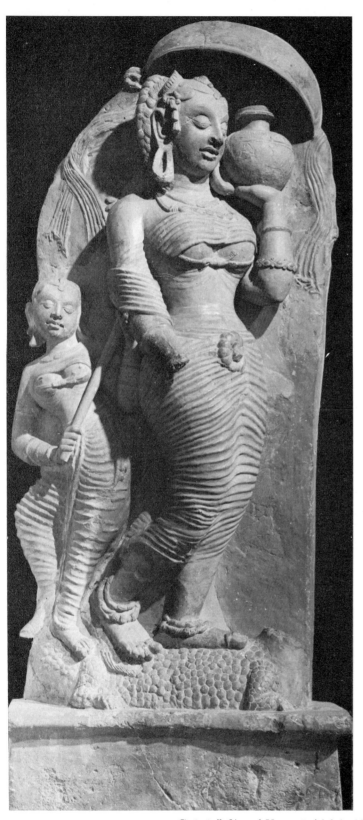 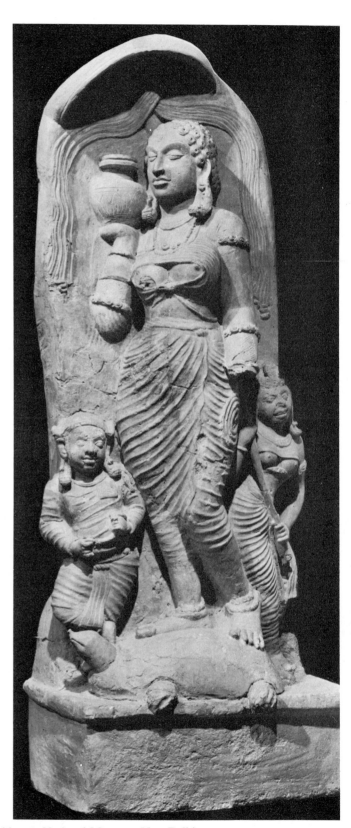

139. Gaṅgā (left) and Yamunā (right), Ahichchhatrā, National Museum, New Delhi.

140. Śiva as Dakṣinamūrti, Ahichchhatrā, National Museum, New Delhi.

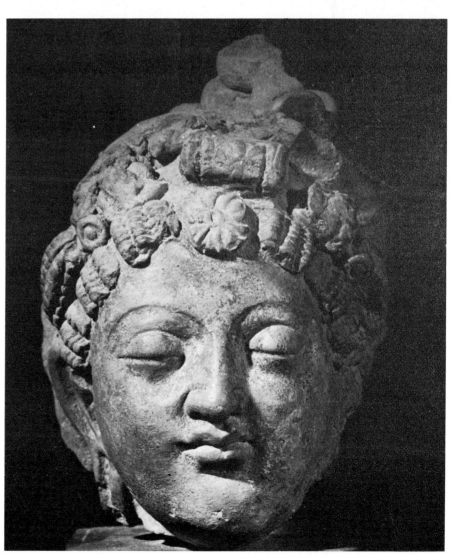

141. Feminine head, Akhnur, National Museum, New Delhi.

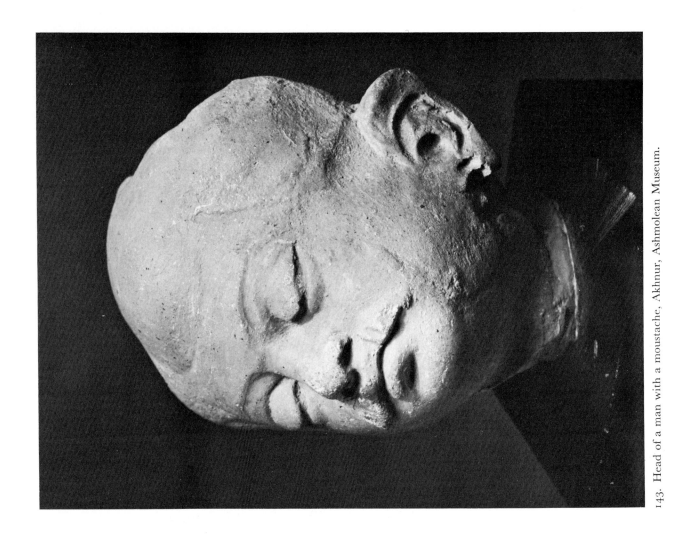

143. Head of a man with a moustache, Akhnur, Ashmolean Museum.

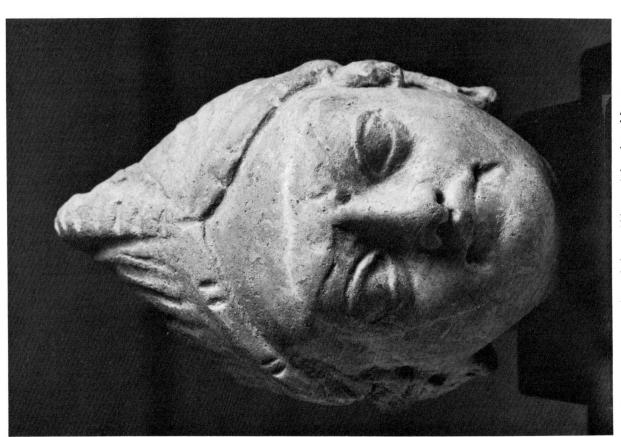

142. Head of a man wearing a helmet, Akhnur, Ashmolean Museum.

144. Large tile with 'ascetics', Harwan, H. A. N. Medd, Ashmolean Museum.

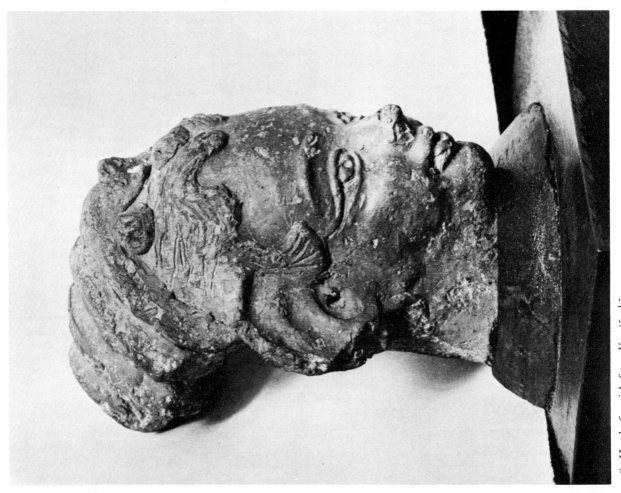

146. Head of a girl, from Kauśāmbī.

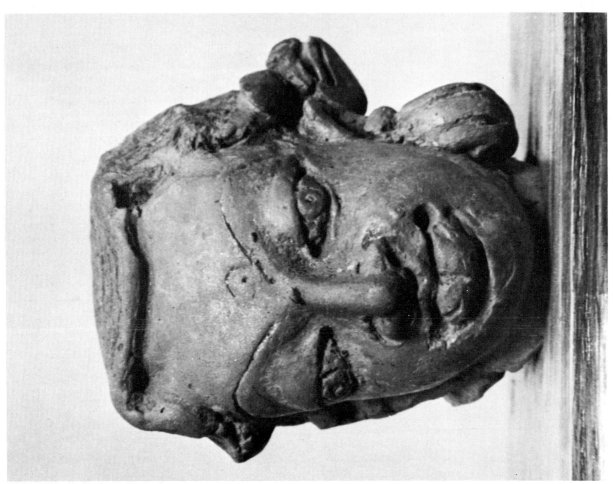

145. Head of a man, Allahabad Museum.

147. Girl seated by a tree, Bhind, National Museum, New Delhi.

148. Relief of a *makara*, North India, probably region of Mathurā, Ashmolean Museum.

149. Śaivite deity, from Saheṭh-Maheṭh, now State Museum, Lucknow.

Notes on the Plates

1. Map of Northern India showing principal Gupta sites.

2. Gupta Gold Coins.

A. S. Altekar, *The Coinage of the Gupta Empire*, Corpus of Indian Coins, vol. 4 (Varanasi, 1957).

(a) Candragupta I—'King and Queen type' (Ashmolean Museum, Oxford)
Obverse: Candragupta I and his queen, Kumāradevī—Legend: *Candra gupta*
Reverse: Goddess seated on a lion, perhaps Durgā—Legend: *Lichchavayaḥ*
Diameter: 20 mm.

(b) Kumāragupta—'Rhinoceros slayer type, (British Museum)
Obverse: The king, riding on a caparisoned horse, attacks a rhinoceros—Legend: (Bhartā?), Khadgatrātā Kumāragupta jayatyaniśam—Metrical.
Reverse: The goddess Gangā—Legend: *Śri Mahendra Khaḍga*.
Diameter: 18 mm.

(c) Kumāragupta—'Horseman type' (Ashmolean Museum, Oxford)
Obverse: The king with wig-like hair, rides a caparisoned horse—Legend: *Pṛthivītalaśvarendra Kumaragupta jaya*
Reverse: Seated goddess—Legend: *Ajitamahendra*
Diameter: 19 mm.

(d) Kumāragupta—'Kārttikeya type' (Ashmolean Museum, Oxford)
Obverse: Standing king with a peacock—Legend: *Jayati svaguṇairguṇa—Mahendrakumāraḥ*
Reverse: Kārttikeya riding on peacock—Legend: *Mahendrakumāraḥ*
Diameter: 19 mm.

3. General view of the Caves, Udayagiri (Vidiśā District), Madhya Pradesh.

Archaeological Survey of India, X. 46–56 and Pls. XVI–XIX (Cunningham). D. R. Patil, *The Monuments of Udayagiri Hill* (Gwalior, 1948).

Two miles west of Vidiśā (formerly Bhilsa), the Udayagiri hill—it is in fact two small low hills with a saddle between them—is one of a number of such sandstone outcroppings in the region, rising abruptly out of a fertile plain. It extends for about a mile and a half and is nowhere wider than a couple of hundred yards. It runs in a general direction from north-west to south-east and its greatest height, according to Cunningham, is 350 ft. The only cave in the southern portion is No. 1 'the false cave'. It is on the eastern side of the hill as are almost all the other caves; the exceptions, niches or panels rather than caves, are on the north face of a narrow defile cut through the northern portion of the hill. The stone, accurately noted by Cunningham, is a soft, white sandstone, in horizontal layers. The exposed surface easily turns black. Portions have been painted a reddish ochre at some time (this accounts for much of the sculpture appearing black in photographs).

4. Remains of an elaborately carved pillar in front of Cave 19—buff sandstone—Udayagiri (Vidiśā District)—early 5th century A.D.

These posts, like the doorway of Cave 19, show a stylistic advance over the ornamentation of the doorways of Caves 4 and 6. So does the female figure in the panel with her marked *déhanchement*. The vegetal scrollwork is more convoluted and more deeply cut.

5. Doorway to Cave 4—buff sandstone—Udayagiri (Vidiśā district)—*c*. A.D. 400.

Note the characteristic T-shape and the (almost obliterated) cornice moulding (*kapota*) with miniature *chaitya* arches in relief. None of the other characteristic elements of the developed Gupta shrine doorways are present here.

6. Doorway to Cave 6—buff sandstone—Udayagiri (Vidiśā District). An adjacent inscription records the gift of the cave, or at least some of the sculpture outside it, in Gupta 82/A.D. 402.

Pilasters flank each side of the doorway. Their bell capitals and the addorsed lions above them echo Mauryan columns, an archaizing tendency often noted in Gupta

work. Two goddesses are placed above, one on each side, standing on *makaras*. They are the immediate precursors, as yet indifferentiated, of the river-goddesses, Gaṅgā and Yamunā (see Pl. 139) who were henceforth almost invariably to occupy a place beside temple doorways. The trees under which they stand and which link them to the *śālabhañjikas* and other female figures of earlier Indian sculpture, are, on the other hand, clearly depicted as a mango (proper right) and an *aśoka* (left). The peculiar ornamentation of the lintel, with its inverted stepped pyramids terminating in human heads, is a characteristic feature of Gupta doorways in this region. Similar lintels can be seen in (or from) the ruins of the temple atop the Udayagiri hill and the Narasiṃha temple at Eran.

For the inscription, which is on the outside of the cave above Pls. 8 and 17, see Fleet, *Inscriptions of the Early Gupta Kings*, pp. 21–5; the gift was made by a *mahārāja*, presumably the local ruler, who was a feudatory of Candragupta II.

7. Doorway to Cave 19—buff sandstone—Udayagiri (Vidiśā District)—early 5th century A.D.

This doorway, like the remains of pillars in front of it (Pl. 4), represents a further development over the two doorways above (Pls. 5 and 6). Figures have taken their places at the foot of the doorway, and panels, many with *mithuna* figures, are placed all around it. The scene at the top represents the Churning of the Milk Ocean.

8. Relief of Viṣṇu on proper left of entrance to Cave 6—buff sandstone—Udayagiri (Vidiśā District)—for date see note to Pl. 6.

This is the perfect example of the early Gupta image of Viṣṇu in Mālwā and Central India, both iconographically and stylistically. Four-armed he stands in *samapāda*. The objects held in his front hands can no longer be discerned but the left hand undoubtedly held the conch. The lower hands are placed on the *cakra* (discus) and the club. These are personified, growing out of small figures, one male (*cakrapuruṣa*) and one female (*gadādevī*) which are called *āyudhapuruṣas*, and are typical of Gupta Vaiṣṇava images, particularly the early ones. The god wears the *kirīṭa mukuṭa* crown and a great floral wreath around his shoulders and reaching to his knees (*vanamāla*), both of which are attributes of Viṣṇu. From the heavy torque around his neck hangs a *śrīvatsa*, an ancient symbol probably dating back to pre-Buddhist times.

Noteworthy stylistic features are the quatrefoil pattern on the crown—with its central lion's head from whose mouth are draped strands of pearls—and particularly the way in which the ends of the cloth holding the crown behind the head are shown as great *bouffant* tufts. From them hang wide bands, much in evidence in Sassanian art, and originally derived from the ends of the Classical Greek diadem used to bind the hair of young male figures. The crinkly ends of the belt show the dainty side of early Gupta sculpture, in marked contrast to the massive bulk of the figure.

9. *Ekamukhaliṅgam* in Cave 4—buff sandstone—Udayagiri (Vidiśā District—*c.* A.D. 400.

Śiva is shown with a third eye and a *jaṭā* in the form of a top-knot, held by a ring, from which a few long strands, ending in curls, fall down on either side. The torque is a splendid representation of Gupta jewellery.

10. Standing Kārttikeya in Cave 3—buff sandstone—Udayagiri (Vidiśā District)—*c.* A.D. 400.

In the right hand, the god of war holds a massive spear. In his left, missing, a cock may be surmised (see Pl. 90). The face is in every way similar to that of the *ekamukhaliṅgam* in Cave 4 (Pl. 9) and the sculpture is probably by the same hand. The body corresponds exactly to the Viṣṇu outside Cave 6 (Pl. 8), with the same barrel chest and huge round shoulders. For similar representation of Kārttikeya, essentially an early and North-West Indian type, see Pl. 90 and Notes.

11. Doorkeeper (*dvārapāla*) outside Cave 6 (proper left)—buff sandstone—Udayagiri (Vidiśā District)—*c.* A.D. 400.

This, with his companion on the other side of the doorway, is the earliest to have survived of all the numberless doorkeeper-figures which guard the entrances to Hindu temples. Plastically, he is treated in the same way as the other large standing figures in or outside Caves 3 and 6, but with considerably more sensitivity. This is detectable in his pose, with its slight *déhanchement*, the treatment of the legs, and of the stomach. This is the first example of the elaborate early Gupta head-dresses, almost barbaric in their heaviness. The flatness of the top of the head, with its carefully waved hair, is similar to that of the rock-cut Śiva at Badoh-Paṭhārī (Pl. 28). This figure appears to have been wearing boots, or at least leggings, which would mark him as a

Yavana (etym. 'from Ionia', hence originally a Greek but later used to designate all foreigners) and indeed many *dvārapālas* are depicted as such, testifying to the employment of foreigners from the north-west as guards.

12. Boar (Varāha) incarnation of Viṣṇu—buff sandstone—'Cave' 5, Udayagiri (Vidiśa District)—early fifth century A.D.
Length of panel—6·705 m.
Height: —3·860 m.
Depth: —1·020 m.

For a detailed iconographic analysis of the rows of figures stretching out on each side of the Boar, see Debala Mitra, 'Varāha-cave of Udayagiri, an iconographic study', *Journal of the Asiatic Society*, vol. v (1963)

The Boar is shown stepping up on to a rock; his left foot is raised, the left knee bent to a right angle. The right leg is stretched stiff, with the foot at right angles to the other. His left arm is stiffly placed on his left knee. The torso is shown full-face, with the head turned sideways to the same plane. The Boar's left hand is on his hip. A very small Bhūdevī perches precariously on the lotus wreath beside the Boar's left shoulder, her feet propped on the top of a lotus creeper. The Boar is represented as a powerfully built man, with heavy legs. The most notable feature is the absence of a neck, the head giving the impression of being sunk between the shoulders. This is a feature of the Kuṣāṇa *varāhas* from Mathurā. Another small feminine figure stands on the Boar's proper right, holding the stem of a large lotus which curls up beside the Boar and terminates in a lotus medallion.

The boar wears a heavy torque and twin bracelets on his wrists, as well as a large flowered *vanamāla*. A *dhoti* falls to just below his knees; a pleated sash girdles his waist with the ends falling between the legs. A small section of the top of the *dhoti* is rolled over, one of the most ubiquitous minor traits of the Gupta style.

The quadruple rows of figures consist of sages (*ṛṣis*), demigods (*asuras*), and, on the top row left, Śiva, Brahmā, and Agni. On the proper right at the top, are two male musicians, one of them playing a lute-like instrument. Below, the waters are shown by wavy lines and at the bottom, lotus leaves and flowers. Two male figures (Ocean?) stand knee-deep in the water. They hold pots. A scarf is looped over their shoulders, and they wear a heavy torque, ear-rings and a turban with a huge central rosette.

13. Detail of Varāha panel.

A quite unique feature in India, the sides of the panel also bear reliefs. On the proper left, a flying (?) figure, with below, Gaṅgā and Yamunā on their respective vehicles, and Ocean. Where the goddesses stand, the waters, here shown by lines streaming downward, divide and then reunite below. The same figures, less well preserved, occur on the proper right, except that the river-goddesses are surmounted by the figure of a corpulent seated man and a group of female musicians and dancers (?). A flute and a lute-like instrument can be clearly discerned.

The water imagery and the portrayal of water by incised wavy lines are of Western Classical origin. An entire room with water indicated on the walls in a similar way has recently been excavated at Haḍḍa. In the light of this discovery, it is significant that the theme is carried over here onto the side walls. M. and S. Mostamindi, 'Nouvelles Fouilles à Haḍḍa (1966–67)', *Arts Asiatiques*, vol. xix (1969).

14 and 15. Details of Varāha panel.

Two large figures, on the proper right, are shown worshipping the Boar. The first is a serpent-king (Nāgarāja), wearing a turban and a torque, with a hood composed of serpents rising behind him. His hands are in *añjali*. Behind him and holding a lotus bud (*utpala*) on a long stalk in his right hand, with the left arm missing, is a large, much-damaged, kneeling figure of a man. He wears a rope-like necklace, one bracelet, and a plaited sacred thread. Little of the head remains, but a portion of the hair or wig, carefully arranged into lengthy sausage-curls, can be seen spread out on the shoulders at the back. Little remains of a third and much smaller standing figure also facing the Boar. He appears to have been male and to have worn a large disk, suspended by a necklace, on his chest. The larger human figure may well be the donor (there is a similar kneeling figure, with a smaller standing figure behind him, below the Viṣṇu Anantaśayana figure in the *défilé*—'Cave' 13), one of the local mahārajas mentioned in inscriptions at the caves, or conceivably, since this panel far outranks in size all the other sculptures, Candra-gupta II himself.

16. Durgā Mahiṣāsuramardinī—carved in the rock beside Cave 17—Udayagiri (Vidiśa District)—*c.* A.D. 400.

The goddess stands in full frontal pose with the buffalo rearing before her, one of her left arms pressing stiffly down upon its

back, in the pose established by the first small Durgā Mahiṣāsuramardinī images from Mathurā in the Kuṣāṇa period. She also wears multiple bracelets, an early feature. The only concessions to a later time are her striding pose, the left foot firmly placed on a higher part of the rock, as if climbing, and the knee correspondingly flexed. She has twelve arms. The front right hand is firmly placed on the animal's back, the next holds his tail, the next holds an arrow, the next holds the *śulā* with which the goddess is piercing the animal's haunch, the next holds a sword, and the last holds one end of a garland held above her head. The other end of the garland is held by her rear left hand. The only distinguishable emblems in her other left hands are the shield and the bow. A small attendant figure stood by her left foot.

17. Durgā Mahiṣāsuramardinī—carved in the rock outside Cave 6—Udayagiri (Vidiśā District—*c*. A.D. 400.

J. C. Harle, 'On a Disputed Element in the Iconography of Early Mahiṣāsuramardinī Images', *Ars Orientalis*, vol. viii (1970).

This splendid although unfortunately badly damaged image of the goddess shows her in a completely new pose from the one adopted in the previous figure, and which was to supersede it. Instead of rearing up, the buffalo is shown with his head pressed into the ground, with the goddess's foot proudly placed upon it. The same diagonal movement is maintained, but it is the haunches and hind legs which are raised.

For the emblems held in the goddess's hands, Cunningham (whose observations were made when the statue may have been better preserved) provides useful identification. Apart from those readily identifiable, he mentions a *cakra*, a bow, a portion of which may be faintly seen held by the goddess's third from left rear hand, and a club, a portion of which may possibly be discerned in a small cylindrical upcropping of rock near the goddess's left foot. The large funnel-shaped object on the proper left, with leaf (?) patterns, has not been identified. The object held above her head is almost certainly a lotus garland (see Harle), one of Durgā's traditional attributes being a garland for her head. The goddess wears a head-dress with panels of hair on either side done into snail-curls, in a way not unlike the head-dresses of some of the Besnagar Mātṛkās (Pl. 32).

18. Head of Viṣṇu—sandstone—Besnagar, now in Cleveland Museum (John L.

Severance Fund), No. 69.57—second half of fourth century A.D.

Ht.: 0·410 m.

This fine head is very similar in style as its find-place (*Indian Archaeology*) (1963–4), p. 89) would lead one to expect—to the Udayagiri cave sculpture, at least to the Viṣṇus outside Cave 6. The *mukuṭa* is very similar and it has the same characteristic tufts representing the ends of the band holding the crown. In fact, being in the round, the presence of the band can actually be confirmed. The treatment of these tufts, already striated and beginning to assume a triangular shape, leaves no doubt that this is indeed the origin of the fan-shaped pleated appendages beside the heads of so many later images, particularly those of Sūrya.

Most significant, however, is that the head shows distinct traces of the later Kuṣāṇa style in Mathurā, in the pursed mouth and the treatment of the eyes. This indicates an earlier date than most, at least, of the Udayagiri sculpture, and further creates a link between the treatment of the face in the late Kuṣāṇa style at Mathurā and sculpture in eastern Malwā in the 4th century A.D.

19. Side view of above.

20. Seated Jina—cream sandstone—Durjanpura, 5 km. from Besnagar—*c*. A.D. 370 (?).

Ht.: approx. 0·600 m.

R. C. Agrawala, 'Newly Discovered Sculpture from Vidiśā', *Journal of the Oriental Institute, MS. University of Baroda*, vol. xviii, No. 3 (1969). For the inscription—G. S. Gai, 'Three Inscriptions of Rāmagupta', ibid.; K. D. Bajpai, 'Fresh Light on the Problem of Rāmagupta', *Indian Historical Quarterly*, vol. xxxviii, No. 1, pp. 80–5.

The inscriptions of all three images vary only in the names of the donors. The title *mahārājādhirāja* applied to Rāmagupta goes far to prove that he was indeed one of the Imperial Guptas.

The figures, all severely damaged, were to all intents and purposes identical. The damaged and missing areas being different in each case, it is fortunately possible to obtain a fairly good idea of a complete figure.

At each end of the base, set in a panel, are small couchant lions with highly stylized tail-fronds, facing outwards. They are easily distinguishable from the outward-facing couchant lions in the earlier Kuṣāṇa sculptures from Mathurā or Kauśāmbī. In the later Kuṣāṇa Buddhas and Jinas from Mathurā the lions on the base face forward.

The general proportions of the bases are also different, wider and flatter than in the great majority of Kuṣāṇa ones. Both the lions and the proportion of the bases are in fact much closer to those in Mathurā images of the fifth century (see Pl. 45). Another relatively late feature is the *cakra*, seen end-on and without a pedestal, with swatches of cloth (?) falling on either side. Bases of similar type may be seen on the defaced and barely recognizable images, so far unpublished, in the Jaina cave at Udayagiri. The inscription in the cave, which would appear to have been carved after the images, bears the date A.D. 426 (Fleet, *Inscriptions of the Early Gupta Kings*, No. 61).

The style of the body is closer to the Gupta style at Mathurā than to the Kuṣāṇa. On the other hand, certain mannerisms place it closer to late Kuṣāṇa work, such as the squatness of the body and the resultant effect, combining with arms of exceptional length, of forcing the latter into a rather exaggerated akimbo position. For the first time, as far as is known, there appears on two of the images, indicated by a line, the clearly marked fold of flesh below the breasts.

The halo bears fairly elaborate decoration but the crispness of execution makes the decoration appear more ornate than it is. Several of the decorative features found on haloes of fifth-century figures and which are considered hall marks of Gupta Buddhas and Jinas are missing, such as the vegetal scrollwork with characteristic bias-cutting or the rope-like bands of pearls with small rosettes at widely spaced intervals. Yet the latter are already to be found in the seated Buddha image dated in the Year 36 (Pl. 43), presumably of late Kuṣāṇa date.

The subordinate figures stand approximately level with the base, in contrast to those in both Kuṣāṇa seated Buddha and Jina stelai, where such figures stand lower than the base, and the Gupta ones, where they are raised higher. The faces, with their large eyes and their general plastic feeling, are of the Gupta style.

21. The site—Eran, Korwai Taluk, Sāgar District, Madhya Pradesh, looking west.
Archaeological Survey of India, vols. vii and x (Cunningham). K. D. Bajpai, 'Fresh Light on the Problems of Rāmagupta', *Indian Historical Quarterly*, vol. xxxviii, No. 1, pp. 80–5.

Eran is about 50 miles north-east of Vidiśā, the nearest town on a motorable road being Khurwai, some 8–10 miles to the west. Eran (pronounced locally 'Iran', with a very strong stress on the first syllable) was called Airikiṇa in ancient times. The stone used for buildings and sculpture is a red-tinted sandstone ranging in colour from light pink to black, the latter doubtless through oxidation.

The fairly detailed description of the site and its remains by Cunningham is valuable in spite of frequent discrepancies between his plan and his text. It provides information on the pristine state of the site as well as the information that the little shrines, which all faced east, are oriented, as he claims to have found in the case of other Gupta shrines, 14° north of east. His testimony is also valuable regarding the original siting of the Nara-siṃha image and the find-place of the Varāha image now removed to the Sāgar Museum. In spite of a drastic tidying up, the main elements of the site are as they were in Cunningham's day, except that no walls whatever remain standing in any but the little temple at the northern end (largely destroyed by the tree). The platform at the right in the picture is simply a montage of architectural fragments, mostly medieval, amalgamated into a platform.

22. Site plan—*Archaeological Survey of India*, vol. x Pl. xxv (Cunningham).

There is no example elsewhere of a twin-celled shrine such as Cunningham shows as C–D. Except for B and possibly part of E, little more than the foundation or one course of stones remains in Cunningham's day as can be seen from the photograph which follows the plate (Pl. XXVI). His plan must consequently be taken with caution.

23. Capital and surmounting figures, with wheel, of Budhagupta pillar—pink sandstone—Eran—dated A.D. 485—'about 5 ft. high' (Cunningham).
Inscription: Fleet, *Inscriptions of the Early Gupta Kings*, pp. 88–90.

This is one of the few dated monuments of the fifth century ('in the year 165, Budhagupta being king'), and the only dated pillar. It was erected by a local king, Mahārāja Mātṛviṣṇu and his younger brother Dhanyaviṣṇu. The latter was to erect the temple of the great theriomorphic Boar at a somewhat later date, his older brother then being dead and the Hun Toramāṇa having become the sovereign lord.

The addorsed lions atop the abacus of the column are a typical Gupta motif, but the provincial character of most of the Eran motifs is nowhere more apparent than in these impressive but completely misunderstood animal figures. Addorsed figures with

a surmounting *cakra* are not unknown in the fourth and fifth centuries (cf. the image from Pawāya in the Gwalior Museum—Pl. 34) but the actual identity of the identical pair here depicted back-to-back is not immediately clear. The inscription refers to the pillar as a flagstaff (*dhvajastambha*) of Janārdana. This last is a name of Viṣṇu, but the iconographic texts do not refer to any specific images of the god under this name. These figures, who hold serpents, have recently been identified, and no doubt correctly, as Garuḍa, the bird vehicle of Viṣṇu (Joanna Williams, "The Sculpture of Mandasor", *Archives of Asian Art*, xxvi, 1972–3, p. 52).

The style is clumsy and a trifle bizarre, particularly in the schematic treatment of the main features of the face, so that it is at first difficult to place in the Gupta period at all. None the less, the wig-like curls in which the hair is dressed, however idiosyncratically treated are a Gupta or immediately post-Gupta trait, and so are the rosettes on the armlets.

One has only to compare these statues with others of the Eran group, and particularly the anthropomorphic Boar (Pl. 26), to notice essential similarities of style, a style which, in the aggregate, can be seen to be a very provincial and occasionally archaizing variant of the metropolitan Gupta style. For instance, the means used to depict the faces of the pillar figures are very similar to those used to delineate the eyes of both Boars.

24. Viṣṇu in his Boar incarnation (theriomorphic version)—pinkish sandstone—'in the first year of Toramāṇa'—Eran

3·450 × 1·565 × 4·000 m.

Inscription—Fleet, *Inscriptions of the Early Gupta Kings*, pp. 158–61.

Fleet already mentions several serious cracks in the Boar (Fleet, p. 159). The inscription, of eight lines, is in front at the bend between the neck and the chest. It records the building of the temple of Nārāyaṇa (Viṣṇu) in the form of a boar in Airikiṇa by Dhanyaviṣṇu, the younger brother of the Mahārāja Mātrviṣṇu, now dead, in the year 1 of Mahārājādhirāja Toramāṇa. These are the two brothers who, in the reign of Budhagupta, had set up the great pillar on the site.

This figure is both the largest and the earliest example of the fully theriomorphic images of Viṣṇu as the Boar. This rather strange conception to Western eyes, with the animal's body almost entirely covered with miniature figures, principally of *ṛṣis*, or sages, was extremely popular in India from the sixth century onwards, and examples abound, including another very large figure at Khajuraho. No convincing explanation has so far been given for the stump over the boar's shoulders (Fleet called it a small four-sided shrine) and it tends to disappear in later periods. The name for this form of the Boar incarnation has been variously given as Ādivarāha and Yajñavarāha.

The body of the boar is covered with row on row of sages, clinging, so says a traditional text, to its mane and bristles. These small standing figures, cut off at the knees, vary little, if at all, with their hair done in large bun-like top-knots, their short pleated *dhotis*, and their right hands in *abhaya* while their left hold elongated water-jars. In order to swell their numbers, heads and necks without torsos are occasionally inserted between them. Some appear to be bearded.

The Boar's ears, eyes, and mouth are all highly schematized; the eyes are highly expressive none the less. The mouth is a perfectly regular slit, with square edges where the snout ends. Upon the protruding tip of the boar's tongue stands a small female figure, carved in relief upon the end of the snout. Within the flat portion inside each ear, a small figure holding a garland is depicted in the conventional 'flying' posture.

Carved on the base, between the legs of the Boar, are the coils of a great serpent and two *nāginīs* (female serpent-goddesses). The remains of two kneeling human figures are also visible. A thick wavy stalk winds up on the outside of the boar's left leg and passes behind his left ear. A sacred thread appears to run up beside the stalk. Seated figures, all male and rather corpulent, are carved on the four sides of the stump above the boar's neck. These in the south and north side have three faces (Brahmā?) and the former sits above an open *tāla* leaf.

The Boar's collar is also richly decorated, bearing large circles, between borders consisting of rows of typical Gupta rosettes. Within the circles are placed male and female figures seated in *padmāsana* (and one scorpion). The men wear typical Gupta 'wigs' and the women's hair is dressed in a characteristic fashion with a central peak or spur. Three or four seated figures appear to have one leg drawn up (*mahārājalīlāsana*).

25. Standing Narasiṃha—pinkish sandstone—Eran—early or mid-fifth century A.D.

Ht.: 1·300 cm.

Now in the centre of the compound, facing east, but originally installed in the ruined temple in the north-west corner of the site (E on Cunningham site plan) where

Cunningham first saw it, already broken off 'at the ankles'. The feet, measuring 37 cm, as well as those of two attendant figures, can still be seen on the base slab which remains in the sanctuary.

The statue is badly damaged, with both arms missing, and it is at present cemented into the ground at mid-thigh, yet it remains an impressive sculpture, particularly seen in profile. It is a considerable advance on the earliest free-standing image of Viṣṇu in the man–lion incarnation to have survived (now in the Gwalior Museum), and probably belongs to the same period as the other sculptures. The mouth is oddly squared off, in a manner reminiscent of the treatment of the snout of the great theriomorphic Boar. Otherwise it would appear to be earlier than the other sculptures found at the site, showing much closer affinities to the sculpture at Udayagiri and certain pieces from Sāñcī. Notably similar (cf. Pl. 40) are the treatment of the waist-band and the discreet but unmistakeable suggestion of the sexual organs as well as the excessively wide shoulders, although the transition from chest to bust is more smoothly executed, which suggests a later date, as does the narrowness of the hips.

26. Standing Viṣṇu as the Boar (anthropomorphic form)—sandstone—Eran, now in Sāgar University Museum—end of fifth, beginning of sixth century A.D.

Ht.: 1·860 m.

Archaeological Survey of India, vol. x, pp. 87–8 (Cunningham).

Inscribed: 'Sri Maheswara-dattasya Varaha-dattasyạ' (*sic*) in 'Gupta characters' (Cunningham).

Removed from the Budhagupta site early in the nineteenth century to a house in the village (Cunningham). This image is remarkable for its splendid condition as well as for the sense of exultant power which it conveys. The extraordinary realism which shows the Boar as a very corpulent as well as powerful man (note particularly the thickness of the arms and waist and the way in which the flesh on the inside of the left arm dimples) is in direct contrast to the bold schematization of legs and particularly hands and feet. This is not only one of the finest of all Indian sculptures but also one of the most original.

The way in which the sash-ends form a powerful cone-like unit at the base is unique and so is the position of the Bhūdevī standing on what appears to be a little sling attached to the *vanamāla*. The little lotus rosette on the back of the Boar's head can occasionally be seen elsewhere (e.g. Varāha

in vestibule of Brahmanical cave, Aihole, where it has become a sort of lotus crown).

27. The Seven Mothers (Sapta Mātṛkās) and Vīrabhadra, a form of Śiva—sandstone—Badoh-Paṭhārī, Vidiśā District, Madhya Pradesh—first half fifth century A.D.

Inscription published in Gwalior Archaeological Department Report (Samvat, 1982), p. 12.

28. Vīrabhadra, a form of Śiva—sandstone—Badoh-Paṭhārī, Vidiśā District, Madhya Pradesh—first half fifth century A.D.

The seated male figure is ithyphallic, an early feature. He wears a sacred thread (*yajñopavīta*). This is one of the best representations, and perhaps the earliest, of the periwig-type of hair-style so characteristic of the Gupta period.

29. Cāmuṇḍā—sandstone—Badoh-Paṭhārī, Vidiśā District, Madhya Pradesh—first half of fifth century A.D.

Although very badly damaged, the extreme emaciation of the goddess can still be clearly seen, particularly in the way the three sinews in the neck stand out. Her head-dress is unlike that of any of the other figures and appears to spread out behind her and carry down below her shoulders. Also, unlike the other figures, she has an emblem (the *kapāla* or skull bowl?) between her legs.

30. Unidentified Mātṛkā—sandstone—Badoh-Paṭhārī, Vidiśā District, Madhya Pradesh—first half fifth century A.D.

Most of these figures wear *cholis* of two distinct types. In one, seen here, a swatch of material stretches across under the breasts, unbroken from shoulder to shoulder. The other takes the form of a little sleeveless waistcoat, cut up to a point between the breasts. The hair-styles are more varied but in several the hair is spread out on to each temple, showing clear comb-lines and brought back in a very stylish spit-curl. This figure wears large disk-like ear-rings with a central dividing-line, of a type usually not seen on such archaic-appearing figures, and holds a lance or a staff; if the former, she can perhaps be identified as Kaumārī. A serried row of bangles adorns her forearm, an early form of ornament. The legs of most of these figures are disproportionately short.

31. Mātṛkā—light brown sandstone—Besnagar, now National Museum, New Delhi, No. 51.101—first half of fifth century A.D.

Ht. approx. 1·250 m.

D. R. Patil. 'Sapta Mātṛkās from Besnagar', *Proceedings of the Indian History Congress*, 1949, Cuttack; R. C. Agrawala, 'Mātṛkā Reliefs

in Early Indian Art', *East and West*, N.S. vol. 21, Nos. 1–2 (March–June 1971).

These figures are carved entirely in the round. The thrones have platforms projecting forward upon which the feet rest. Six more figures are in the Archaeological Museum, Gwalior, but there appears, unaccountably, to be another fragment, a bust, in the Vidiśā Museum. Two rare photographs, front and rear views, showing the group together, less the Vidiśā figure, are reproduced in Agrawala, Figs. 19–20.

Although one figure retains an arm, this is by far the best-preserved of the Mātṛkās. In two other figures, the remains of children can be seen. One figure sits in *sukhāsana*, with one leg drawn up on the throne beside her; the others sit in European fashion (*pralambapāda*), their knees either drawn together or wide apart. Two figures, including this one, wear a curious bodice consisting of a fairly narrow one-piece band leaving both the tops and the bottoms of the breasts exposed. A somewhat similar garment is worn by some of the Badoh Mātṛkās.

32. Three Mātṛkās—light brown sandstone—Besnagar, now Archaeological Museum, Gwalior—first half of fifth century A.D.

Hts. vary between 1·200 m and 1·300 m.

These Mātṛkās, and a number of other sculptures in the Museum are listed in S. R. Takhore, *Catalogue of Sculpture in the Archaeological Museum, Gwalior*, by numbers according to the rooms in which they are located.

The figures wear a variety of fairly simple necklaces or torques, an armlet can be seen on the remains of one arm, and rather narrow single anklets in the cases where the legs and feet remain. Four of the figures wear divided-circle ear-rings. A scarf (?) appears to have been stretched across the laps of all the figures but only the ends, lying on the tops of the thrones, can still be seen.

The most distinctive feature of these figures is the way in which the hair is dressed, in no two cases alike. Some of the styles recall those of Badoh Mātṛkās, in particular the ones with flat curls on either side of the forehead or with a large round boss on top of the head. Other coiffures, with the hair done in little round curls, resemble that of the Durgā outside Cave 6 at Udayagiri. One style of hair appears to be unique in the region: the head covered with sausage-curls or deep waves running parallel back from the face. There are resemblances to a characteristic Gupta male head-dress, the Gupta 'wig', but it is more

likely to have a Gandhāran and ultimately Western Classical origin.

33. Standing Viṣṇu—greyish sandstone—Besnagar (?), now Archaeological Museum, Gwalior—second quarter of fifth century A.D.

Ht.: 0·960 m.

Illustrated in C. Śivaramamurti, 'Geographical and Chronological Factors in Indian Iconography', *Ancient India*, No. 6 (1950), Pl. XVIIID, who gives the find-place as Udayagiri.

Broken just above navel and at shins. Wore a thick *vanamāla* of which only a section remains. Originally four arms, of which only the rear left, holding a unique octagonal lion-headed *gadā* at ear-level, remains. The face is intact, except for the nose. The Viṣṇu crown (*kirīṭa mukuṭa*) has a quatrefoil decorated ground and side-flanges; the crinkled ends of the band holding the crown fast at the back are clearly seen on either side, with the vestigial diadem-ends hung over them. The torque, furthermore, has a pendant *śrīvatsa*, and crinkled ends to the belt, all roughly similar to the standing Viṣṇu outside Cave 6 at Udayagiri. One of the ear-rings, however, is of the divided-circle type, and the treatment of the face is softer.

34. Figure from atop a pillar—cream sandstone—Pawāya, now in the Archaeological Museum, Gwalior—fourth century A.D.

Stella Kramrisch, *Indian Sculpture*, Pl. 45; P. K. Agrawala, 'A Note on the so-called Sūryā statue from Pawāya', *Bulletin of Ancient Indian History and Archaeology*, No. 11 (1968).

Identified as a Bodhisattva by Kramrisch, but the presence of the spoked disk (*cakra*) makes it more likely to be a deity with solar connections, Sūrya or Viṣṇu. The figure is broken off at the knees and the halo is broken into two pieces. The addorsed figure has both hands on its belt and has been identified by Agrawala as the *cakravartin* (World Emperor) form of Viṣṇu.

35. Fan-palm (*tāla*) capital—white sandstone—Pawāya, now in Archaeological Museum, Gwalior—fourth or fifth century A.D.

Ht.: 1·600 m.

Archaeological Survey of India, Annual Report (1914–15), Pt. 1, p. 21 and Pl. XVI. *Archaeological Survey of India*, Annual Report (1915–16), p. 107.

Top broken, also head of lion and other parts. A lion, seen here from rear, is seated

(?) on a lower leaf. The fan-palm is the symbol of Saṃkarṣaṇa.

36. Lion capital—sandstone—Udayagiri, now in Archaeological Museum, Gwalior—third or second century B.C.

Ht.: 2·800 m.

Joanna Williams, "A Recut Aśokan Capital and the Gupta Attitude Towards the Past", *Artibus Asiae*, xxxv, 3, 1973, pp. 225–240.

It is debatable whether or not this is the capital which belonged to the pillar which still remains on top of the Udayagiri hill.

37. Abacus of lion capital—recut.

The various figures symbolizing the zodiacal houses are separated by large, evenly spaced, raised circles or balls within which are shown, in relief, seated male figures. Three superimposed balls in relief, an otherwise unknown motif in India, are placed on the proper right of each circle. There is a blank space and one badly damaged, large circle and set of balls. The figures sit in European fashion on bench-like thrones, with their knees wide apart. They are two-armed and several hold a pot in the left hand, and one a rosary, which rests on or near the left thigh. The right hand is raised to shoulder-height and appears to hold a *chowry* (or a lotus). Pleated drawers are indicated on several of the figures. Several are bearded and they wear a great variety of head-dresses, including a flat Viṣṇu-type crown, a lobed crown, and hair dressed in wig-like Gupta style. They have been thought to represent the planets or *grahas* (C. Sivaramamurti, *Royal Conquests and Cultural Migrations in South India and the Deccan*, Calcutta, 1955); these, however, are only nine in number. Professor Williams is probably correct in identifying them as the twelve Ādityas, sons of Aditi.

The figures representing the Signs of the Zodiac are on the proper left of the large circles, in the accepted order. They are all standing figures (including one pair, for Gemini). They are depicted thus:

Aries	—*Ram-headed man.*
Taurus	—Bull-headed man.
Gemini	—Couple, man and woman, a typical Indian *mithuna*.
Cancer	—Crab-headed man.
Leo	—Lion-headed man.
Virgo Libra Scorpio	} on missing face.
Sagittarius	—Man with a bow standing beside him.

Capricorn —*Makara*-headed man.
Aquarius —Man with a jar.
Pisces —*Fish-headed man.*
(Full italics indicate badly damaged figures.)

38. Seated Buddha stele—sandstone—Eastern side of *Stūpa* I (great *Stūpa*), inside *vedikā*—Sāñcī—prior to A.D. 450–1.

Ht.: 1·625 m.

For all four stelai, see J. Marshall and A. Foucher, *The Monuments of Sanchi*, Pl. LXX and pp. 38–9, and 250–1.

The Buddha is shown seated in *dhyāna-mudrā* where one hand is placed flat above the other (both hands missing), a position of self-absorbed contemplation as indicated by the almost closed eyes of the Buddha. The pleats in the robe (*saṃghāṭi*) covering the upper parts of Śākyamuni's body are symmetrically draped along the centre line of the body. Images with the *saṃghāṭi* shown draped in this way differ fundamentally from those of Gandhāra, where the Buddha's robe is invariably shown draped in an asymmetrical way, from a point at the left shoulder.

The superb vegetal scrollwork in the Buddha's halo, with its characteristic bias-cutting, identifies these Buddhas as works of the Gupta period. Local idiosyncrasies, however, distinguish the halo from those of both Sārnāth and Mathurā (Pls. 67 and 47). The draperies of the two flying figures end in crumpled tab-ends, as do those of the Udayagiri figures, a Gupta hallmark. The way in which they fly upward, however, pre-figures one of the characteristics of later Gupta as well as some post-Gupta figures.

Marshall suggests that the Buddhas represent the four Dhyani Buddhas. There seems little doubt that these are the figures referred to in the inscription (Marshall and Foucher, *The Monuments of Sanchi*, No. 834; Fleet, *Inscriptions of the Early Gupta Kings*, pp. 260–2 and Pl. XXXVIIIB) inscribed on a cross-bar of the *vedikā* near the eastern entrance. It refers to *caturbuddhasya asane*. The seated Buddha illustrated by Codrington (Codrington, *Ancient India*, Pl. 34C). and said to be one of the four Buddhas referred to in the inscription, does not belong to this set.

Marshall maintained that the statue at the southern position was the finest in style and workmanship, and closely related to some reliefs at Udayagiri. He claims that the stone is the same.

Of the two attendant figures, both with their heads irretrievably damaged, the one on the proper left probably wore a cylindrical crown of a type frequently worn by Indra. The position, moreover, is frequently occupied by this god. The fact that he holds a *vajra*, the weapon of Indra, is corroborative evidence, but the *vajra* alone, by this period, could indicate the Bodhisattva Vajrapāṇi.

The pillow, rather than a throne, is a Central Indian innovation. In other respects, even to the poses of the attendant figures, these stelai are derivations of the Katra-type seated Buddha evolved at Mathurā in the Kuṣāṇa period. Only the central figure, the Buddha, belongs to a quite different tradition.

39. Attendant figure of seated Buddha stele—South side of *Stūpa* I (great *Stūpa*), inside *vedikā*—Sāñcī—prior to A.D. 450–1.

The other three stelai, in all of which the Buddha's head is missing, conform in general to the type described above. Of particular interest is the stele on the southern side where the heads of the attendant figures are largely intact and provide a clue to the probable identity of those beside the Buddha of the eastern side. The one on the left, pictured here, wears the type of crown usually worn by Viṣṇu at this time, which leaves no doubt that he is meant to represent Indra. What remains of the face is highly reminiscent of the Viṣṇu head from Besnagar (Pl. 18), which tends to confirm a date for these Buddhas in the first half and possibly first quarter of the fifth century A.D. His companion wears a *jaṭā* and consequently, as expected, represents Brahmā.

40. Nāga King—pinkish sandstone—Sāñcī Museum, No. 2858, formerly A102—First or second quarter of fifth century A.D.

Ht.: approx. 2·000 m.

M. H. Hamid, R. C. Kak, R. Chanda, *Catalogue of the Museum of Archaeology at Sanchi, Bhopal State* (Calcutta, 1922).

This and another generally similar, but more badly damaged, Nāgarāja figure (No. 2859—formerly A103) are roughly equivalent, in the Buddhist idiom, to the standing figures, such as the Kārttikeya, in the Udayagiri caves. They stand similarly stiff-legged (*samapāda*) and have the same barrel chests, tight treatment of the thighs, and crinkled belt-ends. There is a meanness and a lack of vitality in these figures, however, in very marked contrast to their Hindu counterparts and they are probably later, by a quarter- or even a half-century. The

heavy torque already shows the type of decoration which is to distinguish later Gupta work.

The Nāga king wears a crown with three high circular lobes, the central of which bears a lion's head (*kīrti-mukha*) from whose mouth festoons of pearls are draped. In his left hand he holds a lotus and in the right the water-jar, the latter a conventional attribute of such figures. The scarf (*uttarīya*) worn off the shoulder is a carry-over from the Kuṣāṇa into the Gupta period. These figures are very flat, an obviously archaic trait.

41. Vajrapāṇi—cream-coloured sandstone —Sāñcī Museum, No. 2720, formerly A99— *c.* A.D. 450.

Ht.: 1·550 m.

This fragment, broken off at the knees and with both arms missing, is a far finer work than either of the Nāgarājas from the same site. Marshall believed it to be the crowning figure of a Gupta pillar which stood by the north entrance to *Stūpa* I. The pose shows a graceful *déhanchement*, with the weight on the left foot. A thick swatch of cloth across the loins, tied in a huge knot, with the right hand resting near it, gives it an added air of elegance. This is a common feature of Gupta images, and is also seen in figures from Mathurā in the Kuṣāṇa period. This statue is almost fully in the round, with a thick powerful body. The hips, however, are relatively slender, and covered by pleated drawers, a relatively late feature. A smile can still be seen on the damaged face, which is large and round with slightly prominent eyes reminiscent of the seated Buddha on the east side of the great *Stūpa*. There is no halo, but a *prabhāvalli* of the pleated-fan type, into which holes have been drilled, presumably for the addition of a metal halo. The hair at the back is plainly indicated.

Although the right arm is missing, the *vajra* held by the right hand at the waist can still be seen, and the figure thus identified. A curious feature in such a finely finished figure, for the torso still shows a fine polish, is the crude way in which the stone has been scored to show the pleated drawers.

A pair of standing Bodhisattvas (Nos. 2857 and 2848), showing opposite *contraposto* of the body and almost certainly originally the attendant figures on either side of some very large seated Buddha, are very similar to the fragment described above and to all intents and purposes intact. Unfortunately, they are works of inferior inspiration, heavy and flaccid in a way

strongly reminiscent of some Ajantā sculpture. An interesting feature is the elliptical or oval shape of the *prabhāvallī*, like those on the vanished doorkeepers outside Cave 3 at Udayagiri.

MATHURĀ

42. Image of a seated Tīrthaṅkara—red sandstone—Mathurā (Kaṅkālī Ṭīlā)—dated in the year 31—State Museum, Lucknow, No. J36.

<div align="right">0·56 × 0·32 m.</div>

The arms are exaggeratedly akimbo, so that the inside angle at the elbows is 90° or less. This is a characteristic feature of these images, and is due to exaggeratedly long arms, which is canonically correct. The awkwardness of the body should not blind one to the fact that the stone-cutter is thinking in terms of a totally different aesthetic from the characteristic Kuṣāṇa one, and one which approaches quite closely to the Gupta one. This is particularly evident in the face. The halo is already quite elaborately decorated but it is the difference in aesthetic rather than particular details which make it well nigh impossible for these statues to be coeval with those made in the reign of Huviṣka (with dates ranging between the Year 26 and the Year 60 but indisputably referring to the Kaniṣka era). The date must refer to another datum a century or so later. For the first statement of this theory, J. E. van Lohuizen-de Leeuw, *The 'Scythian' Period*, and, for a later evaluation, J. M. Rosenfield, *The Dynastic Arts of the Kuṣāṇas*, pp. 105–6.

43. Seated Buddha—sandstone—find-place unknown, now National Museum, New Delhi—dated 'in the 36th Year', probably mid-third century A.D.

<div align="right">Ht.: 0·275 m.</div>

Journal of the Bihar Research Society, xxxvi, p. 52; xxxviii, p. 230–2; *Indian Archaeology* (1957–8), p. 75, Pl. XCI c.

Inscribed 'Yaśaga rejhano'—note the size of the snail-curls and *urṇa*, and the over-large halo. The figures on the base and the forward-facing lions, as those of Jina images bearing similar dates, are almost unbelievably crude.

44. Seated Buddha—buff sandstone, polished in places and coloured—Bodhgaya, now Indian Museum, Calcutta, No. Bl Cri—dated in the Year 64 of a Mahārāja Trikamala.

<div align="right">Ht.: 1·200 m.</div>

Rajendralal Mitra, *Buddha Gaya* (Calcutta, 1878). A. Cunningham, *Mahābodhi* (London 1892).

This famous sculpture is badly flaked, most of the colour gone, but it is possible to state conclusively that the robe was red. The halo has all but vanished. All that can be said about the small remaining portion is that rays of a lotus medallion are indicated, with a fairly wide border. There are no marks on the soles of the feet. The eyebrows are not raised and the eyes do not have the curious delineation of the tear-ducts at the corners which characterizes many Buddha heads from Mathurā in the Gupta period. The underlip is very full, and there are three folds of skin indicated on the neck.

An interesting feature which has not previously been remarked is that what remains of the hand laid upon the left knee had bindings or lashings (or perhaps. alternatively, the folds of the *saṃghāṭi*) reaching to the knuckles, upon which an object seems to have been placed.

An early Gupta date (i.e. A.D. 320 + 64 = A.D. 384) seems quite acceptable. The pose, with the left hand clenched on the knee, and the *saṃghāṭi* draped over the left shoulder in clearly defined folds, leaving part of the torso uncovered, is that of the Kaṭrā-type Buddhas from Mathurā in the Kuṣāṇa period. So is the exuberant vitality exuded by the pose, the powerful chest, and large navel. The head, however, is in the Gupta style.

45. Image of a seated Tīrthaṅkara—red sandstone—Mathurā, now State Museum, Lucknow, No. J36, dated in the Year 113 of Kumāragupta (A.D. 432–3).

<div align="right">0·927 × 0·700 m.</div>

Unfortunately head and halo are missing. None the less this is a key image. The wide hips and fat appearance of the legs, in contrast with the relatively narrow shoulders and chest, give the figure an epicene appearance in contrast to the powerful masculinity of seated Kuṣāṇa images.

46. Seated Tīrthaṅkara—red sandstone—Mathurā now State Museum, Lucknow, No. J.118—mid-fifth century A.D.

<div align="right">0·951 × 0·596 m.</div>

One of the few intact Gupta images from Mathurā. Although the face shows the hard formalization which seems to have become prevalent at Mathurā in the fifth century, it is a noble stele. The various portions are rhythmically related, the decoration elaborate but still vigorous. The figure is itself one of the triumphs of the Gupta aesthetic of the human body. The *śrīvatsa* on the Jina's chest, a common feature, is incorrectly drawn.

47. Standing Buddha—red sandstone—Mathurā Museum, No. A5—first half of fifth century A.D.

Ht.: 2·140 m.

48. Standing Buddha—red sandstone—Mathurā, now Rashtrapati Bhavan, formerly Indian Museum, Calcutta—mid-fifth century A.D.

Ht.: 1·800 m.

49. Standing Viṣṇu—red sandstone—Mathurā (Kaṭrā-keśavdeva), now National Museum, New Delhi, SR242—fifth century A.D.

1·020 × 0·660 m.

The figure originally had a large, apparently plain *prabhāvalli*. Note the *vanamāla*, the great garland passed over the shoulder and reaching nearly to the ankles, which is characteristic of Viṣṇu. So is the extremely long sacred thread, here shown for the first time with fastenings, etc. Pleated and fairly short lower garments of this type are the usual wear of male figures in Gupta-style sculpture of the fifth century, and in the post-Gupta period.

50. Head of Śiva, from an *ekamukhaliṅgam*—spotted red sandstone—Mathurā, now Ashmolean Museum, Oxford (Dept. of Eastern Art, No. OS.38d)—*c.* A.D. 400.

Ht.: 0·305 m.

Stella Kramrisch, *Journal of the Indian Society of Oriental Art*, vi, 201–2.

The typical Gupta sausage-curls into which the hair is dressed and the suavity with which the power of this head is conveyed make it unlikely to be earlier than A.D. 400. The figure has a third eye, and a lightly indicated moustache. An *ekamukhaliṅgam* head projecting to this extent from the body of the *liṅgam* and of roughly the same date is still in worship at the Mahāvidyādevī temple on the outskirts of Mathurā.

51. Sūrya in the costume of a Kuṣāṇa prince—red sandstone—Mathurā, now Ashmolean Museum (Dept. of Eastern Art, No. 1972.45)—fourth–fifth centuries A.D.

Ht.: 0·220 m.

The squatting figure is flanked by two small sedent lions. Both knees have been knocked off, and the left hand and the top of the sword are missing. Otherwise this small stele is in excellent condition and has preserved a crispness of detail almost unknown in small works of this period.

The lotus (?) flower held flat in the hand is unusual, and so is the long sword with apparently a square-ended scabbard. Another example of the latter exists, how-ever, held by a small seated Sūrya of possibly slightly earlier date (Indian Museum, Calcutta, No. 25033).

Sūrya is shown bearded, as is usually the case in Mathurā after the Kuṣāṇa period: the beard is simply outlined, however, by a deep incised line on the cheeks. Three rows of tightly rolled curls fall on to each shoulder. For very similar boots or buskins on a fragment from Pandrethan, see Kak, *Handbook of the Archaeological and Numismatic Sections of the Sri Pratap Singh Museum, Srinagar*, pp. 39–40.

THE EASTERN MADHYADEŚA AND SĀRNĀTH

52. Standing Buddha—cream sandstone—Sārnāth, now British Museum—mid-fifth century A.D.

Ht.: 1·525 m.

R. Chandra, *Medieval Indian Sculpture in the British Museum*, p. 25; *Archaeological Survey of India*, Annual Report 1925–26, pp. 125–6, Pl. lvi (b); U. P. Shah, *Studies in Jaina Art*, p. 14, fig. 18; P. Chandra, "Some Remarks on Bihar Sculpture From the Fourth to the Ninth Century", *Aspects of Indian Art*, Leiden, 1972.

53. Śiva and Pārvatī—dark red stone (sandstone?)—Kauśāmbī, now Indian Museum, Calcutta, No. KM40; also A25040—dated in the Year 139, probably early third century A.D.

0·750 × 0·350 m

Carved in a dark red stone that appears to be harder than sandstone. A carefully made stele, but not a high finish. The nipples are crudely indicated by circles placed much too far over near the armpits.

It is dated in the Year 139. Other sculptures from Kauśāmbī of roughly the same period bear similar dates and occasionally the names of Māgha kings. These dates are generally thought to belong to the Śaka era, commencing in A.D. 78. This image has, however, been dated as late as the fifth century.

Śiva, with a horizontal third eye and a moustache rather than tusks, wears a *jaṭā* tied at the base and with long bands passed through the top, with a flower (?) on the proper left, and (possibly) a crescent moon on the other side. The god wears small ear-rings, if any.

A curious feature is a narrow line of curls running down in front of Śiva's ears, and passing under his chin where it meets the neck. Part of a rosary (*akṣamāla*) appears to be indicated on the palm of the hand raised in *abhaya*. Śiva wears a *dhoti* (or else

lion-skin) coming down almost to his left ankle. A dangling portion between his legs suggests a lion-pelt but there are no other indications of a skin.

Pārvatī's hair is dressed into a sort of pompom in the front. She wears multiple armlets and bracelets, as well as a single bracelet, and single anklets on her feet. She holds a mirror in her left hand.

Iconographically, this emblem, with the pot Śiva is holding in his left hand, is related to other early Śiva and Pārvatī images, from the far west and north-west of India (Pl. 129). Stylistically, as Stella Kramrisch wrote long ago, the way Śiva is depicted presupposes the Kuṣāṇa style at Mathurā. This insight has been confirmed by further discoveries of second- and third-century dates on sculpture from Kauśāmbī in a provincial variant of the Mathurā Kuṣāṇa style. Pārvatī's head-dress, on the other hand, as Stella Kamrisch pointed out, recalls earlier types.

54. Śiva—buff sandstone stele—said to come from Kauśāmbī area, now Los Angeles County Museum of Art—third-fourth centuries A.D.

Ht.: 0·685 m.

Formerly Scott Collection; then Alice and Nasli Heeramaneck Collection.

Iconographically, this figure is fairly closely related to the Śiva-Pārvatī described above (Pl. 53). He is ithyphallic, has a third eye, holds a pot in a left hand and a rosary in a right which is held in abhaya. The type of jaṭā is also quite similar, and so is the way the scarf is draped over the shoulder and arm, and around the body. The flexible torque, folded back on itself, is characteristic of Kuṣāṇa jewellery: the torque below has a simplified Gupta form. Some of the later features of this image are the third eye being shown vertically, the fact that the image is four-armed, the large size of the weapons held by its rear hands, and the crisp realism with which they are depicted. The body, with its exaggeratedly broad shoulders and long but rather skimpy legs is also definitely post-Kuṣāṇa, as is the face.

55. Seated Buddha—sandstone—Manku-war, now in the Archaeological Museum, Lucknow. Inscribed in the year A.D. 449 of Kumāragupta.

Ht.: 0·770 m.

Mankuwar is a village near the Jumna in Allahabad District. For an account of the image's discovery in 1870, see Fleet, *Inscriptions of the Early Gupta Kings*, p. 45. It appears to have come originally from the ruins of a nearby Buddhist monastery.

Cunningham remarked on the curious cap, with long lappets on the side, and compared it to those 'now worn by the Abbots in Bhutan'—*Archaeological Survey of India*, x, 6. Kumāragupta is called *mahārāja*, not as almost everywhere else, by the paramount title of *mahārājādhirāja*. This has been adduced as evidence of a low ebb in the Gupta's fortunes at the end of Kumāra-gupta's reign due to the inroads of the Huns.

The lions on the base facing forward are astonishingly archaic, almost identical to those on late Kuṣāṇa images from Mathurā. It is particularly surprising to find this and other echoes of Kuṣāṇa Mathurā sculpture in the heart of the Madhyadeśa at such a late date The 'webbed' fingers of the right hand are simply a device so that the fingers will not be unsupported and easily broken.

56. Pillar—sandstone—from Rājghat, Var-anasi, now Bharat Kalā Bhavan, Varanasi, No. 225—dated 478, in the reign of Budha-gupta.

Ht.: 1·335 m: W. (of square portion) 0·325 m.

Adris Banerji, 'Some sculptures from Rajghat, Benares', *Journal of the Gaṅganātha Jha Research Institute*, vol. iii, Pt. 1 (1945), pp. 1–9; D. S. Sircar, 'Two pillar inscriptions', *Journal of the Asiatic Society of Bengal, Letters*, vol. xv, No. 1 (1949), pp. 5–8; John M. Rosenfield. 'On the Dated Carvings of Sārnāth', *Artibus Asiae*, vol. xxvi, No. 1 (1963), pp. 10–26.

57. Detail from above: Viṣṇu. This image, and the Narasiṁha, both appear to be four-armed, both have similar *gadās* and *cakras*, the latter resting on a low pedestal. Both have long *vanamālas*.

58. Same: Vāmana. By analogy with the more detailed and better-preserved but very similar figure on the Kutari pillar-base (Pl. 59), the objects held by this figure can be surmised. So can the *ajina*. Both this and the female figure appear to have only two arms.

59. Base of a column, with Harihara—sandstone—Kutari, Allahabad District, now Allahabad Museum, No. 292—last half of fifth and first quarter of sixth century.

0·650 × 0·410 m.

P. Chandra, *Stone Sculpture in the Allahabad Museum*, No. 203, Pl. LXVIII and LXIX.

The other figures are Vāsudeva (?), Varāha, and Vāmana. Here, the paired deities are joined (or divided) along the centre-line of the body, as in the case of the male-female images of Śiva (*ardhanarī*), all the way up including the crown. The proper left side represents Hari (Viṣṇu). His

characteristic crown can plainly be seen, his upper hand holds the conch, his lower rests on the head of *cakrapuruṣa*, the personified *cakra*. The *dhoti* is lightly pleated—the long *upavīta* turns into a floral section at the knees. On the other side, it is not possible to determine the object held or the gesture made by the upper hand, but the lower rests on an *ayudhapuruṣa* with a trident (?), the emblem of Śiva *par excellence*, sprouting from his head. A tiger-skin, an emblem of Śiva, is depicted in very low relief on the un-pleated side of the *dhoti*.

60. Same, another side with Vāmana—the dwarf *avatāra* holds a rosary in his right hand, a pot and a crooked staff in the other. The deer-skin (*ajina*) is thrown over the shoulder. The Vāmana of the pillar from Rājghat (Pl. 58), although the carving is far less distinct, provides confirmation of the identifications of these objects. The stylized treatment of the rocks below Vāmana is a favourite Gupta device, although it appears already in earlier styles.

61. Standing Viṣṇu—beige/light grey sandstone—Unchdīh, Allahabad District, now Allahabad Museum, No. A.M.857—mid-fifth century
>Ht. (from top of base) o·810 m.

Lower right arm and Gadādevī are missing. Corners of mouth drilled.

62. Standing Viṣṇu—slightly pink sandstone—Jhusī, Allahabad District, now Allahabad Museum, No. 952—early or mid-fifth century.
>Ht.: o·710 m.; from top of base: o·610 m.

Lower right hand broken and joined, upper left hand worn. Lower right arm and hand replaced by plaster. Rather crudely plastered or mended around shins, feet, lower part of *gadā*, etc. This statue is nearly in the round, with the *vanamāla* carried across the back. The torso of this powerful piece is too naturalistic to be in the pure Gupta style.

63. Kṛṣṇa Govardhana—Chunar sandstone—Varanasi, now Bharat Kalā Bhavan, Varanasi, No. 147—early fifth century A.D.
>Ht.: 2·120 m.

The arms, although the hands remain, are replacements. For circumstances of its discovery, and a photograph in original condition, *Archaeological Survey of India*, Annual Report (1926–7), p. 218, and Pl. XLVId. Originally in Sārnāth Museum, *Archaeological Survey of India*, Annual Report (1929–30), p. 201. There was a halo behind the head. The hair is arranged so that a solid

and heavy hank of hair (*śikhā*) protrudes from the head on either side, in the same way that the hair of Gupta Skandas is portrayed (see Pl. 65). The third, central, hank of hair, so often present in images of Skanda (*triśikhin*, having three locks of hair) and sometimes worn by Kṛṣṇa, is not present. For the relationship between Kṛṣṇa and Skanda in so much as they are both children or adolescents, see M. T. de Mallmann, 'A Propos d'une coiffure et d'un collier d'Avalokiteśvara', *Oriental Art*, vol. 1, No. 4. The short *dhoti* is unquestionably pleated, the folds carefully delineated. The fingers of the left hand are grotesquely stubby in relation to the width of the hand.

64. Detail of above.
>The face measures o·380 m. high.

65. Seated Kārttikeya—buff coarse-grained sandstone—Varanasi, now Bharat Kalā Bhavan, Varanasi, No. 224.
>Ht.: o·500 m. above pedestal.

According to J. N. Banerjea (*The Development of Hindu Iconography*) the fruit held in the god's left hand is probably a *mātuluṅga* (citron). The corners of the mouth are drilled. Note the necklace of tiger claws. There is a crescent moon on either side of the head-dress. For these adornments of the child or young prince (one of Skanda/ Kārttikeya's names is Kumāra), see Note to Pl. 60.

66. Standing Buddha, with parasol—Chunar sandstone (?)—Varanasi, now Bharat Kalā Bhavan, Varanasi, No. 148—latter half of fifth century A.D.
>Ht.: 1·950 m.

67. Standing Buddha—Chunar sandstone—Sārnāth Museum, No. 342—dated in 154th year of Gupta era (A.D. 474), in the reign of Kumāragupta II.
>Ht.: 1·930 m.

For these dated Buddhas, and the general development of the Buddha image at Sārnāth, see J. M. Rosenfield, 'On the Dated Carvings of Sārnāth', *Artibus Asiae*, vol. xxvi, No. 1 (1963).

Intact, the excessive size of the halo would be disproportionate. This very fine sculpture is not without traces of mannerism.

68. Standing Buddha—Chunar sandstone—Sārnāth Museum, No. 341—dated in the 157th year of the Gupta era (A.D. 477), in the reign of Budhagupta.
>Ht. o·193 m.

69. Standing Buddha—Chunar sandstone—Sārnāth Museum, No. 346.
>Ht.: 1·780 m.

Note, in comparison with Pl. 68, the variations within a very strict formula. The *déhanchement* here is to the proper left and the proportions are subtly varied. The feet are more realistically portrayed than is common in most of the Sārnāth Buddhas.

70. Seated Buddha—Chunar sandstone—Sārnāth Museum, No. B (b) 181.

Ht.: 1·610 m; W. 0·790 m.

The wide fame of this image is due in part to its near-perfect state of preservation, in part to the aptness of the way in which the Buddha is portrayed. His hands are in the *dharmacakra* or teaching *mudrā*, and this is particularly appropriate since it was at Sārnāth that the Buddha preached his first discourse, setting the Wheel of the Law in motion (see base). For the first time, the late Gupta type of throne which will henceforth prevail for centuries is portrayed, with its rampant leogryphs (*vyālas*), and its aquatic monsters (*makaras*). The flying figures, of course, hark back to the first seated Buddhas from Mathurā.

71. Proper right portion of lintel—buff sandstone—Gaḍhwā, Allahabad District, now State Museum, Lucknow, No. B223a.

0·260 × 0·220 × 0·179 m.

The total width of the lintel (see also note to Pl. 72) is just a little short of 4 m. This implies a much larger doorway than that of any of the Gupta or late Gupta temples so far known, and consequently a much larger temple. Alternatively, the temple may have been of a different type, with a differently proportioned doorway from any of those which have survived, which are admittedly but a tiny proportion of the temples which must have existed. Conceivably, the lintel did not belong to a temple at all, but to a *dharmaśāla*, or almshall, or some other sort of building. There is also the possibility that this is not a lintel (it is, after all, in two pieces), but a frieze or dado placed somewhere in the building, perhaps above the base or between the base mouldings. There is no precedent for this whatever, however, in Gupta architecture as we know it. The earliest narrative friezes are from Early Western Cāḷukẏ monuments at the beginning of the seventh century, usually depicting scenes from the Kṛṣṇa legend. Such a narrative, in the sense of a number of separate incidents, would not seem to be shown here. The balanced nature of the composition, and the presence of the gods, with Sūrya and Chandra at the ends and the great Viṣṇu in the centre, would moreover seem to indicate a lintel, with the

focus on the mid-front as it almost invariably is in Hindu lintels.

For the earliest, and still the fullest, description of Gaḍhwā and its relics, see *Archaeological Survey of India* (Cunningham), vols. iii and x. For the inscription, found there, see Fleet, *Inscriptions of the Early Gupta Kings*, pp. 36–41.

72. Proper left portion of lintel (in two fragments)—State Museum, Lucknow, Nos. B223b and c.

0·27 × 0·115 × 0·218 m.

73. Detail of the Gaḍhwā lintel.

N. P. Joshi, *Catalogue of Brahmanical Sculptures in the State Museum, Lucknow*, pp. 87–8, Fig. 8.

This mysterious figure enveloped in heads and flames has been identified as a Viṣṇu Viśvarupa, an emanatory form of Viṣṇu. There is little doubt that it is a form of Viṣṇu who alone, at this period, wears the long *vanamāla*. There are parallels in Kuṣāṇa and later sculptures for human heads springing from a central figure (see notes to Pl. 128; also the Parel Śiva and a relief, possibly Viṣṇu Viśvarūpas, from Śāmalāji) but not with flames as well. There are two additional faces, what is more, to the main head, a boar's on the left, and a lion's on the right as in Viṣṇu *caturvyūha* images. Here again, the Viśvarūpa Viṣṇu from Bhankari provides a parallel. There are lion- and boar-heads on either side and some twenty emanating figures. What is most unaccountable here is that the principal face seems to be that of a horse, or possibly a lion. Similarly, the head directly above appears to be that of a horse.

There are both attendant figures and *cakrapuruṣas*.

74. Detail of Gaḍhwā lintel.

75. Detail of Gaḍhwā lintel.

76. Detail of Gaḍhwā lintel. Note the small size of some of the figures receiving food. The pillars supporting the roof of the hall are shown in relief. The figure dispensing food appears to be a woman wearing a long garment with sleeves. Her head-covering, apparently wrapping around her chin, appears occasionally in figures from Gandhāra. Scenes with such an authentic *genre*-feeling are practically unknown in Indian sculpture.

77. Detail of Gaḍhwā lintel.

78. Detail of Gaḍhwā lintel.

79. Fragment of door-jamb—reddish or pinkish sandstone—Gaḍhwā, now State Museum, Lucknow, No. B222.

A number of fragments of door-jambs were found at Gaḍhwā. Some at least, like this one, are in a style very similar to the lintel. The fragments in the State Museum, Lucknow, are numbered B220, B221, B222, and B223. These are unpublished. At least three other fragments are still at the site, in a godown. They include those illustrated in *Archaeological Survey of India* (Cunningham), vol. x, Pl. VI; V. A. Smith, *A History of Fine Art in India and Ceylon*, Figs. 114 and 115.

80. Stele with scenes from the life of the Buddha—Chunar sandstone—Sārnāth, now National Museum, New Delhi, No. 49.114.

At the bottom, the conception, birth, and first bath; in the middle panel, the great departure (?), the cutting off of the hair, and the future Buddha seated in meditation; top, the illumination, and preaching the first sermon.

THE PERIPHERY: AJANTĀ AND WESTERN INDIA

81. Facade—Cave 19—Ajantā—end of fifth century A.D.

The new dating proposed by Dr. Walter Spink for the later, or Vākāṭaka, caves at Ajantā has been adopted. See W. Spink, 'Ajantā and Ghatotkacha: A preliminary analysis', *Ars Orientalis*, vol. vi.

82. Interior—Cave 2—Ajantā—end of fifth century A.D.

83. Seated Buddha—Cave 16—Ajantā—end of fifth century A.D.

84. Nāga King and Consort—outside Cave 19—Ajantā—end of fifth century A.D.

85. Pair of flying figures, ceiling, Front Porch, Cave 16—Ajantā—end of fifth century, A.D.

86. Male Figure—polished greenish-black stone—Sāmalāji, now in Baroda Museum and Picture Gallery, No. 2.558—fourth or early fifth century A.D.

Ht.: 0·915 m.

For this and Pls. 88 and 89, see U. P. Shah, *Sculpture from Sāmalāji and Roda*, Bulletin of the Baroda Museum and Picture. Gallery, vol. xiii (Special Number, 1960), and other publications by the same author.

Head, arms, and legs below knees are missing. Square and rectangular holes drilled in left buttock and thigh and right hip. The torso is extremely thick, recalling some of the early Yakṣa figures. The three folds around the neck, however, the way the pleats of the *dhoti* are shown, and particularly the way in which a central loop falls down from the rolled girdle are all identical none the less, except that the girdle is thicker, to the Sāmalāji sculpture of a later date.

87. Viṣṇu—greenish-blue schist—Bhinmal (Jodhpur Division), now Baroda Museum and Picture Gallery, No. 2.676—fourth century A.D.

Ht.: 0·445 m.

U. P. Shah, 'Some Early Sculptures from Abu & Bhinmal', *Bulletin of the Baroda Museum and Picture Gallery*, vol. xii, pp. 51–3, Pl. XXXIX.

Upper left arm missing, probably carried a *cakra*. Note the bar, for additional strength, linking the back of Viṣṇu's head to the top of the mace. The folds around the neck, so characteristic of sculpture from this region, can already be seen, and the type of armlet does not appear to have changed. The thickness of the twisted, rope-like scarf is an early feature, as is the position of the hand held up in *abhaya* at face level and turned sideways. There are flames on each side of Viṣṇu's crown, which is of an early type only seen in late Kuṣāṇa sculpture from Mathurā (Shah, p. 53), with crossed bands and a central rosette.

A small stone head of Viṣṇu or Sūrya found in Kutch with a roughly similar crown and bulging eyes, and upper and lower lids outlined by thick lines in relief, is in a unique style quite possibly closely related, although more sophisticated, to the Bhinmal figure. It has led an eminent authority to postulate a fourth-century date for the latter (U. P. Shah, 'A Kṣatrapa period Head from Daulatpur, Kutch', *Bulletin of the Baroda Museum and Picture Gallery*, vol. xx, 1968).

The early dates assigned to these two pieces are still open to question and there are marked differences in style between them. The Bhinmal figure is crude, the head from Daulatpur highly sophisticated, and it is just conceivable that both are post-Gupta.

Bhinmal (Bhillamāla) is in the Jālor district of Rājasthān, about 60 miles northwest of Mt. Abu.

88. Four-armed standing Śiva with *vāhana*—schist—Sāmalāji, now Baroda Museum and Picture Gallery, No. 2.544—c, A.D. 400.

Ht.: 0·889 m.

U. P. Shah, op. cit.

Part of the halo is restored and the bull's front legs are missing. The nose is missing.

The figure has four arms and stands in *tribhanga*. The two rear hands hold the *śūla* and a serpent; the front right hand holds an *akṣamāla* and the left is placed on the hips. Śiva has a vertical third eye and is ithyphallic (under the drapery) and wears a lion-skin. The bull wears a garland of skulls (?).

The halo is plain and circular. A line under the breasts is faintly delineated with subsequent folds and the region of the navel is treated with great sensitivity. The headdress is a complex one. At the top is an arrangement of hair placed horizontally and tied in the middle. This form of *jaṭā* originally stems from the *krobylos* seen on Gandhāra Maitreyas. Under the jewelled crown is a band of hair in thick curled strands. The god wears dissimilar ear-rings, that on the left a heavy circular one. Two strands of wavy hair rest on each shoulder. The figure does not have a rolled sash, but a simple band—tied in a square knot—holds up the *dhoti*, a small fold of which is turned under the navel. The folds of the *dhoti* are delineated in a way derived from Gandhāra.

The bull has a heart-shaped pendant hanging from a band on his forehead. He is depicted in an extremely awkward way, the fore-part full face, and the hindquarters in profile. This arrangement is found on one of the rare Hindu sculptures from Gandhāra (small relief from Akhun Ḍherī, *Archaeological Survey of India*, Annual Report (1913–14), pp. 276–7 and Pl. lxxii.

A very similar but more badly damaged figure, also from Śāmalāji (Baroda Museum and Picture Gallery, No. 2.551), has the more usual rolled scarf and loop at the waist and stands in *samapāda*. There is a similar Nandi, with the same heart-shaped pendant, but this figure had six arms and attendant figures, typical dwarfs in the Gupta style.

Two two-armed standing figures, in perfect condition and also from Śāmalāji (one in the Trilokanātha shrine in the Śāmalāji temple, the other in the Prince of Wales Museum), complete this group. They hold the *śūla* in one hand; a serpent writhes around the other shoulder. They have attendant figures. In style they are probably slightly later.

89. Cāmuṇḍā—schist—Śāmalāji, now Baroda Museum and Picture Gallery, No. 2.535—*c.* A.D. 400.

Ht.: 1·016 m.

Broken at the waist, part of one arm missing, and with other damage, this figure is identical in style to the previous figure above. The locks are laid on top of the head in an exaggerated *krobylos*. The hair below is dressed in a Western Classical way, two wavy curls fall, as in the Śiva, on each shoulder. Instead of the bull, a lion stands in the same position behind the goddess.

The emaciated goddess is clad only in a lion skin, with a necklace consisting of a serpent and a great garland of intestine (?), with skulls at intervals.

90. Kumāra (Skanda or Kārttikeya)—schist—Śāmalāji, now Baroda Museum and Picture Gallery, BNo. 2.542.

Ht.: 0·889 m.

The halo is half-replaced and part of the *cakra* is missing. The halo is plain and perfectly circular. The god holds a long lance in one hand and a cock in the other. He stands in *samapāda*. Except for his headdress, distinguished by two heavy curling locks (the third is not visible) which are the badge of Skanda as *triśikhin*, he is a perfect example of the general style of these Śāmalāji sculptures, wearing the more usual and characteristic heavy coiled sash with another interwoven to form a central loop. He wears the same simple armlets as all the figures. All these figures have bases.

Skanda is represented in a way established in the north-west and at Mathurā, from which comes the earliest named and dated example (Mathurā Museum, No. 42.29.4). Examples from the former regions, in the Gandhāra style and in potstone, and some perhaps as late as the seventh or eighth centuries, are illustrated in A. Foucher, *L'Art gréco-bouddhique du Gandhāra*, Vol. ii, Figs. 372 and 373, and in Douglas Barrett, 'Sculptures of the Shāhi Period', *Oriental Art*, N.S. vol. iii, No. 2, pp. 54–60, Fig. 11.

91. Skandamātā—greenish-blue schist—from Tanesara-Mahādeva, Rājasthān, now Cleveland Museum of Art, J. H. Wade Fund, No. 70.12—fifth–sixth centuries.

Ht.: 0·788 m.

R. C. Agrawala, 'Some More Unpublished Sculptures from Rājasthān', *Lalit Kalā*, No. 10 (Oct. 1961). Pratapaditya Pal, 'Indian Art from the Paul Walter Collection', *Bulletin* of the Allen Memorial Art Museum, Oberlin College, Oberlin, Ohio—vol. xxviii No. 2 (Winter 1971).

These figures, a group of approximately a dozen, were in worship until very recently. Note the high base-blocks characteristic of much of the figure sculpture in this region. The group includes a Skanda-Kumāra and I have adopted Dr. Pal's suggestion that where the only attribute of a feminine figure is the child, they are probably not Mātṛkās

50

in the usually accepted sense but Kṛttikās (foster-mothers of Kārttikeya, or Skanda-Kumārā). These mothers of Skanda, or Skandamātās, were six in number and some believe that they are at the origin, with another figure added later, of the seven Mātṛkās or Mothers (Sapta mātṛkās).

92. Skandamātā—greenish-blue schist—from Tanesara-Mahādeva Rājasthān, formerly Alice and Nasli Heeramaneck Collection, now Los Angeles County Museum of Art, No. L69.24.300B.

Ht.: 0·762 m.

Note the delicacy with which the hair and the smiling features of the face are carved. The head covering and outer garment, with their suggestion of Western Classical influence, are most unusual.

93. Kaumarī—greenish-blue schist—from Tanesara-Mahādeva, Rājasthān, formerly Alice and Nasli Heeramaneck Collection, now Los Angeles County Museum of Art, No. L69.24.300A.

Ht.: 0·762 m.

There is little doubt that this figure represents Kaumarī, one of the Seven Mothers and the Śakti or energy of Skanda-Kumārā. In Western India, the spear is Skanda's attribute *par excellence* and the Skanda image from Tanesara-Mahādeva wears a similar type of helmet or head-gear. Dr. Pal (Note to Pl. 91) comments on the unusual attributes held in the other two hands, a sort of hunting horn held by a lanyard and a peculiar type of water-jar which he terms a *chuluka* and which he says is usually carried by *yogis*. This, with the serpent coiled around her neck, suggests that the goddess is portrayed as a *yoginī* or demoness.

THE LATE GUPTA STYLE

94. Yaśodharman's pillar and assorted sculpture—cream sandstone—Sondni, near Mandasor—*c*. A.D. 535.

Archaeological Survey of India, Annual Reports (1922–3), p. 185; 1925–6, p. 188; Fleet, *Inscriptions of the Early Gupta Kings*, pp. 142–9.

All that is known to history of Yaśodharman, and his extravagant claim to have defeated the Huns and established an empire in North India, is from his inscription on the column here. It is simply an assumption —which style does not contradict—that the temple, to which the fragments of sculpture assembled here must have belonged, was built at approximately the same time. A pair of flying figures, now in the National Museum, New Delhi (No. 51.94), may be slightly later, as may some of the fragments on the site.

95. Doorkeeper—cream-coloured sandstone —Sondni, near Mandasor—*c*. A.D. 535.

Ht.: approx. 2·600 m.

From a vanished temple on or near the site. Note the strands of hair indicated on the left shoulder. The way the *dhoti* is drawn up into a pucker in front is characteristic of the late Gupta style. The ornament at the top is highly evolved, the hanging acanthus leaves belonging, in fact, to the post-Gupta style.

96. Attendant of a doorkeeper—cream-coloured sandstone—Sondni, near Mandasor—*c*. A.D. 535.

Ht. approx. 0·6100 m.

A detail of the companion of the doorkeeper illustrated in Pl. 95. The little dwarf-figure, with curls cascading down one side of his head and a *vyāghradanta* necklace, is a typical late Gupta figure.

97. Toraṇa pillar, south face—cream-coloured sandstone—Kilchipura, Mandasor District, now in front of Collector's Office, Mandasor Fort—early sixth century A.D.

Ht. approx. 4·900 m.

98. Detail of above.

99. Yamunā, detail, north face of above.

100. Giant Śiva stele—cream-coloured sandstone—from nearby ravine, now in front of Collector's Office, Mandasor Fort— early sixth century A.D.

Ht. approx. 3·000 m.

Archaeological Survey of India, Annual Report (1922–3), p. 186 and (1925–6), p. 187; Joanna Williams, "The Sculptures of Mandasor", *Archives of Asian Art*, xxvi, 1972–3 and references; also C. E. Luard, *Gwalior State Gazeteer*, vol. i, pt. IV.

Śiva is shown as ithyphallic, with the tiger or lion-skin draped around him. He holds a composite trident and axe; his ear-rings are dissimilar, a round one in the left ear. This is a relatively late figure. The massed grotesques on the slab behind, mounting one above the other, surely echo late Buddhist stelai in Gandhāra, and the figures themselves, although technically Śiva *gaṇas*, recall the hosts of Māra.

101. Detail of above.

102. Head of an Ardhanarī (Śiva half-man and half-woman)—red sandstone—Mathurā Museum, No. 13.262—fifth century A.D.

N. P. Joshi, *Mathura Sculptures* (1966), Pl. 80, 81 and 82.

Note the divided-circle ear-ring and the hair in loops, falling down on one side. If, as seems likely, Mathurā remained in the van of stylistic development, this figure, which further east would probably be of sixth-century date, may be as early as A.D. 450.

103. Panel with Viṣṇu asleep on the serpent Ananta—red sandstone—south side, Daśāvatāra Temple, Deogarh (Jhansi District)—*c.* A.D. 500–25.
M. S. Vats, 'Gupta Temple at Deogarh', *Memoirs of the Archaeological Survey of India*, No. 70 (1952); Madhuri Desai, *Deogarh* (1958).

The temple and its sculpture have been attributed a wide range of dates. Note the excessively theatrical poses of the figures below the god. There appears to be an irreverent note in the way the gods above are portrayed.

104. Panel with Gajendramokṣa (Liberation of Indra's Elephant)—red sandstone—north side, Daśāvatāra Temple, Deogarh (Jhansi District)—*c.* A.D. 500–25.

The draperies blowing straight up are a typical late Gupta stylistic trait. Viṣṇu is wearing the round crown, like an inverted thimble, which has now superseded the earlier type which he shared with Indra.

105. Entrance doorway—red sandstone—west side of Daśāvatāra Temple, Deogarh (Jhansi District)—*c.* A.D. 500–25.

Gaṅgā and Yamunā are still lodged at the top of the doorway, on either side, in the T-extension. Otherwise this doorway shows all the characteristics of the late Gupta style: doorkeepers at the bottom of each jamb, a band of *mithuna* panels, an architectural lintel and a panel, with a figure of the god, hanging from the middle. Some of the decorative forms are oversized and coarsened.

106. Entrance doorway—red sandstone—Pārvatī Temple, Nāchnā-Kuthārā (Panna District), Madhya Pradesh—early sixth century A.D.
For the flat-roofed Gupta temples, see O. Viennot, 'Le Problème des temples à toit plat dans l'Inde du Nord', *Arts Asiatiques*, vol. xviii (1968).

Gaṅgā and Yamunā are in their places at the base of the panels. The doorway has lost its T-shape—the vegetal scrollwork is beginning to show a baroque restlessness and over-elaboration.

107. Śaiva *dvārapāla*—red sandstone—Pārvatī Temple, Nāchnā-Kuthārā (Panna District), Madhya Pradesh—early sixth century A.D.

This figure, now in the *garbha-gṛha*, has been moved from its original location.

108. Part of a doorway built into the Teliya Math—sandstone—near Nāchnā-Kuthārā, (Panna District), Madhya Pradesh.

109. Doorway — sandstone — Vāmana Temple, Maṛhiā (Jabalpur District), Madhya Pradesh—early sixth century A.D.
P. Chandra, 'A Vāmana Temple at Maṛhiā and some Reflections on Gupta Architecture', *Artibus Asiae*, vol. xxxii, Nos. 2/3 (1970).

110. *Chaitya*-arch ornament with Yama (the god of Death)—sandstone—Śiva Temple, Bhumara (Panna District), Madhya Pradesh, now Allahabad Museum, No. 153—early sixth century A.D.

0·370 × 0·450 m.

R. D. Banerji, 'The Temple of Śiva at Bhumara', *Memoirs of the Archaeological Survey of India*, No. 16 (1924); P. Chandra, *Stone Sculpture in the Allahabad Museum* (Bombay, 1971).

111. Friezes of panels—same as above, now Allahabad Museum, Nos. 156, 167, 161, etc.

Bottom slab 0·330 × 0·810 cm.

112. Narasiṁha, the lion incarnation of Viṣṇu—red spotted sandstone—vicinity of Mathurā (?), formerly Alice and Nasli Heeramaneck Collection, now Los Angeles County Museum of Art,—early sixth century A.D.

Ht.: 0·839 m.

TERRACOTTAS

113. Head of a man—terracotta—Kauśāmbī, now Allahabad Museum, No. K. 5199—third century A.D.

Ht.: 0·125 cm.

Heads of this type are fully in the round, and belonged to small figurines. There is a figurine in the Allahabad Museum, complete with head in a similar style to the above, the modelling of the body, the way the *dhoti* is draped, and so on, leaving no doubt that these figures were more or less contemporary with Kuṣāṇa-period sculpture at Mathurā.

114. Side view of above.

115. Head of an *asura*—terracotta, traces of red paint—Kauśāmbī, now Allahabad

Museum, No. K. 5263—third–fourth century A.D.

Ht.: 0·210 m.

116. Buddha—terracotta—from great *stūpa* at Devnimori, now Department of Archaeology and Ancient History, M. S. University, Baroda—*c.* A.D. 375.

Ht.: 0·660 m.

R. N. Mehta and S. N. Chowdhary, *Excavation at Devnimori* (Baroda, 1966).

The excavations of the Devnimori area, now submerged under a reservoir, were conducted between 1960 and 1963. The most important monument uncovered was the large *stūpa*. Virtually undamaged, and endowed with a wealth of terracotta sculpture and ornament, this was one of the first major *stūpas* in India to be the subject of a modern scientific excavation. The excavators were able, thanks to its relatively undamaged condition, to reveal its construction down to the position of each individual brick. In addition it yielded inscriptional and numismatic evidence permitting a close dating.

The most important sculptures of the *Mahāstūpa* are a series of practically uniform Buddhas. They appear to have been placed in niches around the second tier of the base of the *stūpa* and a number (9) were found carefully bricked in within the core of the *stūpa*. With one possible exception, these appear to be rejects.

The Buddhas are all reliefs—the flat ground (mostly missing here) is plain and straight-sided, the upper portion triangular except for a short flat side at the top above which the *uṣṇīṣa* projects. Furthermore, the over-all dimensions do not vary, all features testifying to the strong architectural element in the conception of these Buddhas.

The Buddhas themselves are invariably depicted in the pose of meditation (*dhyāna-mudrā*), seated on a sort of flat cushion atop a base with lotus petals. There are variations in detail. In some of the figures the right shoulder is bare, in others the *saṃghāti* or upper body-cloth covers both shoulders; the hair is shown either in snail-curls or in waves forming a particular pattern, familiar from certain Gandhāra Buddhas and late Gupta figures. The pattern consists of concentric half-circles, with the middle of the forehead, at the hair-line, as centre. In some cases the rows of lotus petals on the base are single, hanging down; in others there is an upper row, pointing up. Some faces have *ūrṇas*, others do not.

A classification has been made according to whether the faces are round, oval or almond shape. Be it as it may, they are all strongly marked by a common style, with its exaggeratedly large half-closed almond-shaped eyes, with a huge upper lid, and a softly smiling mouth below. The sweeping lines of brow and eyes are in marked contrast to and dominate the fleshy smiling mouth and shortened chin. Although Gupta in feeling, the debt to Gandhāra, whether because of nearness in time or for some complex historical reason, is more evident here than in any other Gupta sculpture. Paradoxically, the way in which the *saṃghāti* is draped, i.e. symmetrically in folds down the middle of the body, is familiar from Mathurā but unknown in Gandhāra. The snail-curl head-dress, moreover, is rare in Gandhāra. The image illustrated here is a particularly fine one; plastically, the sculpture ranks among the finest of Indian terracottas.

These Buddhas were coloured a whitish cream. They were not polychrome like the figures at Mirpur Khas. The principal parts of the body were modelled separately and then joined together. For the most factual account of the manufacture of classical Indian terracottas, based on actual observation of a large amount of homogeneous material from one monument, see Mehta and Chowdhary, above.

117. Head of a Buddha—terracotta—from great *stūpa* at Devnimori—Department of Archaeology and Ancient History, M. S. University, Baroda—*c.* A.D. 375.

Ht. approx. 0·165 m.

118. Half of a *chaitya* arch—terracotta—from great *stūpa* at Devnimori—Department of Archaeology and Ancient History, M. S. University, Baroda—*c.* A.D. 375.

0·457 × 0·767 m.

The exact position of these *chaitya* arches on the *stūpa* is not clear. Note the stepped ground, presumably for fitting into the brickwork. These and other large architectual features in terracotta were cut into convenient size for handling and then reassembled in position after firing.

119. Half of a *chaitya* arch—terracotta—from great *stūpa* at Devnimori—Department of Archaeology and Ancient History, M. S. University, Baroda—*c.* A.D. 375.

0·457 × 0·767 m.

Note the dentils and the bead-and-reel moulding. Between them these two *chaitya* half-arches illustrate a large number of typical Gupta decorative motifs at their very strongest.

120. Acanthus—rectangular decorative brick—from great *stūpa* at Devnimori—

Department of Archaeology and Ancient History, M. S. University, Baroda—*c.* A.D. 375.

0·432 × 0·254 × 0·510 m.

Three acanthus leaves are depicted with intervening egg-motifs decorated with little circles. These rectangular decorative bricks have the same dimensions as the ordinary bricks used in construction.

121. Large medallion with foliage—terracotta—from great *stūpa* at Devnimori—Department of Archaeology and Ancient History, M. S. University, Baroda—*c.* A.D. 375.

0·408 × 0·408 m.

This is perhaps the earliest example known of that most superb of all Gupta decorative motifs, foliage with an oblique cut.

122. Grotesque face—square decorative brick—from great *stūpa* at Devnimori—Department of Archaeology and Ancient History, M. S. University, Baroda—*c.* A.D. 375.

Approx. 0·110 m. square.

Note animal-ears at top corners. A large variety of these square decorative bricks has been found at Devnimori.

123. Seated Buddha—terracotta relief-plaque—Mirpur Khas, now Prince of Wales Museum of Western India, Bombay, No. 58.

0·260 × 0·470 m.

H. Cousens, *Buddhist Stūpa at Mirpur Khas, Sind*, Archaeological Survey of India, Annual Report (1909–10).

The town of Mirpur Khas is 42 miles east of Hyderabad in Sind (Pakistan). The ground plan of the *stūpa* is more developed than at Devnimori, one side having a projection into which one enters, with three cells. The lower portion of the *stūpa* containing the niches with the Buddhas was preserved by a retaining wall erected, because of subsidence, very shortly after the *stūpa* was finished. The relics unfortunately did not provide evidence for the dating of the *stūpa*. The brickwork decoration is generally flatter than at Devnimori, which argues for a later date. The lower portion or platform of the *stūpa* contained a 'true' arch.

The Buddhas are all seated in *dhyāna-mudrā*, with a *samghāṭi* covering both shoulders. The folds of this upper garment draped symmetrically along the centre-line of the body. The hair of this figure is arranged in snail-curls but some of the Buddhas have wavy hair.

A standing figure was found in the central shrine on the west face of the *stūpa*. He holds a small flower in one hand. The Gupta-type wig, with the curls grouped around a central hemisphere, is usually associated, in Northern and Central India, with the late Gupta style.

124. 'Carved brick' with meander pattern—Mirpus Khas, now Prince of Wales Museum of Western India, Bombay, No. 60.

0·220 × 0·115 m.

125. Decorative brick or tile with acanthus—Mirpur Khas, now Prince of Wales Museum of Western India, Bombay, No. 282.

0·150 × 0·150 m.

126. Decorative brick or tile with grotesque face—Mirpur Khas, now Prince of Wales Museum of Western India, Bombay, No. 661.

0·165 × 0·160 m.

127. Kṛṣṇa's Dānalīlā—terracotta plaque, hand-modelled—Rang Mahal (Suratgarh), Rājasthān now Gaṅga Golden Jubilee Museum, Bikaner, No. 227—*c.* fourth century A.D.

0·320 × 0·255 m.

For this and other terracottas from the former state of Bikaner, see Hermann Goetz, *The Art and Architecture of Bikaner State* (Oxford, 1950); Hanna Rydh, *Rang Mahal*, Acta Archaeologica Lundensia (Lund, Sweden, 1959); U. P. Shah, 'Terracottas from Former Bikaner State', *Lalit Kalā*, No. 8 (Oct. 1960); V. S. Agrawala, 'The Religious Significance of the Gupta Terracottas from Rang Mahal', ibid.

The terracottas are from a number of sites near Suratgarh, some 120 miles north-east of Bikaner.

The scene doubtless depicts an example of *dānalīlā*, i.e. Kṛṣṇa exacting toll from the *gopīs* (or cowherd maidens) in token of his father's authority. The girl's index-finger, near the corner of her mouth, indicates surprise or wonderment. This is perhaps the first depiction in Indian art of a village-woman carrying a pot full of water on her head. Kṛṣṇa wears a moustache, but the way his *dhoti* is drawn up, with festoon-like folds, is a Gupta, not a Kuṣāna, feature. Similarly, the way the tree is stylized, and the decoration at the bottom of the plaque, are both typically Gupta.

128. Umā-Maheśvara—terracotta plaque, modelled—Rang Mahal (Suratgarh), Rājasthān—now Gaṅga Golden Jubilee Museum, Bikaner, No. 228—*c.* fourth century A.D.

0·370 × 0·230 m.

Śiva, with his broadly combed hair, *jaṭā* (top-knot), and third eye, is ithyphallic and holds a pot. Umā holds a mirror. In all these respects they belong to the same iconographic horizon as the Śiva and Pārvatī from Kauśāmbī (Pl. 53). But the Rang Mahal plaque also embodies later and more complex additions. It is perhaps the earliest surviving image to show Śiva, accompanied by a consort, seated on a bull. Stylistically, Umā's head-dress and particularly her long skirt, tight at the knees and then flaring below, are related to a number of figures from North-West India.

Śiva is shown with two other heads, clearly differentiated by their head-dress, and a figure rises, head and shoulders, above his head. He thus belongs to a class of images with heads or figures emanating from them, the earliest of which is the Indra (?) of the Kuṣāṇa period from Mathurā (Mathurā Museum, No. 14.392–395).

129. Female figure—terracotta plaque, modelled—Badopal (Suratgarh), Rājasthān, now Gaṅgā Golden Jubilee Museum, Bikaner, No. 269—c. fifth century A.D.

0·305 × 0·290 m.

For a present-day woman from Northern or Western India, in almost identical dress, see *Journal of Indian Art and Industry*, vol. xii.

130. Fragment of architectural ornament—terracotta, modelled—Rang Mahal (Suratgarh), Rājasthān, now in Gaṅgā Golden Jubilee Museum, Bikaner, No. 292.—c. fourth century A.D.

L: ·229 m; Ht.: 0·114 m.

131. The brick Gupta temple at Bhitargaon, the north side—Bhitargaon, Kanpur District, U.P.—first half of fifth century A.D. *Archaeological Survey of India*, xi, pp. 40–6 (Cunningham); J. Ph. Vogel, 'The Temple of Bhitargaon', ibid. (1908–9), pp. 5–21; R. C. Singh, 'Bhitargaon Brick Temple', *Bull. of Museums and Archaeology in U. P.*, No. 1 (Mar. 1968); same title, ibid., No. 2 (Dec. 1968); same title, ibid., No. 8 (Dec., 1971).

The temple is less than 45 km from Kanpur but it can only be reached by a network of canal and country roads. There are photographs dating back to the 1870s, and the extent to which the temple has been restored can be judged by comparison with them. It appears to have been relatively intact until the middle of the last century, when it was struck by lightning. The lower portion is restored up to the principal niches, having been badly undercut and

eroded. The summit, with its circular capstone, is also modern work designed to prevent the seepage of water. The porch is now severely truncated.

Cunningham attributes the survival of this temple, alone amongst all the other brick temples of the Gupta period, to its isolated location. Other factors must have contributed, however, since a mound only 150 metres away has yielded remnants of another very similar temple.

The temple, which is of the *tri-ratha* type, i.e. with a projecting bay on each of three sides and an entrance-porch, faces east. It was built on a cellular base. Interestingly, there is a second shrine-chamber above the principal one. What remains of the superstructure, composed of gradually diminishing storeys of niches or blank windows, is the earliest surviving example of the North Indian *śikhara*. There is evidence that stone lintels were used in the porch, and that the doorways may have been of stone. The large size of the bricks, reaching 48 cm × 13 cm × 5 cm (Singh), would alone establish the Gupta date of this temple.

Structurally, the temple incorporates a most important feature: true rather than corbelled arches and vaulting, in the porch and shrine chambers. This is one of the few examples dating from pre-Muslim times (also see Mirpur Khas).

The splendidly decorated pilasters and cornices are said to be of carved brick, the multitude of relief-panels are modelled in terracotta. These are said to be poorly fired. The terracotta plaques are of three types: (a) the largest, in the principal niches, are *mūrtis*, images of the gods, depicted either singly or in scenes already established in Hindu iconography; (b) semi-decorative plaques, showing animals, some of them mythical, like the *makara*; (c) plaques from the upper storeys, sometimes single heads or figures, sometimes pairs of figures, men and animals in combat and so on. It is interesting to note, amongst the large *mūrtis*, one or two, like Nāranārāyaṇa, popular in the Gupta period, which tend to disappear thereafter. Erotic groups, even simple *mithuna* couples, seem to be lacking.

There is no evidence, other than stylistic, of the date of the temple and stylistic equivalents elsewhere of the terracotta sculpture which provide some clues must be sought amongst works in stone, for which, thanks to the existence of a few dated pieces, a tentative chronology exists. The style of the cornice decoration recalls the lintels of the doorway of Cave 6 at Udayagiri, the remains from the top of the Udayagiri hill

and temple E at Eran. As for the sculpture, unfortunately none of the figures in the *mūrti* panels have preserved their faces; the heads from the upper storeys tend to be grotesques. In the rare instances where they are not, they reflect a mature, not an early, Gupta style. The type of head-dress worn by the eight-armed Viṣṇu and the crinkled ends of drapery on several figures, belong, on the other hand, to the earlier Gupta period. A date of A.D. 450 would seem to be the latest for this temple.

132. Śiva and Pārvatī on Mt. Kailāsa—terracotta panel—Bhitargaon temple, south side.

Approx. 0·760 × 0·610 m.

Śiva is sitting in the particularly regal position known as *ardhaparyaṅka*, with one leg hanging down, and the other drawn up. Whether it is a real lion or a pelt, whose head appears between his legs, is not clear. The lion is frequently shown in early Śiva images, probably due to an identification, at least iconographic, with Hercules. The god is ithyphallic, although the erect member is contained inside his *dhoti*. The rocks on which Pārvatī is seated, and which help to identify the scene, are treated in typical Gupta fashion.

133. Viṣṇu Aṣṭabhuji (eight-armed Viṣṇu) —terracotta panel—Bhitargaon temple, west side.

Approx. 0·760 × 0·610 m.

Eight-armed Viṣṇus, in small stone reliefs, are known from the Kuṣāṇa or early Gupta period. There appears to have been a boar's head on the proper right, to which must have corresponded a lion's head on the left, thereby indicating a *caturvyūha* Viṣṇu image. The god wears a long *vanamāla*, whose flowers can still be discerned. The only one of his symbols which can be identified with certainty is the club in one of his left hands. He is flanked by a male and a female attendant on each side. The god's pose is unusual. Excessively broad shoulders, a turban-like head-dress, and crinkled ends to various drapery-bands are all characteristic of the earlier Gupta style.

134. The goddess Gaṅgā—terracotta panel —Bhitargaon temple.

Approx. 0·760 × 0·610 m.

Placed in the proper left-hand niche beside the entrance to the temple, on the east side; there is an almost entirely defaced panel, presumably of Yamunā, in the corresponding niche on the opposite side. The general composition of this panel is very similar to that of the Gaṅgā image on one of the door-panels from Gaḍhwā, including

the forward tilt of the goddess's body. The most important study of Gaṅgā and Yamunā (Odette Viennot, *Les Divinités fluviales Gaṅgā et Yamunā aux portes des sanctuaires de l'Inde*, Pl. 19a and 21b, pp. 46 and ff.) places both these images, with some manifestly late ones, in the late sixth or seventh centuries. Stylistic features, however, like the fluttering streamer and the treatment of the *makara* link them to all the other terracottas of the temple, which cannot be later than the fifth century.

135. Bhitargaon temple—the south side.

Note the remaining panels, showing mythical animals with foliaged extremities, in the frieze or dado above the main cornice. The band composed of little inverted stepped pyramids, below the main kapota, is reminiscent of similar bands above the doorway of Cave 6 at Udayagiri, amongst the remains on top of the Udayagiri hill, and those of Temple E at Eran. Another band below, with a triangular motif, suggests similar bands in works of a later Gupta style. The disposition of images in the various sides is as follows: South side (illustrated here)—from proper right to left:

Niche 1—empty.
Niche 2—Gajāsuravadha.
Niche 3—Standing Gaṇeśa.
Niche 4—Śiva and Pārvatī on Kailāsa.
Niche 5—Unidentified *mūrti*.

No account has been taken of the niches on the sides of the projecting bays, most of them empty. One is visible on the extreme proper right above. If the *mūrti* in Niche 2 is correctly identified, it is by far the earliest example of an icon which later becomes extremely popular in South India. The elephant's head, if such it be, is a most striking but quite unelephantine grotesque.

The unidentified *mūrti* consists of a standing four-armed male figure with two attendants. The one on the proper left may have worn 'Scythian' costume. The images on the other faces are as follows:

West Side—Niche 1—empty.
Niche 2—empty.
Niche 3—Varāha.
Niche 4—Eight-armed Viṣṇu (Pl. 133).
Niche 5—empty.

The Varāha (image badly damaged) is depicted as all but neckless, the head sunk between enormous shoulders. Bhūdevī, the earth personified as a maiden, is of relatively large size and rests in the angle formed by the left arm of the Boar. All these are early features.

North side—Niche 1—Gajalakṣmī.

Niche 2—Madhukaitabha-
vadha.

Niche 3—Śumbhaniśumbha-
vadha.

Niche 4—Narānarāyaṇa or
Kṛṣṇa-Balarāma.

Niche 5—empty.

In Niche 1, the badly damaged figure of the goddess is shown on a lotus. Since the lustrations are being performed by human figures, the icon is technically not Gajalakṣmī. The badly damaged icons in Niches 2 and 3 were identified for me by Śri S. K. Agrawala. In the former, a pair of supine figures, surmounted by a four-armed one can alone be identified. In the latter, the spirited figure of a four-armed goddess grasps the ropes of a swing with her upper hands while she subdues two large figures, one on either side, with her lower hands. These figures can be identified as demons by their scales.

The image in Niche 4 probably represents Narānarāyaṇa, as in the famous panel from Deogarh although one figure has a hood of serpents' heads.

136. Two royal warriors in chariots—terra-cotta plaque, modelled—Ahichchhatrā, District Bareilly, Uttar Pradesh, 'from the Śiva temple', now in the National Museum, New Delhi—fifth–sixth century A.D.

0·648 × 0·711 × 1·041 m.

V. S. Agrawala, 'Terracotta Figurines of Ahichchhatrā, District Bareilly, U.P.', *Ancient India*, No. 4 (July 1947–January 1948).

Note the boar- and crescent-standards and the fact that each warrior has four quivers of arrows.

137. Śiva *gaṇas* destroying Dakṣa's sacrifice—terracotta plaque, modelled—Ahichchhatrā, District Bareilly, Uttar Pradesh, 'from the Śiva temple', now in the National Museum, New Delhi—fifth–sixth century A.D.

0·661 × 0·635 × 0·127 m.

One of the most popular Śaivite myths is illustrated here. Śiva became angry when his wife, Satī, failed to be invited to a great sacrifice which her father was about to perform and to which all the great gods had been invited. Three of them can be seen at the bottom left, one wearing a crown with a high central rosette such as Viṣṇu is often depicted as wearing. The figure on the far left is unquestionably Indra: he is holding a *vajra* and a crown of a special shape which in earlier times he shared with Viṣṇu images (see Pls. 8 and 18). Śiva, in his anger,

destroyed Dakṣa and his sacrifice. Here his coarse and dwarfish followers or *gaṇas* are shown disrupting the latter. The two figures at the top left have been identified as Dakṣa and the *ṛṣi* or sage who was celebrating the sacrifice.

138. *Kinnara-mithuna*—terracotta plaque, possibly moulded—Ahichchhatrā, District Bareilly, U.P. 'from the Śiva temple', now in the National Museum, New Delhi fifth–sixth century A.D.

0·661 × 0·661 × 0·102 m.

The centaur in India takes a female form. Here one of these forms a *mithuna* (loving couple) with the man, apparently a princely warrior, whom she is carrying. Note the rocks beneath the figures. *Kinnaras* and other mythical beasts were thought to frequent hills and mountains. Note the typical Gupta tree.

139. Gaṅgā (left) and Yamunā (right)—terracotta plaques, modelled—Ahichchhatrā, District Bareilly, U.P., 'from the Śiva temple', now in the National Museum, New Delhi, Nos. L2 and L1—fifth–sixth century A.D.

Much restored. Revealing and highly *recherché* types of bodices seem to have been in vogue in Gupta times. Compare the ones worn by these figures from Ahichchhatrā with those of the Badoh and Besnagar *mātṛkās* (Pls. 30 and 31). The supreme and disdainful elegance of the two river-goddesses, the mannered grotesquery of their attendants and the extreme realism with which the *makara*'s scales are treated, combine to produce the very quintessence of the Gupta style.

140. Śiva as Dakṣiṇāmūrti—terracotta plaque, modelled—Ahichchhatrā, District Bareilly, U.P., 'from the Śiva temple', now in the National Museum, New Delhi—fifth–sixth century A.D.

0·508 × 0·508 × 0·102 m.

Heavily restored. While the water-pot is one of the commonest objects in Indian iconography, it is most exceptional to find plants depicted growing from it, as here.

141. Feminine head—terracotta—Akhnur, Jammu and Kashmir, now in the National Museum, New Delhi, No. 51208/2—probably sixth century A.D.

C. L. Fabri, 'Akhnur Terracottas', *Mārg*, vol. viii, No. 2 (1955).

Akhnur is a small town 19 miles north-west of Jammu City. These Akhnur terra-cottas have been given dates from the sixth to the eighth century. They bear a certain

relationship to a group of terracottas from Ushkur (ancient Huvishkapura), near Bārā-mūlā, in Kashmir, the latter definitely influenced by the later Gandhāra style.

142. Head of a man wearing a helmet—terracotta—Akhnur, now Ashmolean Museum, Oxford (Dept. of Eastern Art, No. OS.50A)—probably sixth century A.D.

<div style="text-align: right">Ht.: 0·125 m.</div>

Illustrated in Fabri (see above), Fig. 9B 'A Warrior of Māra's army'.

143. Head of a man with a moustache—terracotta, Akhnur, now Ashmolean Museum, Oxford (Dept. of Eastern Art, No. OS.50)—probably sixth century A.D.

<div style="text-align: right">Ht.: 0·100 m.</div>

144. Large tile with 'ascetics'—stamped terracotta—Harwan, Kashmir, now Ash-molean Museum, Oxford, on loan from H. A. N. Medd, Esq.—fourth or fifth century A.D.

<div style="text-align: right">0·515 × 0·330 m.</div>

R. C. Kak, *Ancient Monuments of Kashmir*, pp. 108–11 and Pl. XXII, 2.

Harwan is a small village about 2 miles beyond the Shalimar gardens, 8 miles north of Śrīnagar. Sir Aurel Stein identified it with the ancient Shaḍarhadvana ('grove of the six saints') mentioned in the *Rājata-raṅgiṇī* as the place of residence of the great Buddhist patriarch Nāgārjuna.

All the tiles of this type, which served as the risers for the bench around a court, are stamped with numbers in the Kharoṣṭhī script. The court was also paved with stamped tiles bearing, however, a much greater variety of motifs. This tile bears the number 32. Why the tiles are numbered is a mystery although it has been suggested that it was done so that the workmen who installed them would know the order in which the tiles were to be placed. Another mystery centres around the emaciated squatting figures. The Buddhists did not approve of extreme asceticism and if the figures depicted are Hindu, then one would have expected some of the other marks of the Hindu ascetic or sage (matted locks on head, etc.). Finally, the physiog-nomy of the heads in profile at the top are like nothing in Indian, or for that matter, Central Asian art; indeed, the style of all the tiles found at Harwan is unique, which makes it particularly difficult to determine their probable date.

If the style is unique, however, the themes and motifs, which are abundant if all the tiles are considered, are easily traceable. Most of them are plainly Indian; a few,

such as the mailed horsemen, of Sassanian origin; some show a non-Gandhāran West-ern classical origin. Certain early features appear dominant, such as the *vedikā* motif and the practice of depicting torsos or heads as if seen in a balcony, a favourite Kuṣāṇa device at Mathurā. But large circular ear-rings, and what seems to be a provincial version of the Gupta sausage-curl head-dress or wig, neither of which appear in India much before the mid-fourth century, would seem to assign a fifth-century date to the Harwan work. The style is provincial and consequently it seems unlikely to have been in advance of the Indian Doab.

145. Head of a man—terracotta, modelled—Allahabad Museum.

The treatment of the hair leaves no doubt that this is a Gupta piece. The way the terracotta is handled is reminiscent of Rodin's modelling.

146. Head of a girl—terracotta, modelled, painted red—from Kauśāmbī, now Allaha-bad Museum, No. K2522.

<div style="text-align: right">0·110 × 0·085 m.</div>

147. Girl seated by a tree—terracotta relief-plaque—Barehat, Bhind District, now National Museum, New Delhi.

<div style="text-align: right">0·250 × 0·210 m.</div>

Indian Archaeology (1959–60), p. 69, and Pl. LVIIIC.

Bhind lies north-east of Gwalior, only some 20 miles from the Jumna.

148. Relief of a *makara*—terracotta, model-led—North India, probably region of Mathurā, now Ashmolean Museum, Ox-ford (Dept. of Eastern Art, No. 1971–13)—*c.* A.D. 450.

<div style="text-align: right">0·180 × 0·420 m.</div>

149. Śaivite deity—terracotta plaque—Saheth-Maheth, prob. the latter, now State Museum, Lucknow, No. B593.

<div style="text-align: right">Ht.: 0·305 m;
W.: 0·215 m.</div>

The figure is a divinity (four arms) and marked as a form of Śiva by its clearly indicated ascetic traits: emaciation, the *jaṭā* (piled up hair and matted locks), and the rosary of *akṣa* seeds (*akṣamālā*) held over the head. Early Śivas are often shown with a moustache, but rarely is the god depicted with such realism.

There are several other terracottas from the Bhitargaon temple on Lucknow. The well-known plaque showing Viṣṇu reclining on the primeval serpent (Anantaśayana), in a most irreverent vein, is in the Indian Museum, Calcutta.